DESIGNING LEARNING WITH EMBODIED TEACHING

Teaching and learning involve more than just language. The teachers' use of gestures, the classroom spaces they occupy, and the movements they make, as well as the tools they use, work together with language as a multimodal ensemble of meanings. Embodied teaching is about applying the understandings of multimodal communication to the classroom. It is about helping teachers recognise that the moves that they make and the tools they use in the classroom are part of their pedagogy and contribute to the design of the students' learning experience.

In response to the changing profile and needs of learners in this digital age, pedagogic shifts are required. A shift is the evolving role of teachers from authority of knowledge to designers of learning. This book discusses how, using examples drawn from case studies, teachers can use corporeal resources and (digital) tools to design learning experiences for their students. It advances the argument that the study of the teachers' use of language, gestures, positioning, and movement in the classroom, from a multimodal perspective, can be productive.

This book is intended for educational researchers and teacher practitioners, as well as curriculum specialists and policymakers. The central proposition is that as teachers develop a semiotic awareness of how their use of various meaning-making resources express their unique pedagogy, they can use these multimodal resources aptly and fluently to design meaningful learning experiences. This book also presents a case for further research in educational semiotics to help understand the embodied ways of meaning-making in the pedagogic context.

Fei Victor Lim is Assistant Professor at the National Institute of Education, Nanyang Technological University, Singapore. He has published on and been cited for his work in multimodal discourse analysis, designs for learning through classroom orchestration, and multimodal literacy. He serves on the editorial teams of the *Asia Pacific Journal of Education, Computers and Composition*, and *Designs for Learning*. He is also Principal Investigator and Co-Principal Investigator of several research grants. He was previously Lead Specialist and Deputy Director, Technologies for Learning, at the Singapore Ministry of Education, where he has experience in translational research, policy formulation, and programme development, with a focus on how educational technology can improve teaching and learning.

Routledge Studies in Multimodality

Edited by Kay L. O'Halloran, University of Liverpool

For more information about this series, please visit: www.routledge.com/
Routledge-Studies-in-Multimodality/book-series/RSMM

DESIGNING LEARNING WITH EMBODIED TEACHING

Perspectives from Multimodality

Fei Victor Lim

Routledge
Taylor & Francis Group

LONDON AND NEW YORK

First published 2021
by Routledge
2 Park Square, Milton Park, Abingdon, Oxon OX14 4RN

and by Routledge
52 Vanderbilt Avenue, New York, NY 10017

Routledge is an imprint of the Taylor & Francis Group, an informa business

© 2021 Fei Victor Lim

British Library Cataloguing-in-Publication Data
A catalogue record for this book is available from the British Library

Library of Congress Cataloging-in-Publication Data
A catalog record has been requested for this book

ISBN: 978-0-367-37335-1 (hbk)
ISBN: 978-0-367-37336-8 (pbk)
ISBN: 978-0-429-35317-8 (ebk)

Typeset in Bembo
by Newgen Publishing UK

CONTENTS

FIGURES

TABLES

FOREWORD

We live in a world of changes – as always. However, today's changes seem to be as profound and pervasive as those that took place during the industrial revolution. We often try to capture these new changes in terms of digitisation and globalisation, and Zygmunt Bauman has characterised our time in terms of 'Liquid modernity' (2012). At the same time, these terms and descriptions sometimes seem to point at something far above us, or far away from us. Many of us do not seem to feel comfortable with these new changes. The following questions are often formulated: What do these changes actually mean for me, my family or for my work? Is my knowledge still of relevance? And you can also hear statements like: 'Digitisation is something *they* are doing to my job'. Two types of responses have been observed on how to handle these new challenges: the one focusing on the 'good old days' in the 1950s or 60s; and the other focusing on the development of new competencies.

Education, like enterprises, organisations, and other institutions, are today changed in terms of information storage and new communicative patterns, as well as new ways to analyse effects of their activities with the help of AI and Big Data. In schools, we can see the increasing use of tools such as PowerPoint, learning platforms, and apps for learning. Learning analytics is a tool that can help policymakers and educational leaders to monitor the work of schools; teachers to monitor the work of individual students; and the individual student to monitor their own learning. This also raises new questions concerning ethics: which data should we collect, and which data should we share with others?

Another issue is that teachers' professional needs may not always be the same as the needs of big EdTech-companies. To be part of the shaping of the future – on the basis of knowledge and experience – teachers need to develop their digital competencies. These digital competencies concern aspects such as computational thinking (as a way to analyse problems), programming, and insights in the world of apps, AI, and learning analytics.

This book is well-written and offers a systematic introduction to the new information landscape in schools. It addresses ways of looking at teaching and learning, the role of design in teaching, what we see *as* learning and knowledge, and how we can understand multimodal communication and knowledge representations. Learning is (nowadays) not only a question of remembering by heart, but also being able to understand and use different kinds of multimodal knowledge representations. This view of learning is related to a wider understanding of text and of how different text-elements are – or could be – orchestrated and presented.

A wider understanding of learning also entails a view of learning as embodied and situated, which opens up new reflections on how one can design learning environments and learning resources. Today, we see new possibilities for an education that not only focuses on 'facts' or 'knowledge', but also supports creativity, collaborative work, responsibility, and self-regulation, and which gives the students tools to think and analyse different phenomena in nature and society. We should support students with the knowledge and the competencies to understand complexity and work with wicked problems, for example environmental pollution and sustainable living, based on a humanistic tradition (Morin, 2008; UNESCO, 2019).

This book shows how we can understand – and act – in schools in an era of change. It offers a refined understanding of multimodal communication and learning, of embodied teaching and semiotic technologies, as well as of pedagogic discourses, spaces, and gestures. It casts an eye on the multimodal classroom and how the work in this classroom can be orchestrated. It also gives examples of the differences between the ways two teachers design learning experiences, and discusses how teachers can design for learning in the modern classroom.

Staffan Selander
Senior Professor
Stockholm University

References

Bauman, Z. (2012). *Liquid Modernity*. Cambridge/Malden, MA: Polity.
Morin, E. (2008). *On Complexity*. Cresskill, New Jersey: Hampton Press.
UNESCO (2019). *Futures of Education. Learning to Become. A Global Initiative to Reimagine How Knowledge and Learning Can Shape the Future of the Humanity and the planet.* [ED/2019/ERF/1]

ACKNOWLEDGEMENTS

I am indebted to Professor Kay O'Halloran, who first introduced me to the paradigm-changing world of multimodal studies in 2000. Many of the ideas presented in this book stem from her guidance to me as my Master and PhD supervisor. I am fortunate and grateful to have her as a mentor over the last 20 years.

It is my honour to have Senior Professor Staffan Selander write the foreword for this book. Staffan has pioneered the paradigm of designs for learning and his work has laid the theoretical foundations for much of the research in educational semiotics.

I am grateful to my former directors at the Educational Technology Division, Ministry of Education, Singapore. Dr Shirleen Chee, Professor Cheah Horn Mun, Miss Chan Lai Peng, Mr Chua Chor Huat, and Mr Kwan Yew Meng. Their trust and support have given me the wings to apply my research to practice and policy. The seven years spent under their leadership at the Ministry were formative in shaping my convictions and understandings of education, research, and service.

Dr Phillip A. Towndrow and Dr Jonathon Adams are both charitable and critical friends who have provided incisive and insightful feedback on the draft of this book. I have learnt much from both of them and am thankful for their camaraderie. I would also like to register my appreciation to Dr Toh Weimin and Miss Tan Jia Min for their valuable editorial support. I also thank Ms Katie Peace, Commissioning Editor for Routledge, for her faith in the value of this work, and A/P Loh Chin Ee for making the introduction.

I am blessed with the strong support of a loving family – my lovely wife, Yvonne, and amazing children, Alden, Avern, and Arielle. It is such a joy to journey through life with you. Thank you for dreaming and believing together with me.

This book is dedicated to the memory of the late Professor Gunther Rolf Kress, whose life and legacy continue to inspire future generations of scholars in understanding the social view of meaning-making. Gunther's intellectual generosity, warmth, and kindness have touched innumerable lives. I am privileged to be one amongst many.

1

EMBODIED TEACHING

Introduction

Watch Miss Gan in the classroom and one cannot help but be mesmerised by the way she teaches with such seemingly effortless flair and ease. Given that it was the beginning of the academic year, the class we observed was both newly formed and new to her. As such, the 14-year-old students were still settling in to the routines and a few were getting restless during the one-hour lesson. Any teacher, with unfamiliar visitors seated in the classroom, might be flustered. Miss Gan, however, was unfazed. In a calm and almost zen-like manner, she addresses the disciplinary issues, such as inattentiveness, minor disruptions, and distractions, during the lesson through a fluent use of pauses, gesture, and movement. Through these non-verbal ways of expression, she was able to address the misdemeanor of the students, without needing to use even a single negative word to reprimand students. What was remarkable was that the students understood her non-verbal cues effectively and responded positively to her silent communication. When she made a pregnant pause, the class promptly hushed and paid attention. When she gesticulated to a distracted student to focus on what she had written on the board, the child did, and nodded in response. When she moved towards a group of students that was inattentive, the students stopped what they were doing and gave her their attention. It was, to us, an impressive example of the orchestration of the students' learning experience using embodied meaning-making.

Educational sociologist Basil Bernstein describes pedagogic discourse as comprising two discourses – regulative discourse and instructional discourse. The maintenance of control and discipline in the lesson is an aspect of regulative discourse, whereas the teaching of the content knowledge and skills of the curriculum is a part of the instructional discourse. A teacher, therefore expresses her pedagogy through both the expression of instructional and regulative discourse. A case has

been made in the example of Miss Gan, as well as others in the studies described in this book, that the regulative discourse can be expressed non-linguistically, that is through the use of non-verbal modes, such as gestures, positioning, and silences. This allows for the use of language to express the instructional discourse – that is on teaching the content knowledge and skills to be learnt, rather than on classroom management. An advantage of reserving language for teaching and learning, and using 'silent discourses' to address disciplinary issues, is that the learning experience and environment for the student is more positive – nary a harsh word needs to be spoken during the lesson, yet discipline and control are stealthily maintained.

While this may seem like new knowledge to some, many teachers teaching classes prone to disciplinary issues have developed such instincts intuitively through experience over the years. Many, like Miss Gan, might be slightly surprised when this 'orchestration skill' is pointed out to her and might self-deprecatingly brush it off as nothing significant. However, one distinguishing characteristic of a 'good' teacher is pedagogy – and pedagogy is often more than words.

Teaching and learning in the classroom is a multisensory experience. Embodied teaching is about applying the understanding from multimodal communication into the pedagogic situation. It is about sensitising the teacher to the fact that they are designing students' learning experience literally in every move that they make. Whether the students feel safe to participate or are inhibited from speaking up are often a result of the meanings they perceive from their teachers' embodied semiosis. This book discusses, with examples drawn from case-studies, how teachers can use corporeal resources and (digital) tools to design learning experiences for their students. The central proposition is that as teachers develop a semiotic awareness of how the choices made in their use of various meaning-making resources express their unique pedagogy, they can use these multimodal resources with aptness and fluency to design meaningful learning experiences.

Educational semiotics

What makes a 'good' teacher? Is it in their capacity to inspire, their creativity to interest, or their capability to impart? If so, how are these intangibles embodied by the teacher and demonstrated in the lesson?

This book is about the 'silent discourses' in the classroom. We communicate, not only with words, but also with the ways we move, the ways we look, and the ways we use our body to signify, that is the use of embodied modes. The teacher orchestrates the various choices in these meaning-making or semiotic resources and design the learning experience for students. Students know this. They intuitively sense how to respond to a teacher – when to offer their views freely, challenge the teacher's argument, or simply shrink back in silence. It is often not just what the teacher says, but the meanings made through a gesture of folding arms, a step back, or a shake of the head that can end talk.

This is of course not to suggest that language is unimportant. Education psychologist, Lev Vygotsky, observed that language is the chief means in which humans

make meaning. Yet, we all do know that language is not the only means in which humans make meaning. In fact, as Jewitt, Bezemer & O'Halloran (2016: 3) state in their book on *Introducing Multimodality*, 'multimodality marks a departure from the traditional opposition of "verbal" and "non-verbal" communication, which presumes that the verbal is primary and that all other means of making meaning can be dealt with by one and the same term'. While language has been the most well-studied mode of meaning-making, there is a growing interest and body of work that investigates multimodal communication.

Educational semiotics is the study of signs and meaning-making in the context of teaching and learning. It includes the study of knowledge representations in textbooks and learning resources, the development of multimodal literacy in students, that is critical viewing of multimodal texts and effective representing skills in the making of multimodal compositions, as well as the orchestration of embodied and multimedia resources to design positive learning experiences in the classroom. In other words, educational semiotics is about understanding how students learn through meaning-making with multimodal resources, and how teachers teach through designing learning with multimodal – embodied and digital resources. The latter is the focus in this book.

This book outlines the value of focusing on the teacher's use of language, gesture, positioning, and movement in the classroom, described in this book as embodied semiotic modes. The thesis is that as teachers develop a deeper understanding of how the choices made in their use of corporeal resources can express various shades of meaning, and the possibilities and limitations of technological tools, described in this book as semiotic technologies, they can better design various learning experiences for their students. This book advances the argument that the role of the teacher today has evolved into that of a designer of learning. As such, there is a need to better understand how different semiotic resources – both embodied semiotic modes and semiotic technologies – can be used more appropriately in the teacher's multimodal classroom orchestration to design students' learning experiences.

Teachers and teaching

In today's digital age where information is just an Internet-connected device away, are teachers still relevant? As technology becomes more pervasive in our daily lives, there are pertinent questions asked on what jobs technology can displace. The teacher today cannot just be an authority and transmitter of knowledge but must grow in their role and understanding to become a designer of learning (Selander, 2008; Laurillard, 2012; Lim & Hung, 2016). As a designer of learning, the teacher has heightened 'semiotic awareness' (Towndrow, Nelson, & Yusoff, 2013), and demonstrates a fluency in orchestrating a multimodal ensemble (Jewitt, Bezemer, & O'Halloran, 2016; Lim, submitted for publication) of semiotic resources through embodied teaching. As a designer of learning, the teacher exploits the affordances in (digital) teaching resources to bring new possibilities into the classroom. From the perspective of embodied teaching, teachers, far from being 'de-professionalised' or

made redundant, are in fact becoming more critical as designers of various meaningful learning experiences and environments for their students.

The importance of having 'good' teachers cannot be overstated. Earlier studies, such as 'How the world's best performing school systems come out on top' by McKinsey & Company (2007), have since concluded that the main driver of learning and performance is in the quality of the teachers and that the quality of the education system cannot exceed the quality of its teaching force. Muller (2007: 26) describes the teacher as 'an authoritative pedagogical agent' and argues for sound teacher's competency and strong knowledge expertise, opining that 'the condition for teachers to be able to induct pupils into strong internal grammar subjects is that they themselves already stand on the shoulders of giants that they can speak with the disciplinary grammar'. Muller (2007: 26) also reports that in his survey of the global literature on successful learning, 'teacher competence is by far the most important factor in learner attainment'.

This resonates with Macken-Horarik, Love, and Unsworth's (2011) study of the English classroom. They argue that '[t]eachers are central… [as] teachers are the ones who will need to revise, or indeed establish, a grammar that relates purposefully to the texts of contemporary school English and builds knowledge about language progressively and cumulatively' (Macken-Horarik et al., 2011: 10).

O'Halloran (2007) also highlights the importance of the teacher in her documentation of the difference in teaching and learning practices in Mathematics classrooms that are differentiated on the basis of socio-economic status. She observes that 'as the divide grows between different types of schools, so do the experiences, qualifications and salary of the teaching staff' (O'Halloran, 2007: 235). As such, O'Halloran (2007: 235) argues for the need to 'develop theoretical and practical approaches for developing effective teaching strategies, particularly for teachers working with disadvantaged students'. O'Halloran (2007) emphasises the importance of teacher-training, crediting the teacher as a critical factor in the outcome of the students' achievements.

Likewise, Allington and McGill-Franzen (2000: 149) explain that 'we need to concentrate our efforts on enhancing the expertise of teachers… Happily, there seems to be growing recognition, among some policymakers, that it is teachers who teach, not materials.' Undoubtedly, the teacher is central in the implementation of national curriculum objectives, examinations syllabi and the educational policies in the classroom.

Pedagogic discourse

Professor of Education Jay Lemke (2002: 75) argues that classroom learning is 'an example of the general process of ecosocially-mediated development'. The meanings made by the teacher to the students represent the privileged form of knowledge that has been institutionalised through policy and syllabus, packaged into the curriculum, and expressed in the multimodal pedagogic discourse as the lesson experience.

Initiation of the students into the various specialised fields of disciplines takes place via an immensely complex ensemble of semiotic resources, including embodied semiotic modes and semiotic technologies. Semiotic technologies are tools and resources that teachers use to make knowledge representations in the lesson. They can include the use of whiteboards, PowerPoint slides, students' computing devices, and learning management systems and digital platforms with analytics prowess. Instructional materials such as textbooks and worksheets, media of learning through computers and videos as well as pedagogical practices in the form of teaching methodologies and learning frameworks are semiotic choices that teachers would make and orchestrate in the design of the lesson experience for students. Pedagogic semiosis occurs through the use of modalities (such as visual, aural, and somatic) and semiotic modes (such as language, images, gestures, mathematical, and scientific symbolism). Given their unique functional affordances, the modalities and semiotic modes specialise in particular communicative load in the construction of the classroom experience for the student. Hence, the pedagogic work performed by the teacher in the classroom entails the joint co-deployment of embodied semiotic modes and semiotic technologies in a multimodal ensemble.

As mentioned earlier, sociologist Basil Bernstein developed the notion of 'pedagogic discourse' as part of an intricate set of proposals to explain the 'production, reproduction, and transformation of culture' (Bernstein, 1990: 180). Pedagogic discourse is not simply a general term to describe all communication in the classroom. Rather, it is used in the specialist sense in this study, following the work of Bernstein. Bernstein (1990: 183) elucidates:

> We shall define pedagogic discourse as the rule which embeds a discourse of competence (skills of various kinds) into a discourse of social order in such a way that the latter always dominates the former. We shall call the discourse of transmitting specialized competences and their relation to each other instructional discourse, and the discourse creating specialized order, relation and identity regulative discourse.

Given the nature of pedagogic discourse as possessing both the aspects of instruction and regulation, Bernstein (2000: 184) notes that the pedagogic discourse is said to be 'a discourse without a specific discourse', for it has no discourse of its own. Rather, the pedagogic discourse is said to be 'a principle for appropriating other discourses and bringing them into a special relation with each other for the purposes of their selective transmission and acquisition'.

The understanding of the nature of the pedagogic discourse in teaching and learning, as developed by Bernstein and adapted by others such as Christie (1995, 2002, 2007), Christie and Macken-Horarik (2007, 2011), O'Halloran (2004, 2011), and Wignell (2007) is extended to what is described as 'multimodal pedagogic discourse' in this book. Although given that all discourse is multimodal and that adding the modifier 'multimodal' to pedagogic discourse is, strictly speaking, unnecessary,

the nomenclature of multimodal pedagogic discourse is used in this book to foreground the multimodal nature of the pedagogic discourse investigated.

Professor of Language and Literacy, Frances Christie, has applied Basil Bernstein's work on the operation of the pedagogic discourse to develop an account of pedagogic discourse analysis which draws on genre theory. Although focusing primarily on language, Christie's (1993, 1997, 2002) work on pedagogic discourse analysis provides the critical basis for the contextualisation and classification of the multimodal pedagogic discourse described in this book. Christie (1993, 1997, 2002) explains that classroom sequences constitute 'Curriculum Genres' and 'Curriculum Macrogenres'. She demonstrates how the pedagogic discourse is constructed linguistically. Christie (2002) follows Bernstein's recognition of the regulative discourse embedding the instructional discourse, although she prefers to describe it as the regulative register projecting the instructional register, recasting the same notions in terms of Systemic Functional Theory. As such, Christie (2002: 25) argues:

> The pedagogic discourse found in the curriculum genres of schooling functions in such a way that it is realized primarily in a first order or regulative register, to do with the overall pedagogic directions taken, their goals, pacing and sequencing, and a second order or instructional register to do with the 'content' and its specialized skills at issue. The first order or regulative register projects a second order or instructional register.

The regulative register is an important aspect of pedagogic discourse that calls for deeper investigation and analysis. Christie (2002: 162) explains that:

> the regulative register is instrumental in bringing the classroom text into being, and in determining the directions, sequencing, pacing and evaluation of activity; how the latter realizes the 'content' or the specialist experiential information that constitutes the substance of the teaching-learning activity and how the regulative register actually appropriates and speaks through the instructional register.

Christie (2002: 173) also argues that '[a] successful instance of a classroom discourse will be one in which the regulative discourse appropriates and speaks through the instructional register functioning in such a way that a form of "regulation" occurs, in the sense that Bernstein intended'.

Drawing also from Foucault's (1969 [1972]) conceptions of power and the archaeology of knowledge, Christie (2002: 162) describes schooling as 'one of the most important agencies of symbolic control in the modern world'. Hence, pedagogic discourse continues to be of much interest to educational researchers and sociologists, given its significant influence and the subtlety through which this influence is exercised.

Acculturation and initiation of the students into the various specialised fields of disciplines take place via an immensely complex ensemble of embodied semiotic

modes and use of semiotic technologies. The pedagogic discourse is thus instrumental in building and shaping consciousness, and schools are agencies of 'symbolic control'. Ruqaiya Hasan, Professor of Linguistics, also described two types of semiotic mediation that occurs in the classroom. Visible semiotic mediation is realised through the instruction of the teacher and invisible semiotic mediation is realised through the manner in which this instruction is carried out, mostly through the other semiotic modes other than language (2001). The latter, which is often less explicitly articulated, is more ideologically laden and may perhaps be uncovered through a multimodal analysis of the pedagogic discourse. As Christie (2002: 166) observes, '[a]uthority is at its most powerful when it expresses itself in abstraction of this kind, because the human agency involved is rendered invisible in favour of the more abstract principle that is expressed'.

As such, although Bernstein (1990, 2000) originally formulates the concept of instructional and regulative discourse in pedagogic discourse, in light of the language used, it may be productive to extend the concept to multimodal pedagogic discourse. This enables an investigation on how different semiotic resources contribute in expressing the instructional and regulative discourses in the classroom through the visible and invisible semiotic mediation of the multimodal resources. In focusing on the analysis of multimodal pedagogic discourse, we share the convictions espoused by Christie (2002: 24) that

> [i]t is of the utmost importance to analyse and explain how the pedagogic discourses of schooling work, how access to forms of knowledge is made available, how such forms are variously distributed to persons in culture and how they function to shape consciousness.

Steve Walsh, Professor of Applied Linguistics at Newcastle University, argues that 'language teachers can improve their professional practice by developing a closer understanding of classroom discourse and, in particular, by focusing on the complex relationship between language, interaction and learning' (2011: 1). In this book, I concur with Walsh's (2011) argument but widen the definition of classroom discourse to include other embodied semiotic modes such as the use of gestures, positioning, and movement in the classroom, as well as the use of semiotic technologies.

Social semiotics lens on teaching and learning

In this book, we will develop the understanding of embodied teaching from the perspective of educational semiotics and multimodal communication. In every academic endeavour, it is useful to be aware and make explicit the theoretical framing that one has. This is so that the audience is clear of the inherent assumptions and possible bias that the author may inevitably carry so as to align with, interrogate, or perhaps even reject these assumptions. In this book, the theoretical orientation follows from Gunther Kress and Theo van Leeuwen's social semiotics, which

was fundamentally influenced by Michael Halliday's Systemic Functional Theory. Michael Halliday was well-known as a linguist and most famous for his pioneering work in sociolinguistics through developing a systemic functional grammar to study language in use and in context. However, Michael Halliday, arguably, was first and foremost a semiotician who saw language as social semiotic, a resource which humans use to make meaning in society. His seminal work in 1978, *Language as Social Semiotic*, continues to be influential today in defining the social view on meaning-making, and laying the foundation for the work in social semiotics today.

Semiotic modes refer to the various sign systems (Halliday, 1978) or sociocultural semiotic resources (Kress, 2010) which are combined in communicative artefacts and processes to create meaning. Each semiotic mode has specific affordances or meaning potential in communicating meaning. The different meaning potentials of different modes have a fundamental effect on the choice(s) of mode in specific instances of communication (Kress, 2010). The production and reception of modes require common semiotic principles (Kress & van Leeuwen, 2001) to interrelate all sign repertoires present semantically and formally (Stöckl, 2004). An example of a common semiotic principle is semiotic cohesion, discussed in Chapter 6, which refers to the intersemiotic texture or cohesive devices between different semiotic modes, such as language and image (Liu & O'Halloran, 2009), and language and gesture (Lim, 2019a).

What does it mean to adopt a social semiotic lens to multimodal communication and educational semiotics in this book? Bezemer and Kress (2016: 4) argue that it is important to respond 'theoretically to the social', recognise the ways available for making meaning and describe the 'semiotic work done'. In this light, the central tenets of multimodal social semiotics have been adopted as shared assumptions in the development of the ideas in embodied teaching.

The first tenet is the recognition that in classroom teaching, the teacher communicates with multimodal ensembles drawing not only from speech and writing, but also through semiotic modes such as gaze (Amundrud, 2018), gestures (Lim, 2019b), positioning, and movement (Lim, O'Halloran, & Podlasov, 2012). The latter two semiotic modes are the focus of discussion in this book. Each of the semiotic mode offers specific affordances, that is meaning potential, in communication. As such, it is of value to understand the specific affordances in the use of these semiotic modes and how they interact and interplay to express the teacher's pedagogy.

The second tenet in multimodal social semiotics is its definition and explication of 'pedagogy'. As Bezemer, Diamantopoulou, Jewitt, Kress, and Mavers (2012: 5) espouse, pedagogy, in this approach, is the 'transposition of social relations from the social world around the school into the classroom, as a metaphor of what kinds of social relations can be imagined, and which the school might prefer'. Pedagogy is an expression of the meanings made through the teacher's orchestration of a multimodal ensemble of semiotic resources. This includes both the embodied semiotic modes as well as the semiotic technologies available to the teacher. The teacher's multimodal choices in designing the learning experience enact the social relationship between the teacher and students.

The third tenet is on recognising signs of learning (Kress & Selander, 2012). Meaning-making is guided by interest, which shapes attention to a part of the work and acts as the motivation for principles of selection, As a learner makes meaning for herself, outwardly, new ways of conceiving the world, she integrates these into her inner conceptual resources. As such, learning takes place as the learners' entire set of resources is augmented and transformed. In that regard, every act of meaning-making, regardless if the sign has been outwardly, in representing, or inwardly in viewing, is creative and new. From the lens of multimodal social semiotics, this 'serial, ongoing process of transformative engagement, integration and inner transformation, together with the newly resultant state, constitutes learning' (Bezemer, Diamantopoulou, Jewitt, Kress, & Mavers, 2012: 6).

The fourth tenet in multimodal social semiotics is the broadening of focus beyond artefacts, such as textbooks and digital media resources for learning to include social interactions, specifically the pedagogic relationship between the teacher and students in the classroom. The focus is on how specific semiotic modes and semiotic technologies offer and influence the nature of the pedagogic relations between the teacher and students. In pedagogic interactions, the designs for learning and signs of learning are intertwined, where the teacher designs for learning and the students demonstrate signs of learning.

Systemic Functional Multimodal Discourse Analysis (SFMDA)

While Michael Halliday devoted his life's work to advancing our understanding of language, his work has inspired many, including this author, to foray into the study of other semiotic modes. Examples of leading lights in the field of multimodal exploration from the systemic functional theoretical perspective include Michael O'Toole for his work on art and architecture, Kay O'Halloran on mathematics, film, propaganda, and digital humanities, and Len Unsworth on picture books, educational texts, and mobile apps. Their work, together with many other scholars, has profoundly inspired and influenced the development of this book. The contributions of these scholars in advancing the ideas put forth in this book will be described in relation to the topics discussed within each chapter.

The approach used in this book to analyse the multimodal choices in embodied semiosis is the Systemic Functional Multimodal Discourse Analysis (SFMDA) approach described in O'Halloran and Lim (2014) and Jewitt, Bezemer, and O'Halloran (2016). SFMDA is an extension of the Systemic Functional Theory developed by Halliday (1978, 1985). Halliday had always been interested in the pedagogic application of his theory. He developed Systemic Functional Linguistics originally for the teaching of Mandarin from his seminar paper Grammatical Categories in Modern Chinese (Halliday, 1956 [1976]) (see Fawcett, 2000). Christie (2007: 1) observes that '[f]or Halliday, educational processes are part of the very warp and weft of life, and educational sites constitute major contexts for close analysis in language'. Systemic Functional Linguistics examines the meanings made in

language through the systems choices oriented around ideational, interpersonal, and textual metafunctions (Halliday, 1985 [1994]; Halliday & Matthiessen, 2004).

Halliday (1985a: 4) explains that linguistics is at the same time a 'kind of semiotics' because language is viewed as 'one among a number of systems of meaning that, taken all together, constitute human culture'. As Djonov (2005: 46) argues, 'Systemic Functional Linguistics is thus a social semiotic theory because it models language in relation to social context'.

The use of the term 'systemic' to describe the multimodal discourse analysis approach adopted in SFMDA is apt. Halliday (1985a: 4) explains that systems of meaning are social systems. They are 'modes of cultural behaviour'. This is because meanings are always exchanged in interactions between people and the sociocultural groups they represent. For example, Halliday (1978: 12) sees language and society as a 'unified conception' which needs to 'be investigated as a whole'. The same understanding is extended to the inextricable unity between multimodal semiotic resources and society in SFMDA as well.

The notion of choice is central in Systemic Functional Theory. Halliday (1994: xiv) declares that 'Systemic theory is a theory of meaning as choice, by which language, or any other semiotic system, is interpreted as networks of interlocking options.' Meaning is therefore made through realised choices from paradigms and in syntagms. Semiotic resources comprise networks of interlocking options from where the meaning-maker selects. As Halliday (1994: xiv–xxvi) elucidates, the choice is 'not a conscious decision made in real time but a set of possible alternatives' from which choices are made in actual texts. van Leeuwen (1999: 29) explains that these choices usually 'result from a convention followed unthinkingly, a habit acquired unreflectively, or an unconscious impulse'.

The choice available and exercised by the meaning-maker is further developed by Gunther Kress, within social semiotics, in recognition of the 'interest' of the sign-maker. Kress (1993) argues that all acts of meaning-making are motivated by interest. He defines interest as

> the articulation and realisation of an individual's relation to an object or event, acting out of that social complex at a particular moment, in the context of an interaction with other constitutive factors of the situation which are considered as relevant by the individual.
>
> (Kress, 1993: 174)

As Jewitt (2009: 31) explains, 'interest connects a person's choice of one resource over another with the social context of sign production'. Kress et al. (2001: 5) argue that

> the assumption is that the relation between form and meaning, signifier and signified, is never arbitrary, but that it is always motivated by the interests of the maker of the sign to find the best possible, the most plausible form of the expression of the meaning that she or he wishes to express.

As such, the perspective offered by Systemic Functional Theory, and by extension SFMDA, is that meaning-making is a result of choice. These choices may not always be conscious or intentional, but they are always motivated according to the interest of the meaning-maker. In this light, the interpretation of meanings made in texts stems from Edmund Husserl's (1907 [1964]) conception of intersubjectivity. The intersubjective position has been adopted as a useful perspective in the interpretation of meanings within the literature in Systemic Functional Theory (see, e.g. Halliday, 1975, 1994; Hasan, 1992; Hasan, Cloran, & Butt, 1996; Thibault, 2004). White (2003) extends this in Systemic Functional Theory, specifically in Appraisal Theory. He argues that 'stance and attitude are fundamentally social rather than personal, that when speakers/writers take a stand, when they construct for themselves a particular persona or identity, it is via a process of engaging with socially-determined value positions' (White, 2003: 280). In a sense then the social intersubjective position is the general triangulation of agreement, a shared understanding, within a semiotic community towards a particular contextualised interpretation of meanings in discourse. In this book, we argue that with multimodal semiotic awareness, teachers can become more fluent in their use of the available semiotic resources in designing students' learning experiences.

One of the advantages of the SFMDA perspective, in foregrounding the notion of choice and meaning potential in system networks is, as Machin (2009: 182) observes in O'Toole's (1994 [2010]) study of painting, 'to replace terms such as "evoke" and "suggest" that we often use to discuss works of art with systematic and stable terms that allowed us to talk in concrete terms about how such a composition communicates'. This is enabled through the meta-language which Systemic Functional Theory offers and the theoretical perspective which SFMDA presents. As such, in this book, a meta-language for the description of semiotic modes such as the teacher's use of space and gestures in the classroom is proposed. This allows educational researchers and teachers to describe and discuss their use of these semiotic modes and the meanings they make. In other words, the aim is to provide language for us to talk about multimodal pedagogic discourse.

Systemic Functional Theory is also concerned with the functional meanings made by the semiotic resources in society. Halliday (1994: xiii) explicates that the use of the term 'functional' in Systemic Functional Theory is 'because the conceptual framework on which it is based is a functional one rather than a formal one'. He explains that '[e]very text … unfolds in some context of use'. The focus in Systemic Functional Theory is to understand and evaluate the meanings as they are used in context.

Central to the Systemic Functional Theory is the view that meaning is function in context. This is derived from the work of anthropologist Bronislaw Malinowski. For Halliday (1978: 2), language as a social semiotic means 'interpreting language within a sociocultural context, in which the culture itself is interpreted in semiotic terms – as an information system'. Hence, a premise in Systemic Functional Theory is that meaning is made and can only be interpreted in context. Systemic Functional Theory asserts a systematic relationship between the sociocultural context in which

language occurs and the functional organisation of language (see Halliday, 1978; Halliday & Hasan, 1985). The notion of context is important not just in Systemic Functional Theory but also as observed by Machin (2009: 189), 'in critical discourse analysis… it is notable that two of the best-known writers, van Dijk (1993) and Fairclough (1995), both stress the need for contextual knowledge'.

In keeping with this, the SFMDA approach interprets meanings made by the semiotic modes, such as gesture and the use of space in positioning and movement of the teacher, within its specific contexts of situation and culture. In this book, the meanings made in the classroom are located and interpreted within the different lesson microgenres and lesson genres. The Curriculum Genre Theory, developed by Frances Christie and discussed in Chapter 2, offers a productive frame for situating the meanings made through the multimodal semiotic resources in the lesson within its context.

In SFMDA, as it is in Systemic Functional Theory, the meaning potential of the various semiotic resources is not only represented in system networks, but the meanings are also organised metafunctionally. Halliday's (1978) social semiotic theory models the meaning potential of semiotic resources into three distinct metafunctions: (1) interpersonal meaning, which is the enactment of social relations; (2) ideational meaning, which is expression of our ideas about the world; and (3) textual meaning for the organisation of the meaning into coherent texts and units.

The metafunctional organisation of meanings is particularly helpful in multimodal studies as it presents a shared set of fundamentals across semiotic resources for integration and comparison. Meanings are made through the semiotic mode of language, gesture, and the use of space in the classroom. The organisation of meanings across the semiotic resources thus offers a unifying platform for studies in intersemiosis. This is discussed further in Chapter 6 of this book.

Multimodal research offers much promise for classroom studies and applications. The multimodal perspective offered in SFMDA brings into focus the other modalities in pedagogical semiosis, and interprets the meanings made in pedagogic discourse through the integration and interplay of the co-deployed modalities. The SFMDA approach, as outlined in this chapter, accentuates the need for the development of new theories and strategies in teaching and learning that take into account multimodality. As such, the new paradigm of teaching and learning afforded through a multimodal lens presents a research space inviting deeper exploration and further investigation. Likewise, the understanding of the nature of multimodal semiosis in pedagogic discourse offers a viable and valuable contribution to classroom research and practices.

From embodied teaching to designing learning

This book is about designing learning with embodied teaching, that is, how the teacher expresses a specific pedagogy through multimodal semiotic resources. The chapters in this book are organised according to the teacher's use of embodied modes such as movement and positioning in classroom space, and the use of gestures

in the lesson. We will also explore the meanings made through various semiotic technologies for teaching and learning as well as reflect on how these multimodal resources can be orchestrated in the design of students' learning experiences.

In this chapter, I have introduced the concept of 'embodied teaching'. The notion will be illustrated with specific examples in the other chapters of the book. I also present the theoretical orientation in which the book is based on, specifically, the tenets of social semiotics and the principles of Systemic Functional Multimodal Discourse Analysis (SFMDA). This book is situated within the field of educational semiotics, where the lens of social semiotics is applied to view and provide insights on teaching and learning. This book also applies the SFMDA approach to study the multimodal choices made in pedagogic discourse. I argue that in recognising the choices made by the teachers and drawing attention to the meaning potential of these choices, the teachers can develop a semiotic awareness to design meaningful learning experiences for their students.

Chapter 2 situates the discussion in this book by describing the value of applying the understanding from the field of multimodal studies to classroom research. I will show how the Curriculum Genre Theory developed by Frances Christie (1993, 1997, 2002) and extended by Kay O'Halloran (1996, 2004) is used to describe the lesson microgenres within each lesson. Based on Lim (2011) and Lim and Tan (submitted for publication), I argue that this is a productive endeavour as through the identification of lesson microgenres, teachers will be able to recognise the stages within each lesson and consider the nature of the multimodal ensembles most appropriate for each stage of the lesson.

Chapter 3 explores the teacher's use of the physical space in the classroom through the introduction of the notion of 'Spatial Pedagogy'. The chapter discusses how the positioning and movement of the teacher in the classroom are fundamental to the pedagogical process. Following the work by cultural anthropologist Edward Hall (1959, 1966) and based on Lim (2011) and Lim, O'Halloran and Podlasov (2012), I argue that specific spaces in the classroom take on certain meanings because of the nature of pedagogic discourse that occurs on the site and the positioning and distance of the site relative to the students and the teaching resources. In this light, spatial pedagogy is expressed through the patterns of positioning and the directionality of movement, as well as the intersemiotic correspondences in the use of space with other semiotic modes (e.g. language, gesture, and teaching materials). I use examples from a study of how two teachers navigate the space in the classroom differently despite teaching the same topic in the lesson to highlight their different spatial choices in embodied teaching.

In Chapter 4, we turn our attention to another fundamental aspect of embodied teaching – the teacher's use of gesture in the classroom. With the ubiquity of video recording technologies today, it is now possible to collect multimodal classroom data, such as the teachers' use of gestures, positioning, and classroom space to enact specific pedagogy. Such data can help teachers review and reflect on the meanings made in their gestural choices. This awareness supports teachers in understanding the meaning potential in their use of corporeal resources to design specific learning

experiences for their students. While the technologies to collect such data are now easily accessible, the challenge of sense-making from the data remains. How can the gestural choices made by the teacher be annotated, analysed and interpreted? Drawing from Systemic Functional Theory, and based on Lim (2011), and Lim (2019a), I show how the SFMDA approach can be applied to annotate and analyse the teacher's gestures in the classroom. The SFMDA approach to the analysis of the teachers' gesture builds on current research and theoretical conceptions of gestures and extends the classifications with examples from a selection of instances from an authentic classroom corpus.

Chapter 5 explores the various educational tools and resources, both techno-logical and non-technological, for teaching and learning in the classroom. These include the optimal use of popular resources in many classroom environments, such as the ubiquitous whiteboard, as well as the introduction of new and emerging technologies for learning, such as the use of apps for digital play and learning in the classroom. The (digital) educational tools and resources are described as semiotic technologies, that is technology for making meaning. This perspective offers consideration on the design, use, and sociocultural context in which the semiotic practice is situated within. I argue that educational tools, especially technologies for learning, can productively enhance existing instructional practices and enable new innovative practices in the classroom. Notwithstanding, it is also useful to acknowledge the opportunity cost that these tools can bring. Embodied teaching involves a recognition of the value and cost that specific semiotic technologies can bring as we use them to design various learning experiences for our students.

Chapter 6 discusses the orchestration of meanings through the teacher's multimodal ensemble of semiotic resources. The teacher's combinational use of language, gestures, and classroom space is looked at as an expression of her pedagogy. The ideas in the chapter will be illustrated from the study of two teachers in Singapore based on Lim (2011) and Lim (2019b). From the analysis and interpretation of the teachers' multimodal selections in these case studies, an emergent meaning of 'structured informality' as an expression of the teacher's pedagogy is described. Structured informality offers a way to consider how teachers can design an effective learning experience for their students using multimodal resources.

The conclusion in Chapter 7 draws coherence across the key ideas in the book and shifts the focus from teaching to learning. The purpose of embodied teaching is to design learning and design for learning. The contributions in this book are situated within Michael Halliday's clarion call for 'appliable linguistics', where there is a cogent agenda towards translating and applying knowledge into practice as part of theory-building. I discuss the need for translational research in multimodal studies as well as reflect on the implications of the understandings developed in this book on professional development for teachers as well as for policy and curricular impact. Finally, future directions for research and practice in the field of educational semiotics are proposed to galvanise other like-minded educational researchers, teacher practitioners, and policymakers to be a part of this adventure to design learning through bettering teaching from a multimodal lens.

Some two decades ago, Gunther Kress declared that

> it would be an unforgivable dereliction of the responsibilities of intellectuals if the potentials of representation and communication – of literacy in a very broad and metaphoric sense – offered by current developments were not fully explored, and a concerted attempt made to shape their direction.
>
> (2000: 161)

This book joins other scholarly efforts over the years in response to Gunther Kress's exhortation to harness the advances in understandings made in multimodal studies to inform and transform teaching and learning at the frontline of education – the classroom.

REFLECTION QUESTIONS

1. What are the different learning experiences that teachers can design for their students?
2. How can teachers express the regulative discourse in the lesson through their use of gestures, movement, and silences?

References

Allington, R.L. & McGill-Franzen, A. (2000). Looking back, looking forward: A conversation about teaching reading in the 21st century. *Reading Research Quarterly* 35(1). 136–153.

Amundrud, T. (2018). Applying multimodal research to the tertiary foreign language classroom: Looking at gaze. In H.D.S. Joyce & Feez. S.(eds), *Multimodality Across Classrooms: Learning About and Through Different Modalities*. 160–177. London & New York: Routledge.

Bernstein, B. (1990). *Class, Codes and Control: Volume IV. The Structuring of Pedagogic Discourse*. London & New York: Routledge.

Bernstein, B. (2000). *Pedagogy, Symbolic Control and Identity: Theory, Research, Critique*. Lanham, Maryland: Rowman & Littlefield Publishers Inc.

Bezemer, J, & Kress, G. (2016). *Multimodality, Learning and Communication: A Social Semiotic Frame*. London: Routledge

Bezemer, J., Diamantopoulou, S., Jewitt, C., Kress, G., & Mavers, D. (2012). Using a Social Semiotic Approach to Multimodality: Researching Learning in Schools, Museums and Hospitals. NCRM Working Paper. NCRM. (Unpublished).Christie, F. (1993). Curriculum genres: Planning for effective teaching. In B. Cope & M. Kalantzis (eds), *The Powers of Literacy: A Genre Approach to Teaching Writing* (154–178). Pittsburgh: University of Pittsburgh Press.

Christie, F. (1995). Pedagogic discourse in the primary school. *Linguistics and Education* 7(3), 221–242.

Christie, F. (1997). Curriculum macrogenres as forms of initiation into a culture. In F. Christie & J. R. Martin (eds), *Genre and Institutions: Social Processes in the Workplace and School* (134–160). London: Cassell.

Christie, F. (2002). *Classroom Discourse Analysis: A Functional Perspective*. London & New York: Continuum.

Christie, F. (2007). Ongoing dialogue: Functional linguistic and Bernsteinian sociological perspectives on education. In F. Christie & J. Martin (eds), *Language, Knowledge and Pedagogy: Functional Linguistic and Sociological Perspectives* (3–13). London & New York: Continuum.

Christie, C. & Macken-Horarik, M. (2007). Building verticality in subject English. In F. Christie & J. Martin (eds), *Language, Knowledge and Pedagogy: Functional Linguistic and Sociological Perspectives* (156–183). London & New York: Continuum.

Christie, C. & Macken-Horarik, M. (2011). Disciplinarity and school subject English. In F. Christie, & K. Maton (eds), *Disciplinarity: Functional Linguistic and Sociological Perspectives* (175–197). London & New York: Continuum.

Djonov, E.N. (2005). Analysing the Organisation of Information in Websites: From Hypermedia Design to Systemic Functional Hypermedia Discourse Analysis. Unpublished doctoral dissertation. University of New South Wales, Sydney.

Fairclough, N. (1995). *Critical Discourse Analysis*. London: Longman.

Fawcett, R. (2000). *A Theory of Syntax for Systemic Functional Linguistics*. Amsterdam/Philadelphia: John Benjamins.

Foucault, M. (1972). *The Archaeology of Knowledge and the Discourse on Language* (A. Sheridan, Trans.). United States: Pantheon Books. (Original work published 1969.)

Hall, E. (1959). *The Silent Language*. New York: Doubleday.

Hall, E. (1966). *The Hidden Dimension*. New York: Doubleday.

Halliday, M.A.K. (1956/1976). Grammatical categories in modern Chinese. *Transactions of the Philological Society* 1956, 180–202.

Halliday, M.A.K. (1975). *Learning How to Mean: Explorations in the Development of Language*. London: Edward Arnold.

Halliday, M.A.K. (1978). *Language as Social Semiotic: The Social Interpretation of Language and Meaning*. London: Edward Arnold.

Halliday, M.A.K. (1985a). Part A. In M.A.K. Halliday & R. Hasan (eds), *Language, Context, and Text: Aspects of Language in a Social-Semiotic Perspective* (1–49). Geelong, Victoria: Deakin University Press.

Halliday, M.A.K. (1985/1994b). *An Introduction to Functional Grammar* (2nd edition). London: Arnold (1st edition 1985).

Halliday, M.A.K. (1989). *Spoken and Written Language*. Oxford: Oxford University Press.

Halliday, M.A.K. & Hasan, R. (1985). *Language, Context, and Text: Aspects of Language in a Social-semiotic Perspective*. Geelong, Victoria: Deakin University Press.

Halliday, M.A.K. & Matthiessen, C.M.I.M. (2004). *An Introduction to Functional Grammar* (3rd edition). London: Arnold (1st edition 1985).

Hasan, R. (1992). Meaning in sociolinguistic theory. In K. Bolton & H. Kwok (eds), *Sociolinguistic Today: International Perspectives* (80–119). London & New York: Routledge.

Hasan, R. (2001). The ontogenesis of decontextualised language: Some achievements of classification and framing. In A. Morais, I. Neves, B. Davis, & H. Daniels (eds), *Towards a Sociology of Pedagogy. The Contributions of Basil Bernstein to Research* (47–80). New York, Washington, Frankfurt, Berlin, Brussels, Vienna and Oxford: Peter Lang.

Hasan, R., Cloran, C., & Butt, D. (eds) (1996). *Functional Descriptions: Theory in Practice*. Amsterdam: Benjamins.

Husserl, E. (1964). *The Idea of Phenomenology*. The Hague: Martinus Nijhoff. (Original lectures given in 1907.)

Jewitt, C. (2009). Different approaches to multimodality. In C. Jewitt (ed.), *The Routledge Handbook of Multimodal Analysis* (28–39). London & New York: Routledge.

Jewitt, C., Bezemer, J., & O'Halloran, K.L. (2016). *Introducing Multimodality*. London & New York: Routledge.

Kress, G. (1993). Against arbitrariness: The social production of the sign as a foundational issue in critical discourse analysis. *Discourse and Society* 4(2), 169–191.

Kress, G. (2000). Design and transformation: New theories of meaning. In B. Cope & M. Kalantzis (eds), *Multiliteracies: Literacy Learning and the Design of Social Futures* (153–161). South Yarra, Victoria: Macmillan Publishers Australia Pte Ltd.

Kress, G. (2010). *Multimodality – A Social Semiotic Approach to Contemporary Communication*. London & New York: Routledge.

Kress, G. & Selander, S. (2012). Multimodal design, learning and cultures of recognition. *The Internet and Higher Education*. 15(4). 265–268.

Kress, G. & van Leeuwen, T. (2001). *Multimodal Discourse: The Modes and Media of Contemporary Communication*. London: Edward Arnold.

Kress, G., Jewitt C., Ogborn, J., & Tsatsarelis, C. (2001). *Multimodal Teaching and Learning: The Rhetorics of the Science Classroom*. London & New York: Continuum.

Laurillard, D. (2012). *Teaching as a Design Science. Building Pedagogical Patterns for Learning and Technology*. New York & London: Routledge.

Lemke, J.L. (2002). Travels in hypermodality. *Visual Communication*. 1(3), 299–325. Retrieved from www-personal.umich.edu/~jaylemke/papers/hypermodality/travels-App.htm

Lim, F.V. (2011). A Systemic Functional Multimodal Discourse Analysis Approach to Pedagogic Discourse. Doctoral thesis. National University of Singapore.

Lim, F.V. (2019a). Investigating Intersemiosis: A Systemic Functional Multimodal Discourse Analysis of the Relationship between Language and Gesture in Classroom Discourse. Visual Communication, Online First.

Lim, F.V. (2019b). Analysing the Teachers' Use of Gestures in the Classroom: A Systemic Functional Multimodal Discourse Analysis. *Social Semiotics* 29 (1), 83–111.

Lim, F.V. (submitted for publication). Towards Education 4.0: An Agenda for Multiliteracies in the English Language Classroom.

Lim, F.V. & Hung. D (2016). Teachers as learning designers: What technology has to do with learning. *Educational Technology* 56(4), 26–29.

Lim, F.V. & Tan, J.M. (submitted for publication). Lesson Microgenres: An Approach to Multimodal Classroom Discourse.

Lim, F.V., O'Halloran, K. L., & Podlasov. A. (2012). Spatial pedagogy: Mapping meanings in the use of classroom space. *Cambridge Journal of Education* 42(2), 235–251.

Liu, Y. & O'Halloran, K. L. (2009). Intersemiotic texture: Analyzing cohesive devices between language and images. *Social Semiotics* 19(4), 367–388.

Machin, D. (2009). Multimodality and theories of the visual. In C. Jewitt (ed.), *The Routledge Handbook of Multimodal Analysis* (181–190). London & New York: Routledge.

Macken-Horarik, M., Love, K., & Unsworth, L. (2011). A grammatics 'good enough' for school English in the 21st century: Four challenges in realising the potential. *Australian Journal of Language and Literacy* 34(1), 9–21.

Martin, J.R. (1992). *English Text: System and Structure*. Amsterdam/Philadelphia: John Benjamins Publishing Company.

McKinsey & Company (2007). How the world's best-performing school systems come out on top. Retrieved from www.mckinsey.com/clientservice/social_sector/our_practices/education/knowledge_highlights/best_performing_school.aspx

Muller, J. (2007). On splitting hairs: Hierarchy, knowledge and the school curriculum. In F. Christie & J. Martin (eds), *Language, Knowledge and Pedagogy, Functional Linguistic and Sociological Perspectives* (65–86). London & New York: Continuum.

O'Halloran, K.L. (1996). The Discourse of Secondary School Mathematics. (unpublished doctoral dissertation). Australia: Murdoch University.

O'Halloran, K.L. (2004). Discourse in secondary school Mathematics classrooms according to social class and gender. In J.A. Foley (ed.), *Language, Education and Discourse: Functional Approaches* (191–225). London & New York: Continuum.

O'Halloran, K. L. (2007). Mathematical and scientific forms of knowledge: A systemic functional multimodal grammatical approach. In F. Christie & J. Martin (eds), *Language, Knowledge and Pedagogy, Functional Linguistic and Sociological Perspectives* (205–236). London & New York: Continuum.

O'Halloran, K. L. (2011). The semantic hyperspace: Accumulating mathematical knowledge across semiotic resources and modalities. In F. Christie, & K. Maton (eds), *Disciplinarity: Functional Linguistic and Sociological Perspectives* (217–236). London & New York: Continuum. Retrieved from http://multimodal-analysis-lab.org/_docs/pubs15-O'Halloran(in_press)-Accumulating_Maths_Knowledge_in_Classroom.pdf

O'Halloran, K.L. & Lim, F.V. (2014). Systemic functional multimodal discourse analysis. In S. Norris & C. Maier (eds), *Texts, Images and Interactions: A Reader in Multimodality* (pp. 135–154). Berlin: De Gruyter.

O'Halloran, K.L., Chua, A., & Podlasov, A. (2014). The role of images in social media analytics: A multimodal digital humanities approach. In D. Machin (ed.), *Visual Communication*, pp. 565–588. Germany: De Gruyter.

O'Toole, M. (1994/2010). *The Language of Displayed Art* (2nd edition). London & New York: Routledge (1st edition 1994).

Potter, J. & McDougall, J. 2017. *Digital Media, Culture and Education: Theorising Third Space Literacies.* London: Palgrave Macmillan.

Sadovnik, A. R. (ed.) (1995). *Knowledge and Pedagogy: The Sociology of Basil Bernstein.* Norwood, NJ: Ablex Publishing Company.

Selander, S. (2008). Designs for learning – A theoretical perspective. *Designs for Learning* 1(1): s. 10–22.

Stöckl, H. (2004). In between modes: Language and image in printed media. In E. Ventola, C. Cassily, & M. Kaltenbacher (eds), *Perspectives on Multimodality* (9–30). Philadelphia and The Netherlands: John Benjamins Publishing Company.

Thibault, P. (2004). *Brain, Mind and the Signifying Body: An Ecosocial Semiotic Theory.* London & New York: Continuum.

Towndrow, P.A., Nelson, M.E., & Yusuf, W.F.B.M. (2013). Squaring literacy assessment with multimodal design: An analytic case for semiotic awareness. *Journal of Literacy Research* 45(4), 327–355.

van Dijk, T.A. (1993). Principles of critical discourse analysis. *Discourse & Society* 4(2), 249–283.

van Leeuwen, T. (1999). *Speech, Music, Sound.* London: Macmillan.

Walsh, S. (2011). *Exploring Classroom Discourse: Language in Action.* London & New York: Routledge.

White, P. (2003). Beyond modality and hedging: A dialogic view of the language of intersubjective stance. *Text* 23(2), 2594–2598.

Wignell, P. (2007). *On the Discourse of Social Science.* Darwin, Australia: Charles Darwin University Press.

2
MULTIMODAL PEDAGOGIC DISCOURSE

Discourses in the classroom

What makes up the design of a lesson? Is the lesson a single composite entity where the focus is solely on the dissemination of knowledge or does it comprise parts in which each can be viewed as distinctly different from the other? How can we begin to describe the learning experience of students from a lesson? This chapter invites us to consider the different types of meaning-making activities within a lesson. We will examine the value of identifying distinct stages in a lesson, described as 'lesson microgenres' and explore how the lens of multimodal social semiotics can help us understand the meanings that are made multimodally in these lesson microgenres. I suggest that identifying the lesson microgenres offer a 'mirror' for the teacher to reflect on the types and nature of discourses occurring in the classroom. The categorisation of the lesson into specific multimodal pedagogic discourses also provides an analytical frame for educational researchers to understand, study, and compare across lessons, as the lesson microgenres facilitate the visualisation of patterns of lesson microgenres in each lesson. In the next section, we introduce the Curriculum Genre Theory, which offers the theoretical basis for the development of a framework of lesson microgenres within each lesson.

Teaching is more than talk. It is also about the different ways in which meanings are made by the teacher in the classroom. The various meanings expressed through their multimodal discourses bring about different learning experiences for students. Pedagogic discourse is always expressed multimodally – through the teacher's language, gestures, movement, positioning, as well as the use of semiotic technologies in the classroom. Regardless of whether they are used intentionally or incidentally, these semiotic resources work in combination to express specific meanings to the students – most of the time coherently, sometimes (unwittingly) not – but as Kress (2010) argues, always motivated. The effects of the teacher's use of embodied

semiotic modes and semiotic technologies in the lesson contribute to the learning experience of the students.

The understanding that teaching and learning in the classroom is not accomplished through language alone has been of interest to some educational researchers, even before a dominant focus on multimodality emerged in recent years. For example Lawn (1999) observes that many teachers do not recognise the impact of the classroom, as the material environment, on teaching. Englund (1997: 277) also notes that the teacher possesses different possibilities in the construction of a lesson experience for the students and these potentials are 'concretized in different ways in different classrooms'.

Classroom arrangements and display have also been considered as providing pedagogic resources, serving to transmit the pedagogic practices and 'fundamental regulatory principles' that govern a school (Daniels, 2001: 169). In their study on English Language classrooms in the United Kingdom, Gunther Kress and his colleagues conclude that 'subjects, actualized in particular classrooms, can be inflected in radically different ways, from patriarchal to democratic' (Kress et al., 2005: 18). This is consistent with Seaborne and Lowe's (1977) earlier argument that a building literally 'makes' a teaching method.

Despite this, research into pedagogic discourse and interaction between teacher and students has traditionally tended to focus on an analysis of classroom language alone (see, e.g. Sinclair & Coulthard, 1975; Mercer, 2000 ; Walsh, 2006, 2011). More often than not, the emphasis has been on verbal exchanges, while downplaying or neglecting the meanings made in the teacher's use of gesture, positioning, and movement in the classroom. However, as Kress (2003: 35) observes, '[l]anguage alone cannot give us access to the meanings of the multimodally constituted messages; language and literacy now have to be seen as partial bearers of meaning only'. The focus on just the linguistic aspect of classroom interaction will not account for the orchestration of the semiotic modes in designing the learning experience for students.

From the students' perspective, they do not just listen to what the teachers say in the classroom; they watch, and 'read', the teacher as the teacher 'performs' the multimodal pedagogic discourses in the classroom. Michael O'Toole, Emeritus Professor of Communication Studies at Murdoch University, in his seminal work on multimodality, *The Language of Displayed Art*, observes that '[w]e "read" people in everyday life: facial features and expression, stance, gesture, typical actions and clothing' (O'Toole, 1994: 15). Norris (2004: 2) also argues that '[a]ll movements, all noises, and all material objects carry interactional meanings as soon as they are perceived by a person'. In this sense, the teacher communicates multimodally with the students the very moment she steps into the classroom, with nary a word needed. Our communication is more than what is said and heard but by what we perceive through facial expressions, gazes, gestures, and movements.

Kress et al. (2005) demonstrate that even in an English classroom, language may not always be the dominant semiotic resource. In a similar vein, Bourne and Jewitt (2003) investigate the ways in which the interpretation of a literary text is mediated and (re)construed through social interactions. Their work suggests how the lens of multimodal social semiotics contributes to a more complete understanding of the

teaching and learning in the classroom. Flewitt (2006: 46) explains that 'language is only one tool in a range of human semiosis, and that individuals' choices of semiotic modes are motivated by a complex web of interconnecting personal, institutional and social factors'. In light of this, O'Halloran (2007b: 79) observes that '[t]he study of linguistic discourse alone has theoretical limitations which have the potential to simplify and distort the actual nature of pedagogical practice'. Hence, the focus of educational research can benefit from moving beyond an emphasis on language to examine the other meaning-making resources as well. In designing the learning experience, we argue that the teacher should be aware of the different ways meanings can be made across an ensemble of semiotic resources. We posit that this semiotic awareness can help the teacher to design various learning experiences for her charges, with a fluency in the multimodal orchestration of meaning-making resources.

Curriculum genre theory

Frances Christie, Emeritus Professor of Language and Literacy Education at the University of Melbourne, developed the theory of Curriculum Macrogenre and Curriculum Genre (1993, 1997, 2002) to investigate the different stages in the teaching of a topic in a subject and to map the development of a topic. Curriculum Genre Theory was developed to study the organisation and structure of learning in the classroom as well as how they are situated and related to the macro-design of the curriculum. The value in adopting Curriculum Genre Theory to study the progression of the lesson is espoused in Christie's (2002: 2) argument that '[u]nless we are willing to engage seriously with the discourse patterns particular to the institution of schooling, we fail genuinely to understand it'.

Frances Christie draws from Systemic Functional Theory, such as genre theory in the Systemic Functional tradition and aspects of sociological theories by Bernstein (1990, 2000), particularly his theoretical conceptions on the pedagogic discourse Christie (2002: 3) views 'classroom activity as structured experience and associated notion of classroom work as social practice'. Christie (2002: 3) proposes that 'pedagogic discourse can be thought of creating curriculum genres and sometimes larger unities referred to as curriculum macrogenres'. These Curriculum Genres and Curriculum Macrogenres represent units of curriculum activity. The endeavour to map out these patterns of pedagogic discourse will show the unity, development, consistency, and change of the curriculum design in and over time. It will also enable comparisons across other lessons and subject disciplines.

Christie (2002: 96) observes that 'curriculum activity that is expressed mainly in discrete curriculum genres carrying little sense of progression and development in learning is found in teaching and learning at all levels of schooling'. As such, she argues that unless there is evidence of significant change and development in understanding and in learning of a kind that marks an entry to new forms of 'uncommonsense knowledge' (see Bernstein, 2000: 28–29), it is difficult to justify seeing the series of teaching episodes that emerges as more than a collection of discrete activities.

In light of this, Christie (2002) proposes the Curriculum Macrogenre model to exemplify the organisation of teaching and learning in different subjects, where

the Curriculum Genres are not discrete but inter-related in various ways. Christie (2002: 25) explains that this

> tells us not only about the manner in which pedagogic knowledge and relationships are constructed, but it allows us to make judgements about the relative success of the different models of pedagogy and of the pedagogic subject that appears to apply.

For the educational researcher, the value of the Curriculum Genre Theory is such that it can be 'a principled basis for making selections of classroom text for analysis and interpretation' (Christie, 2002: 22).

Despite only investigating the linguistic discourse in the classroom, Christie (2002: 3) acknowledges that language, however, must not be understood as some 'discretely independent entity, but rather as part of complex sets of interconnecting forms of human semiosis'. In other words, the pedagogic discourses are multimodal and expressed simultaneously in time and space.

Lesson microgenres

Kay O'Halloran, Chair Professor of Communication and Media at the University of Liverpool, in her investigation of the Mathematics classroom (1996, 2004), extends Frances Christie's Curriculum Genre Theory, to the level of a lesson unit and proposes the notion of 'lesson microgenres' in the Mathematics classroom. O'Halloran (1996: 59) draws from Lemke's (1990) formulation of Activity Types and recasts them into 'lesson microgenres', each comprising specific types of discourses. Kress and van Leeuwen's (2001: 4) definition of discourse as 'socially constructed knowledge of (some aspect of) reality' is adopted in this book.

The lesson microgenres are realised multimodally – often with language, but also with other semiotic modes – expressed in time and space. O'Halloran (1996: 65) explains that 'the unfolding of actual texts is displayed dynamically in clause time. In this way, the synoptic description of the microgenres for the analysis of lessons is used to dynamically represent the unfolding of an actual text.'

In this chapter, the examples of the lesson microgenres are based on a case study of the General Paper classroom in Singapore, where the data was collected. General Paper is a subject offered at the Singapore–Cambridge General Certificate of Education Advanced (GCE-A) Level Examinations and is often described as an advanced English Language subject, where students are to produce a composition and respond to comprehension questions in the examinations. The General Paper subject is offered by students preparing for the two-year GCE-A Level Examinations in a junior college. Based on the case study, we propose four main categories and 25 lesson microgenres in a typical General Paper lesson. They are Lesson Initiation, Lesson Diversion, Lesson Progress, and Lesson Closure. The list of lesson microgenres is represented in Table 2.1. The lesson microgenres express specific multimodal pedagogic meaning-making interactions and hence are labelled as

TABLE 2.1 Lesson microgenres in a General Paper lesson

Lesson initiation

Discourse on Greetings	Polite address by the teacher and students at the start and close of the lesson
Discourse on Attendance	Confirmation on students' presence in the classroom
Discourse on Homework Check	Discussion of work set from previous lesson
Discourse on Lesson Objectives	Orientation to the aims of the lesson
Discourse on Administration	Operation matters unrelated to teaching and learning
Discourse on Revision	Reference to content taught in previous lesson
Discourse on Explanation of Events	Reference to the research study

Lesson progress

Discourse on Instructions	Directions to prepare for specific lesson activity
Discourse on Philosophy	Discussion of questions that promote critical reflection
Discourse on General Knowledge	Discussion of questions on facts
Discourse on Language	Teaching of grammar and vocabulary
Discourse on Skills	Teaching of disciplinary skills
Discourse on Content	Teaching of subject knowledge
Discourse on Reading	Read aloud of passage by teacher or students
Discourse on Exams	Reference to assessment
Video-Screening	Use of video
Student Work	Students performing assigned task in groups or individually
Discourse on Personal Coaching	Response to individual student during student work

Lesson diversion

Discourse on Motivation	Encouragement of students
Discourse on Rapport-Building	Relating with students
Discourse on Discipline	Enforcement of expectations and rules for behaviour
Discourse on Permission	Address of student's request
Discourse on Time Check	Reference to time
Discourse on External Distraction	Reference to interruptions

Lesson closure

Discourse on Summary of Lesson	Summation of key learning points
Discourse on Issuing of Homework	Reference to follow-up work from the lesson
Discourse on Arrangements for Next Meeting	Reference to future plans

'discourses'. In the context of the General Paper lesson, the lesson microgenres for each stage of the lesson is presented, with a short description in Table 2.1.

Analysis of two lessons

In this section, we describe how each of the 25 lesson microgenres is expressed through the multimodal pedagogic discourse in the lesson. While talk is usually the

main semiotic mode in which the discourse is realised, we will also consider how the other semiotic modes, such as gestures, movement, and positioning, can express the pedagogic discourses in the classroom multimodally.

The examples of the lesson microgenres are drawn from a case study of a General Paper lesson, described also as English lesson, conducted by Lee and Mei (pseudonyms) at a pre-university in Singapore from Lim (2011). Lee and Mei differ in gender and also in teaching experience. Lee, male, in his twenties, is a novice teacher with less than two years of experience in teaching General Paper. Mei, female, in her thirties, is an experienced teacher and has taught General Paper for more than ten years. She also holds leadership appointment in the English Department and is involved in the planning of the curriculum and the Scheme of Work for the teachers in the school.

Lee's lesson covers 6035 seconds (\approx 100 minutes) and Mei's lesson covers 5633 seconds (\approx 93 minutes) in duration. In the descriptions of the lesson microgenres below, the time, as well as the percentage of total time, the teacher spends on each lesson microgenre is presented. This is to provide a sense of the proportion of lesson time committed to the specific discourse. The difference in overall lesson timing is because Mei walks into the classroom several minutes after the bell has rung, a common practice for many teachers in the school. Both teachers also do not dismiss the class immediately after the bell has rung but continue with the lesson closure up to several minutes after the bell.

Both Lee and Mei's lesson are selected for analysis and comparisons because of the similarities they share contextually. Situated as the final lesson before the Preliminary Examinations, the lesson genre is that of a Review Lesson. Given these similarities, it is interesting to observe how each teacher expresses unique pedagogies through their use of semiotic resources to design different lesson experiences for their students.

Lesson initiation

Discourse on Greetings can be realised through gestures such as a nod of the head and facial expressions, for example a smile of acknowledgement. Typically, with language, Discourse on Greetings is expressed through social formalities, such as with the adjacency pairs 'OK, Morning everyone' by Mei to elicit the response of 'Good Morning' from the students. Discourse on Greetings is located both in the main categories of Lesson Initiation and Lesson Closure. Beyond phatic communion realising mainly interpersonal meanings, Discourse on Greetings can be used as a marker of structure to bring a sense of regulation into the lesson. This is because Discourse on Greetings in the pedagogic setting has evolved into a signal for the official beginning and ending of the lesson. This is evident in Mei's lesson where she spends 29 seconds (0.52%) on Discourse on Greetings. This includes her verbal greeting as she positions herself in an authoritative space, in the front centre of the classroom, pausing as she waits for the students to get ready, stand up from their

seats, and return her verbal greetings. This social ritual is performed both at the beginning and at the end of her lesson.

Discourse on Attendance occurs when the teacher checks if specific students are present in class. This can be expressed through gestures as the teacher points and silently counts the number of students in the classroom. It could also be expressed with the use of an attendance sheet, where the teacher ticks off the names of students in the class. Linguistically, the Discourse of Attendance was expressed by Lee who said, 'Now, let's wait for some of you to turn up.' Time spent on the Discourse on Attendance suggests the teacher's emphasis on student's attendance. Interpersonally, the teacher asserts power and control over the students through the Discourse on Attendance, which is an example of the regulative discourse of schooling. Lee spends 15 seconds (0.25%) on Discourse on Attendance. There is no Discourse on Attendance in Mei's lesson.

Discourse on Homework Check refers to discussion relating to work set from the previous lesson. This is realised linguistically, for instance, in Lee's series of interrogations, 'I asked you to read the text. Did you read the text?' and in Mei's questions, 'You were supposed to have gone back to do your research right? You have not done it huh?' Discourse on Homework Check is also realised multimodally through activities where students submit the homework, either passing down the rows to the front, or walking up to the teacher and handing the homework to him – though seldom the other way, where the teacher walks to collect it from the students. It would be a marked selection if that were to occur. This is because, interpersonally, the power of the teacher is asserted through the Discourse on Homework Check as it involves control and monitoring to ensure students have been compliant to instructions given in the preceding lesson. Lee spends 7 seconds (0.13%) and Mei about 9 seconds (0.16%) on Discourse on Homework Check.

Discourse on Lesson Objectives orientates the students to the aims of the lesson. Discourse on Lesson Objectives occurs when the teacher explicates the aims of the lesson. For instance, Lee explains, 'This time I am targeting AQ (Application Question) because I think AQ is the place where we can score more marks.' Likewise, Mei states explicitly in her Discourse on Lesson Objectives, 'The focus of today's lesson is on AQ'. While mostly realised through talk, Discourse on Lesson Objectives often takes place in the authoritative spaces in the classroom, such as the teacher moving into the front centre of the classroom or speaking around the teacher's desk. Lee spends about 63 seconds (1.06%) and Mei about 21 seconds (0.36%) on Discourse on Lesson Objectives. Lee spends more time on Discourse on Lesson Objectives because he introduces a new tool, in the form of a template to aid in the answering of the Application Question, a type of question in the comprehension examinations.

Discourse on Administration refers to administrative matters unrelated to teaching and learning. This could be realised without accompanying speech, for instance, when the teacher hands out forms or letters to specific students without elaboration. Both teacher and student operate on a common assumption that the document is self-explanatory. In Lee's lesson, about 2 minutes (2.11%) is spent on

the Discourse on Administration. This is because Lee's lesson is the first lesson of the day. During that period, all schools were issued an advisory for temperature monitoring of students due to the Swine Flu epidemic. As such, Lee spent time on having students take their own temperature using their personal thermometer and having them record it down in the form provided.

Discourse on Revision occurs when the teacher makes references to what has been taught in the previous lesson to contextualise the focus for the day's lesson. This is mostly expressed through language. For instance, Lee explains, 'During the last few weeks… We look back on common test papers.' Likewise, Mei reminds the students, 'Remember last week I gave you Set 1… I did walk through the sample with you, did I?' Lee spends 30 seconds (0.5%) and Mei spends slightly more time at 49 seconds (0.87%) on Discourse on Revision. Both teachers point to the lesson materials as the point of reference to what has been previously taught.

Discourse on Explanation of Event is not a typical lesson microgenre as it occurs due to the fact that the specific lesson was being observed by the researchers as part of a study. In the two lessons, the Discourse on Explanation of Event provides information to the students about this study. Lee spends 43 seconds (0.71%) and Mei spends 36 seconds (0.64%) on this. Lee instructs the students to be as natural as possible. He explains, 'First thing, this is for research purpose. So we don't have to act and make sure that this is a perfect class.' Mei reminds the students that they have the option to leave the class and see her for a make-up session if they do not wish to participate in the study. She emphasises, 'I am serious. If you are uncomfortable you could just step out.'

Lesson progress

Discourse on Instructions presents overt directions for the students in preparation for a specific lesson activity. This is mainly realised through language and often as the teacher positions himself in the authoritative spaces in the classroom. Lee devotes almost 6 minutes (5.74%) and Mei spends almost 7 minutes (7.20%) on the Discourse on Instructions. Longer time spent on the Discourse on Instructions suggests more sign-postings and scaffolds provided to structure the lesson activities. Examples of Discourse on Instructions are when Mei issues the command, 'You got your compilation. I want you to turn to page 71.' In doing that, she signals that the passage is the main text for her lesson. Lee, when introducing the template to organise their Application Question response, articulates a more procedural instruction and interjects with the rationale for his directives. He explains,

> First, what we will do is that we will take out a piece of paper. Shall we? And we will draw this template on that piece of paper… Draw it down so that you have some ideas what you are doing.

Coupling instructions with explanations, instead of using a direct command, tempers the authority that Lee asserts as a teacher. The explanation allows for the students to understand the pedagogic intent behind his instruction.

Discourse on Philosophy is related to the teaching of the disciplinary knowledge of the subject. Discourse on Philosophy involves the discussion of ideas and concepts through questions that promote critical reflection. They are usually open-ended questions that provoke thought and challenge understanding rather than seek a 'correct' response. For instance, Mei asks, 'What does being successful mean?' Through that, she elucidates from her students the varied and competing definitions of success. Lee also uses the Discourse on Philosophy in his lesson. An instance is in his response to a student's criticism of the school's effort to monitor the Swine Flu epidemic. He explains, 'Whenever crisis or situations like these happen, we try to do our best. That's what we can do. We can't do more than our best. Can we?'

Discourse on General Knowledge is also related to the teaching of the disciplinary knowledge of the subject. It involves discussions and close-ended questions on general knowledge and current affairs. Usually, an ideal answer is already in the mind of the teacher. Examples of Discourse on General Knowledge are in Lee's question, 'What is the positive aspect of hydroponic technology?' and in Mei's question, 'Can anybody tell me what is Olympus?' While useful to deliver content knowledge to the students, an over-use of Discourse on General Knowledge can possibly alienate those who do not have the 'right' answer. These can be students from less privileged socio-economic background that may not have the extent of exposure and experience that their more privileged peers may possess (see, e.g. Christie, 2002; O'Halloran, 2004). On the other hand, Discourse on Philosophy promotes engagement and builds higher order thinking skills. Hence, a good complementary use of Discourse on General Knowledge with Discourse on Philosophy can possibly empower weaker students with the necessary knowledge and ways of critical thinking to close the gap. Mei spends about 16 minutes (17.09%) as compared to only 33 seconds (0.55%) by Lee on the Discourse on Philosophy. Lee spends about 21 minutes (20.93%) as compared to under 3 minutes (3.00%) by Mei on the Discourse on General Knowledge.

Discourse on Language is the explicit teaching or discussion on the metalanguage, by drawing attention to the use of language, for example on grammar and the meaning of specific words. Discourse on Language contributes to the development of students' meta-linguistic awareness. Examples of Discourse on Language occur when Lee says, 'Now, if it is French we don't say the T' as well as when Mei asks, 'What's anxiety?' and explains 'An anxious person is a worried person.' Mei spends almost 6 minutes (6.06%) on Discourse on Language, which contrasts with Lee's 5 seconds (0.08%).

Discourse on Skills is the explicit teaching of skills as part of students' learning of the disciplinary skills of the subject. An instance is when Lee clarifies, 'Now, remember for AQ (Application Question), we don't have to write a thesis on the passage. Just two or three or four good points. That's it.' Likewise, Mei reminds, 'The other thing I want to highlight is when you refer to the main ideas selected; always make it a point to make line references.' Mei's focus on the Discourse on Skills is indicated by the almost 24 minutes (24.84%) spent as compared to Lee's 10 minutes (9.91%).

Discourse on Content is discussion specific to the subject content of the course materials, in the case, the comprehension passage. Lee exemplifies this when he says, 'So we are to explore the idea… about hunger or displacement. So did we find them in the text?' Similarly, Mei notes, 'Point one. If anyone today can attract young people's attention: Celebrity.' Discourse on Content differs from Discourse on General Knowledge because in Discourse on Content, the focus is on the course materials, in this case, the passage in the text. Lee's focus on Discourse on Content is indicated by the 14 minutes (14.10%) as compared to Mei's under 7 minutes (6.93%) spent on this microgenre.

Discourse on Reading is when an extended part of the passage is read aloud by the teacher or students. This is sometimes performed by a student who is asked to stand up from his seat to read. Both Lee and Mei spend very little time on Discourse on Reading. Lee spends under 34 seconds (0.56%) and Mei spends under 17 seconds (0.30%) on Discourse on Reading. Discourse on Reading may feature more in the English classes at the Primary and Secondary Level as choral reading. Having students read passages aloud is a pedagogical strategy employed to help them develop fluency and prepare them for the oral component of the examinations. Since the subject General Paper is examined only in the written mode, it is unsurprising that Discourse on Reading is given lower emphasis in both lessons.

Discourse on Examinations occurs when there is explicit reference, typically verbally, made to the examinations. Interestingly, despite the lesson in the case-study being the final class before the Preliminary Examinations, Discourse on Examinations is used only about 20 seconds (0.33%) by Lee and none at all for Mei. An example is given in Lee's admonition, 'During your A–Levels test, you won't have 15 minutes to think'. Even here, the Discourse on Examinations is somewhat enmeshed in the Discourse on Discipline as he reminds the students to stay focused on the task and work on it quickly. The lack of reference to the examinations might be due to the Preliminary Examinations being perceived not to be as important as the ultimate Singapore-Cambridge General Certificate of Education (Advanced Level) Examinations, which students will sit for later.

Video-Screening is the use of multimedia in the lesson to bring in additional information on the subject content. Video–Screening takes up almost 16 minutes (15.62%) and is ranked second highest amongst all the lesson microgenres in Lee's class. Lee shows three videos consecutively. The purpose of the Video-Screening is explained later. He states, 'I think that will help you with the solutions and ideas… during exams situations you have to tap your content knowledge'. For Lee, Video-Screening contributes to broadening the students' subject content knowledge.

Student Work occurs when the teacher sets a task for the students to perform either individually or collaboratively in groups. Multimodally, this is often accompanied by the teacher's pacing around the classroom or positioning himself in the surveillance space to monitor the students. Tasks in Student Work include answering the comprehension questions or working on exercises based on their preceding discussion. Mei spends almost 15 minutes (14.61%) whereas Lee spends less time at under 3 minutes (2.82%) on Student Work. Technically, for the purpose

of simplifying the analysis, the time in Student Work is coded when Discourse on Personal Consultation is not takng place.

Discourse on Personal Consultation occurs when a student asks a question to the teacher during Student Work. The teacher usually moves next to the student, and may stand, bend, or sit next to the student to address his question as the rest of the class continues with their work. Examples of how the Discourse on Personal Consultation is expressed verbally can be observed when in Lee's class, a student expressed his uncertainty with what is expected of him and Lee attempts to coach him through asking him a series of questions, 'You don't know what to write. So what are you supposed to assess? What did the writer say?' Mei spends under 2 minutes (2.01%) and Lee spends more than 9 minutes (9.21%) in on Discourse on Personal Consultation. This may be because he has introduced new knowledge – the use of a template to answer AQ – in the lesson. As such, the total time where students engage in a practice activity in both lessons is about 17 minutes (16.62%) for Mei and less at about 12 minutes (12.03%) for Lee.

Lesson diversion

Discourse on Motivation is when the teacher inspires and encourages the students in their studies. This is often accompanied by positive affect in the teachers' facial expressions, nods with the head, as well as the use of gestures that are representational of affirmations, such as the 'thumbs up' sign. Lee spends more than 4 minutes (0.65%) and Mei spends about 2 minutes (0.23%) on the Discourse on Motivation. After explaining in the Discourse on Explanation of Event, Lee shifts into the Discourse on Motivation and encourages the students, 'I am sure in future you also will be doing research… That means you will either do a Masters or a doctorate'. Discourse on Motivation can also occur in the main category of Lesson Diversion, when it interrupts the Lesson Progress, and is used to encourage the students in their learning. For instance, Mei exhorts, 'The concepts are not unfamiliar right? Don't let the language hinder your understanding. Deal with the concepts'.

Discourse on Rapport-Building builds solidarity and mitigates the hierarchical relationship between teacher and students. It can occur in the main category of Lesson Initiation as well as in Lesson Closure. Typically, teachers will relate certain anecdotes about their personal lives. The field of discourse shifts from classroom business and subject matters to personal business. An instance is when Lee comments, 'I like African music; it's good' after the Video-Screening which used African music. Mei uses Discourse on Rapport-Building primarily to share stories and jokes with her students. For instance, when a student asks her how old she was, she replied, 'I am old enough to start getting fat and start getting wrinkles.' Discourse on Rapport-Building is often characterised by laughter from both teacher and students as a way to affirm solidarity. Lee and Mei spend about the same amount of time on Discourse on Rapport-Building. While the Discourse on Rapport-Building is categorised under Lesson Diversion, a moderate use of Discourse on Rapport-Building is useful in establishing a strong rapport with the students and

in promoting engagement with the lesson. Both the Discourse on Motivation and Discourse on Rapport-Building contribute to a more intimate teacher–student relationship and a sense of affiliation between the teacher and students.

Discourse on Discipline occurs when the teacher asserts her authority and enforces certain rules and norms of accepted behaviour in the class. Discourse on Discipline can be realised without language. For instance, the teacher may choose to stop talking abruptly, and use silence to draw attention to a student's misdemeanor during the lesson. Discourse on Discipline can also be realised through the gesture of pointing, where the teacher singles out an inattentive student, and directs him back to attentiveness, without the use of words. In other instances, the teacher could walk towards a misbehaving student and stand next to her, and have the student conform, without needing to reprimand her. Such multimodal expressions of the Discourse of Discipline modulate the authority and calibrate the power of the teacher over the students. Of course, Discourse on Discipline is usually expressed verbally when the teacher chides the class or scolds a student. However, such an expression of the Discourse on Discipline is seldom observed at the pre-university level as the students are adolescents and are more mature. As such, the teacher tends to be more mindful of exercising explicit power and asserting their status differentiation overtly.

In the case study, Lee uses significantly more Discourse on Discipline – almost seven times that of Mei. Some of the strategies employed by Lee and Mei during Discourse on Discipline are to include the use of humour, not singling specific students for admonition publicly, and mitigating the intensity and severity through use of semiotic modes, other than language. For example Lee uses humour as he teases, 'Evan. Haven't you seen a camera before? Please pay attention.' Likewise, when Mei wishes to rebuke a few students who have not done their homework, she addresses the class collectively and couches the misdemeanour in general terms. She obfuscates, 'And if you haven't done it, something is very wrong OK. You have been given a problem. You have to go and find the solution.' In the two lessons, Discourse on Discipline is usually brief when it does occur. There is always a swift restoration to a sense of normalcy in the classroom. It is also interesting to note that the Discourse on Discipline is regularly followed by the Discourse on Rapport-Building. While it is a stark contrast to the high power in the Discourse on Discipline, Discourse on Rapport-Building quickly restores the status quo in the teacher–students relationship, reduces the tension, and alleviates any awkwardness so that the lesson can continue.

Discourse on Permission occurs during the approval or denial of students' requests. Often, it is a request to visit the toilet. This can be realised with a simple nod or shake of the head, with gestures, with or without the use of speech. As Discourse on Permission foregrounds the status differentiation between the teacher and students, strategies are used to maintain rapport and moderate the exercise of authority. These strategies include the use of politeness markers such as 'please' and humour, often as lighthearted sarcasm. For instance, when asked for permission to visit the toilet, Lee jokes, 'Go toilet? The most important question. Yes please.' Lee spends

about 10 seconds (0.17%) and Mei spends almost 40 seconds (0.71%) on Discourse on Permission.

Discourse on Time Check serves a regulative function of reminding the students of the time left for a particular activity before moving on to the next stage of the lesson. It is also sometimes a self-reminder for the teacher to proceed to the next stage of the lesson, usually towards the Lesson Closure. Discourse on Time Check is used to regulate the activity in the lesson. This could be realised gesturally with a look at the watch to check the time, a glance at the clock, or verbally, such as when Lee urges the students during Student Work, 'Now we have five more minutes left. Even if it is wrong, you think first.' Similarly, Mei announces before the Student Work, 'I give you a quick three minutes.' Lee spends about 47 seconds (0.78%) and Mei spends only 5 seconds (0.09%) on Discourse on Time Check.

Discourse on External Distraction refers to external distractions that might occur in the course of a lesson. They are unplanned and may come in the form of other people knocking on the door of the classroom, interrupting the lesson. This also includes incidents such as Mei's mobile phone ringing during her lesson and her knocking into the table microphone accidentally.

Mei reacts to the Discourse on External Distraction with a calm and confidence demeanour, perhaps commensurate to her years of experience as a teacher. When her mobile phone rings suddenly during lesson, she deals with the awkwardness with self-deprecatory humour. She says drily, 'Teacher picks up the handphone. Turn off the sound. Waste three seconds of the students' time. And it goes away.' The students laugh and the episode is promptly over as Mei continues with the lesson. Similarly, when Mei accidentally knocks into the table microphone, she quickly acknowledges her clumsiness with 'Oops! That's the mic' and replaces the microphone. She concludes, 'That's it' and continues with the lesson. Lee also responds to distractions by addressing them directly. When loud feedback was produced by the microphone, Lee asks a series of questions to the students, 'What happened? Got echo? Maybe it is too loud, is it?' When a student suggests that it may be due to the recording, he dismisses the answer with a rhetorical question, 'Now that is not logical. How would recording produce echo?' Lee spends about 52 seconds (0.86%) on Discourse on External Distraction as compared to Mei's under 12 seconds (0.21%).

Lesson closure

Discourse on Summary of Lesson Points is typically a verbal summation of the key learning points of the lesson. Pedagogically, it helps the students to recap the main ideas of the lesson. Discourse on Summary of Lesson can be well-structured. For instance, when key learning points of the lessons are reiterated in Mei's lesson. Mei uses questioning to get students to recall the key points that have been discussed. This engages the students as the onus is on them to collectively reflect on the ideas from the discussion and identify the main points from there. She rephrases the feedback from the students in the appropriate terminology by writing them

down on the whiteboard. She humorously draws attention to her reformulation by announcing, to the laughter of the class, 'OK, I am not quite writing what you say.' It can also be less structured, such as in Lee's summative comments on the lesson, where he briefly concludes, 'And actually what we discussed today is enough right? We looked at it from various angles but you have to pick only three out of it.' The 'various angles' is not described to the students again. Lee spends only about 4 seconds (0.07%) on Discourse on Summary of Lesson whereas Mei spends a much longer time at 4 minutes (4.53%). This signals the importance of Discourse on Summary of Lesson in her class.

Discourse on Issuing of Homework is the instructions on homework and follow-up actions required from the students. While this is present in both lessons, they differ in terms of specificity and overt commitment from the teacher to provide feedback on the work. Perhaps in providing students greater autonomy and independence, Lee appears perfunctory in the issuing of homework and does not express any commitment to provide feedback on their work. This may be because that there are no more formal lessons until after the Preliminary Examinations. Rather than issuing a typical instruction, Lee suggests, 'When you go home today, I think, why don't you try making that table out of other AQ (Application Question) questions and see whether that works for you.' Lee spends about 9 seconds (0.15%) on the Discourse on Issuing of Homework.

Mei issues very explicit instructions on what she expects the students to do as their homework. She spends almost 46 seconds (0.82%) on the Discourse on Issuing of Homework. She lists her expectations specifically and relates them back to what has been covered in the lesson. She explains,

> Based on our last three-minute discussion, try and write one portion of the AQ (Application Question). Get a strategic quote from the passage, talk about your response to the writer's views, provide your examples, explain how your examples help you answer the question. Will it worsen or will it not worsen? Evaluate it. Give me reasons for your evaluation. Six steps for these points which we just discussed.

Mei also articulates her commitment to provide feedback on the students' work. She declares, 'As long as if you do write it, I will look at it.' Nonetheless, her firm approach is moderated with the conditional clause, 'as long as if you do write it'. This offers a leeway, given that this is the last lesson, for students who do not wish to do the homework. In this, Mei moderates the exercise of power by managing the interpersonal dynamics in an otherwise potentially highly authoritative event.

Discourse on Arrangement for Next Meeting is the administrative arrangement for subsequent classes. As the two lessons investigated are the final lesson before the Preliminary Examinations commence in the following week, the week after the lesson has been demarcated as the Study Break for the students where there are no formal lessons. Students may choose to come to school and arrange for personal consultation with the teachers. Hence, the Discourse on Arrangement for Next

Meeting in the two lessons involves both teachers expressing commitments to be around for the students during the Study Break. For instance, Lee explains, 'Practically the whole of the week, teachers are free and if you need help you are supposed to look for us. So this is the last lesson before our prelims, but you can still look for me.' Lee informs the students that the responsibility is on them to make arrangements to meet him. Similarly, Mei assures the students that she can meet them on specific days. She states,

> Twelfth and thirteenth I am away on course. So Tuesday and Friday, I am available. OK, I am here. I will make myself to be here for as long as you need me to be. So do message me if you need to meet.

Both teachers spend approximately the same amount of time on Discourse on Arrangement for Next Meeting with Lee spending about 1 minute (1.13%) and Mei at slightly more than 1 minute (1.79%).

Visual analysis of lesson microgenres

The identification of various lesson microgenres in each lesson allows us to present a graphical and visual analysis which could surface the frequencies and patterns across teachers and lessons. It also provides a map of the types of multimodal pedagogic discourses in the lesson and offers insights on the learning experience for the students. For the purpose of illustration, the lesson microgenres in the two lessons by Lee and Mei are represented in graphs, pie-charts, and network visualisations for discussion. The data visualisations can support teachers in reflecting on the design of their lesson and how the multimodal pedagogic discourses in their lesson can be more aptly deployed. The lesson microgenres are discussed in relation to Lee and Mei's lesson in this section and represented in Figure 2.1

Figures 2.2 a–b show the top five lesson microgenres in each of the teacher's lesson. The dominance of these lesson microgenres is reflective of both the teachers' pedagogical inclinations as well as the learning experience which the students had in the lesson. The identification of the most frequent lesson microgenres encourages the teacher to reflect on how her lesson was designed and if it was implemented according to what she had intended it to be.

In Lee's lesson, Discourse on General Knowledge takes up more than a fifth of the total lesson time. This is followed by Video-Screening and Discourse on Content. The dominance of the Discourse on General Knowledge, Video-Screening and Discourse on Content indicates Lee's focus on the subject content knowledge. The amount of time spent on the Discourse on Personal Consultation also indicates a focus on the practice and application of skills, specifically in dialoguing with individual students during Student Work. The significantly more time spent on Discourse on Personal Consultation than in Mei's lesson may be due to Lee's introduction of new knowledge in the lesson and as a result, students had questions on how to apply the template proposed during Student Work.

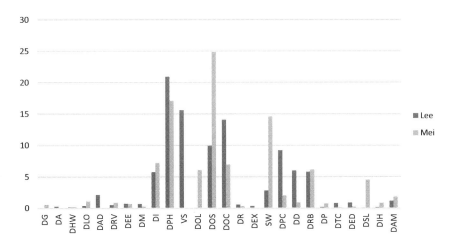

FIGURE 2.1 Comparisons of lesson microgenres in Lee and Mei's lesson

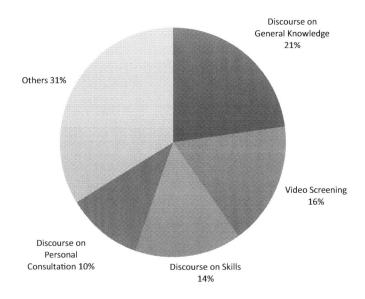

FIGURE 2.2a Top 5 lesson microgenres in Lee's lesson

In Mei's lesson, Discourse on Skills takes up a quarter of the total lesson time. This indicates a focus on disciplinarity skills of the subject in the lesson. She also pays significant attention to the development of critical thinking and reflection through the Discourse on Philosophy, which is the second highest lesson microgenre. Discourse on Philosophy is valued in all subjects, but especially in General Paper.

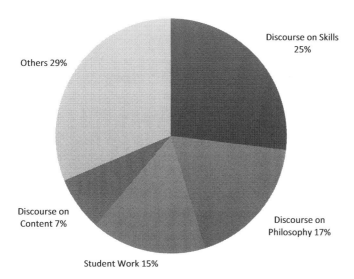

Others 29%

Discourse on Skills
25%

Discourse on
Content 7%

Discourse on
Philosophy 17%

Student Work 15%

FIGURE 2.2b Top 5 lesson microgenres in Mei's lesson

Considerable time is also spent on Student Work. This suggests an emphasis on practice and application of skills. Discourse on Instructions is featured significantly as well. Through Discourse on Instructions, a clear structure and organisation of the different activities in the lessons is evident in Mei's lesson.

The lesson microgenre graphs in Figures 2.3a–b can be generated through an open-source software Cytoscape. The Cytoscape software is used to visualise the data in terms of network graphs consisting of nodes and directed edges. Developed by Shannon et al. (2003), Cytoscape is an open source bioinformatics software platform for visualising molecular interaction networks and integrating these interactions with gene expression profiles and other state data. However, its application is not confined within the scientific disciplines. Network graphs have also been used in the social sciences in fields ranging from education, sociology to political science. For example Bender-deMoll and McFarland (2006) explore the affordances of dynamic network visualisations as a methodological tool and propose a framework for visualising social networks using data from a high school economics classroom. Likewise, Butts and Cross (2009) use network graphs to visualise global patterns of stability and change within blogs during the United States Presidential election campaign, and Dekker (2005) applies network graphs to analyse conceptual distance between people as an indication of the nature of communication within an organisation. In this case study, network graphs are used to display the unfolding of the lesson in its activity stages. It is also used to represent the spatial patterns of positioning and movement of the teacher in the classroom, described in the next chapter.

Here, Cytoscape is used to visualise the lesson microgenres in each lesson according to:

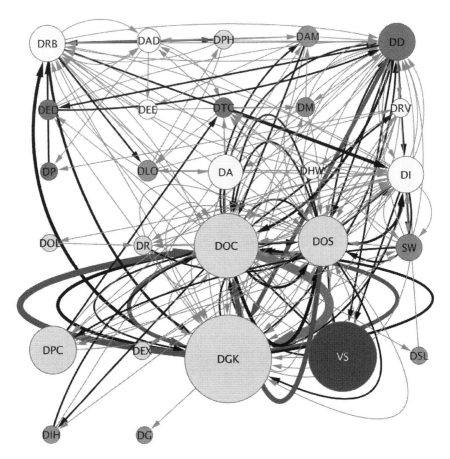

FIGURE 2.3a Lee's lesson microgenre

1. Categories of lesson microgenre: different categories of lesson microgenre can be represented by different colours. [This is not shown in Figure 2.3a–b as the image is reproduced in black and white in this book.]
2. Lesson development: lesson microgenres as they unfold in sequence are represented through sequence in positioning. The first lesson microgenre is represented in the first row and subsequent rows from left to right. The next occurrence of the same lesson microgenre is represented as an arrow leading back to its first occurrence.
3. Frequency of occurrence: the larger the size of the node, the more frequent is the lesson microgenre selected.
4. Interconnectivity: the arrows represent the interconnectivity of the lesson microgenres to one another. The frequency of occurrence can also be represented in colour. For example Grey: 1 occurrence; Black: 2 to 10 occurrences; Blue: 11–19 occurrences; and Red: 20 or more occurrences. [This is not shown in Figure 2.3a–b as the image is reproduced in black and white in this book.]

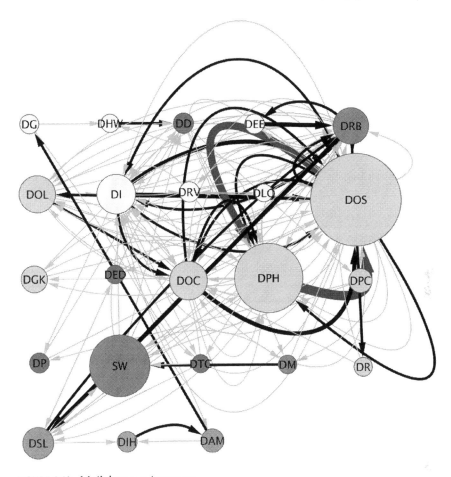

FIGURE 2.3b Mei's lesson microgenre

In terms of the progression of the lesson, the layout of the lesson microgenres is in accordance to their first appearance. As displayed in Figure 2.3a, the long pre-amble in Lee's lesson is represented in the top three rows with a total of 15 lesson microgenres before the lesson microgenres in Lesson Progress (in green) appear. Discourse on Skills, which contributes to the primary subject content knowledge, is the 19th lesson microgenre to appear. The late entry into the Lesson Progress stage is because Lee's lesson has many diversions from the lesson progress. In addition, the unusual situating of Discourse on Arrangement for the Next Meeting, a lesson microgenre typically in the category of Lesson Closure, in the early part of the lesson is observed.

Mei's lesson development adheres to a structured progression from Lesson Initiation, to Lesson Progress, and to Lesson Closure, punctuated by moments of Lesson Diversion. Unlike Lee, Mei moves promptly into Lesson Progress after five lesson microgenres and Discourse on Skills appears as the tenth lesson microgenre.

The coherent sense of structure present in the sequence indicates a cohesive framework in which the orchestration of the entire lesson is conducted.

The frequency of occurrence of the lesson microgenres is in tandem with the information in Figures 2.2a–b. The size of the nodes in Figures 2.3a–b shows that Discourse on General Knowledge, Video-Screening and Discourse on Content dominate in Lee's lesson and Discourse on Skills, Discourse on Philosophy and Student Work are prominent in Mei's lesson. Their relative proportions to the other lesson microgenres are displayed in Figures 2.2a–b as well. The size of the lesson microgenres representing Lesson Diversion is also comparatively smaller in Mei's lesson than in Lee's.

An advantage of visualising the lesson microgenres in Figures 2.3a–b is the display of the interconnectivity and the frequency of connectivity between the Lesson Microgenres. For instance, examining the arrows to and from Discourse on Skills, there appears to be a strong connectivity, as indicated by the thicker arrows, between Discourse on Skills, Discourse on General Knowledge and Discourse on Content in Lee's lesson. This suggests a frequent shift from a discussion on skills to general knowledge and passage content as well as vice versa. Mei's graph, however, shows a strong connection between Discourse on Skills and Discourse on Philosophy, as indicated by the thicker arrows. This indicates a regular transition between a discussion on skills to critical reasoning and vice versa.

The presence of thicker arrows in Lee's graph indicates a lot of transitions across lesson microgenres. This suggests that Lee's lesson is generally more dynamic. In contrast, Mei's graph has only one pair of thicker arrows, indicating a strong affinity between Discourse on Skills and Discourse on Philosophy. This also suggests that her lesson unfolds generally in a more organised and structured manner, with less transitions from one lesson microgenre to another.

The visualisations in Figures 2.3a–b offer many insights on the various lesson microgenres and the design of the learning experience for further mining. For instance, it is possible to examine any of the lesson microgenre and investigate its connections to the other lesson microgenres.

Designing learning with lesson microgenres

In this chapter, we posit that recognising the different types and nature of multimodal discourses in the classroom can help the teachers reflect on their students' learning experiences and if the lesson was implemented as intended. The approach of using lesson microgenres to analyse the multimodal pedagogic discourse in the English classroom is further described in Lim and Tan (submitted for publication). The identification and visualisation of lesson microgenres provide a 'mirror' for the teacher and encourage her to design the students' learning experiences with aptness and fluency by paying more attention to specific meaning-making interactions.

While each of the lesson microgenres serves a clear communicative purpose in the lesson, a neat and well-defined categorisation can, at times be elusive. For

instance, the distinction between the lesson microgenres of Discourse on General Knowledge and Discourse on Subject Knowledge is based on the latter being specific to the passage content in question, whereas the former refers to general knowledge and current affairs. Lesson microgenres can also be located in two activity stages of the lesson genre. For instance, the lesson microgenre of Discourse on Motivation can be a part of Lesson Initiation but also as Lesson Diversion if it occurs in the midst of Lesson Progress. Similarly, the lesson microgenre of Discourse on Instructions can occur both in Lesson Initiation and Lesson Progress as the teacher moves from one activity to another during the lesson.

Perhaps the categorisation of lesson microgenres need not be an exact science as the multimodal pedagogic discourses can arguably express more than one lesson microgenre in an instance. What is more important is for the teachers to recognise and appreciate the range of meaning-making interactions in the lesson and, with that understanding, reflect on their lesson, and design various learning experiences for their students. This necessitates an awareness of the affordances of the various semiotic modes, as well as aptness and fluency in their expression of specific meanings. For the educational researcher, the identification of lesson microgenres in the lesson provides a basis for analysis that is anchored in time and multimodal meaning-making, which, while still centred on language, recognises and facilitates identification of meaning-making interaction in the classroom across semiotic modes, in addition to talk.

REFLECTION QUESTIONS

1. What are the different ways teachers can express meanings in the classroom without using language?
2. How does awareness of the different lesson microgenres in your lesson help you be more aware of what and how you are teaching?

References

Bender-deMoll, S. & McFarland, D. (2006). The art and science of dynamic network visualization. *Journal of Social Structure* 7(2). Retrieved from www.cmu.edu/joss/content/articles/volume7/deMollMcFarland/

Bernstein, B. (1990). *Class, Codes and Control: Volume IV. The Structuring of Pedagogic Discourse.* London & New York: Routledge.

Bernstein, B. (2000). *Pedagogy, Symbolic Control and Identity: Theory, Research, Critique.* Lanham, Maryland: Rowman and Littlefield Publishers.

Bourne, J. & Jewitt, C. (2003). Orchestrating debate: A multimodal approach to the study of the teaching of higher-order literacy skills. *Reading (UKRA)* 37(2), 64–72.

Butts, C.T. & Cross, B.R. (2009). Change and external events in computer-mediated citation networks: English language weblogs and the 2004 U.S. electoral cycle. *Journal of Social Structure* 10(3). Retrieved from www.cmu.edu/joss/content/articles/volume10/Butts/blogties.1.0.pdf

Christie, F. (1993). Curriculum genres: Planning for effective teaching. In B. Cope & M. Kalantzis (eds.), *The Powers of Literacy: A Genre Approach to Teaching Writing* (154–178). Pittsburgh: University of Pittsburgh Press.

Christie, F. (1997). Curriculum macrogenres as forms of initiation into a culture. In F. Christie & J.R. Martin (eds), *Genre and Institutions: Social Processes in the Workplace and School* (134–160). London: Cassell.

Christie, F. (2002). *Classroom Discourse Analysis: A Functional Perspective*. London & New York: Continuum.

Daniels, H. (2001). *Vygotsky and Pedagogy*. London: RoutledgeFalmer.

Dekker, A. (2005). Conceptual distance in social network analysis. *Journal of Social Structure* 6(3). Retrieved from www.cmu.edu/joss/content/articles/volume6/dekker/

Englund, T. (1997). Towards a dynamic analysis of the content of schooling: Narrow and broad didactics in Sweden. *Journal of Curriculum Studies* 29(3), 267–287.

Flewitt, R. (2006). Using video to investigate preschool classroom interaction: Education research assumptions and methodological practices. *Visual Communication* 5, 25–50.

Kress, G. (2003). *Literacy in the new Media Age*. London & New York: Routledge.

Kress, G. (2010). *Multimodality: A Social Semiotic Approach to Contemporary Communication*. London & New York: Routledge.

Kress, G. & van Leeuwen, T. (2001). *Multimodal Discourse: The Modes and Media of Contemporary Communication*. London: Edward Arnold.

Kress, G., Jewitt, C., Bourne, J., Franks, A., Hardcastle, J., Jones, K., & Reid, E. (2005). *English in Urban Classrooms: A Multimodal Perspective on Teaching and Learning*. London, UK: RoutledgeFalmer.

Lawn, M. (1999). Designing teaching: The classroom as a technology. In I. Grosvenor, M. Lawn, & K. Rousmaniere (eds), *Silences and Images: The Social History of the Classroom* (65–82). New York: Peter Lang.

Lemke, J.L. (1990). *Talking Science, Language, Learning, and Values*. Norwood, NJ: Ablex Publishing.

Lim, F.V. (2011). *A Systemic Functional Multimodal Discourse Analysis Approach to Pedagogic Discourse*. Doctoral thesis. National University of Singapore.

Lim, F.V. & Tan, J.M. (submitted for publication). Lesson Microgenres: An Approach to Multimodal Classroom Discourse.

Mercer, N. (2000). *Words and Minds: How We Use Language to Think Together*. London & New York: Routledge.

Norris, S. (2004). *Analysing Multimodal Interaction: A Methodical Framework*. London & New York: Routledge.

O'Halloran, K.L. (1996). *The Discourse of Secondary School Mathematics*. (unpublished doctoral dissertation). Murdoch University, Australia.

O'Halloran, K. L. (2004). Discourse in secondary school Mathematics classrooms according to social class and gender. In J.A. Foley (ed.), *Language, Education and Discourse: Functional Approaches* (191–225). London & New York: Continuum.

O'Halloran, K. L. (2007b). Systemic functional multimodal discourse analysis (SF-MDA) approach to Mathematics, grammar and literacy. In A. McCabe, M. O'Donnell, & R. Whittaker (eds), *Advances in Language and Education* (75–100). London & New York: Continuum.

O'Toole, M. (1994/2010). *The Language of Displayed Art* (2nd edition). London & New York: Routledge (1st edition 1994).

Seaborne, M. & Lowe, R. (1977). *The English School: Its Architecture and Organisation Vol II 1870–1970*. London: Routledge & Kegan Paul.

Shannon, P., Markiel, A., Ozier, O., Baliga, N.S., Wang, J.T., Ramage, D., Amin, N., Schwikowski, B., & Ideker, T. (2003). Cytoscape: A software environment for integrated models of biomolecular interaction networks. *Genome Research Nov* 13(11), 2498–2504.

Sinclair, J. & Coulthard, M. (1975). *Towards an Analysis of Discourse: The English Used by Teachers and Pupils.* London: Oxford University Press.

Walsh, S. (2006). *Investigating Classroom Discourse.* London & New York: Routledge.

Walsh, S. (2011). *Exploring Classroom Discourse: Language in Action.* London & New York: Routledge.

3

SPATIAL PEDAGOGY

Semiotics of space

Mr Keating is a model teacher. He inspires a love for learning amongst his students and his performance in the classroom has mesmerised many. Mr Keating's skilful orchestration of his embodied semiotic modes reveals a thoughtful and careful design to engage students and arouse their interest towards the learning of poetry. In one of the more memorable lessons, Mr Keating demonstrates this through the semiotic modes of language, use of space and movement to communicate his argument convincingly. His discernible argument structure is expressed not only through language but reinforced through the use of classroom space and movement.

Mr Keating begins as he stands in the front centre of the classroom and presents his main argument, saying, 'No matter what anybody tells you, words and ideas can change the world.' He then takes a step forward towards the students, and asserts, 'I see that look in Mr Pitt's eye, like nineteenth century literature has nothing to do with going to business school or medical school. Right?' Expressing an ironic concession of the point by taking a step backwards to the front centre of the classroom, Mr Keating concedes, 'Maybe. Mr Hopkins, you may agree with him, thinking, "Yes, we should simply study our Mr Pritchard and learn our rhyme and meter and go quietly about the business of achieving other ambitions."'

Mr Keating then proceeds to advance his argument, by walking slowly towards the students, and stops in the centre of the classroom. He makes an unusual marked semiotic selection for a teacher, by squatting down. With the attention of the students all drawn to him, he delivers the coup-de-grace – the main thrust of his argument that

> We don't read and write poetry because it's cute. We read and write poetry because we are members of the human race. And the human race is filled

with passion. Medicine, law, business, engineering, these are noble pursuits, and necessary to sustain life. But poetry, beauty, romance, love, these are what we stay alive for.

Dramatic no doubt. But this is not surprising, given that Mr Keating is a character played by Robin Williams, in the critically acclaimed 1989 film, *Dead Poets' Society* directed by Peter Weir. Mr Keating's deft co-ordination of the semiotic modes of language, use of space and movement, to express his message in the classroom is the reason why his classroom performance has captivated audiences then, and continues to be discussed today.

In the seminal book, *The Presentation of Self in Everyday Life*, sociologist Erving Goffman first describes the theatrical and performative nature of human communication and interaction. Goffman (1959) extends the metaphor of a performance to the roles a social actor plays in the various areas of life. Through his work, he pioneered an approach known as the dramaturgical analysis for the study of self-presentation. In the classroom, the role of the teacher is defined according to the pedagogic relations between the students and him. The teacher is expected to perform a role with many parts. Centrally, as discussed in this book, the teacher is a designer of learning for students. Just as a theatrical performer expresses meanings through the meaningful orchestration of the semiotic modes, every move of the teacher can be observed by the students and conveys meanings – intentional or incidental – as part of the learning experience in the classroom.

The use of the multimodal ensemble by Mr Keating, described in Lim (2010), may be crafted, directed, rehearsed, and staged, but its relevance to the typical teacher is no less. Teaching is a performance. The teacher takes on a persona, like any stage performer, and communicates with more than words. In the design of the learning experience for students, the teacher exploits the affordances of various semiotic resources to express different discourses and orchestrates the multimodal ensemble to reinforce the communication of the key messages of the lesson. In uncovering how the embodied semiotic modes of the use of space and movement in the classroom can express specific meanings, we invite teachers to reflect on their pedagogy and to adopt a more apt use of these meaning-making resources in their design of the students' learning experiences.

And so, it is perhaps now rhetorical to ask, 'Does where the teacher stand in the classroom matter? Is the way she moves from one space to another, and paces around the classroom part of the design of the learning experience of the students?' In this chapter, we describe a typology of classroom spaces and discuss the meanings made through the teacher's use of space and movement in the classroom. We will explore the concept of 'spatial pedagogy', described in Lim, O'Halloran, and Podlasov (2012) and Lim (2011) to illustrate the semiotics of space and movement with examples from Lee and Mei, two teachers of General Paper, introduced earlier in Chapter 2. Finally, we explore the productivity of the concept of 'spatial pedagogy' and the typology of classroom spaces for educational researchers through surveying the range of related research projects across the world in recent years.

A pedagogy of space

The study of space is pioneered by anthropologist Edward Hall's development of the concept of proxemics. His defining work, *The Hidden Dimension*, describes the distance sets' hypothesis. In it, Hall (1966) defines four general sets of space – namely Public, Social-Consultative, Casual-Personal, and Intimate. This is based on the typical distances in which such interactions occur, as well as the extent of visibility and contact experienced by the other party (see Figure 3.1). In the context of the classroom, most communication takes place within the Social-Consultative Space, with some instances in the Casual-Personal space, such as during the lesson microgenre on the Discourse on Personal Coaching.

The Social-Consultative Space is where most of the lesson microgenres take place. It is the stage in which the professional role of the teacher is enacted and defined by the societal and cultural norms of propriety and formality in relation to the students. In the light of the different types of lesson microgenres and the range of meanings expressed in the Social-Consultative Space in the classroom, a finer identification and more delicate delineation of the various spaces within the Social-Consultative Space can be developed. This allows us to discuss the differences in the ideational, interpersonal, and textual meanings of the various spaces within the Social-Consultative Space.

As introduced in Chapter 1, this book adopts the social semiotic lens (Halliday, 1978; Kress, 2010) on teaching and learning. In particular, the analytical position offered by the Systemic Functional Multimodal Discourse Analysis is taken

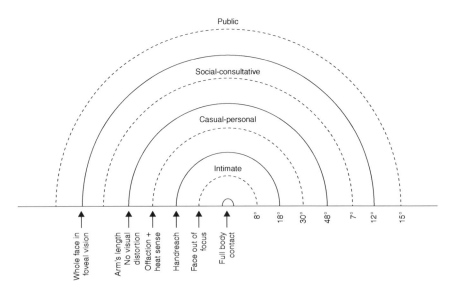

FIGURE 3.1 Hall's (1966) distance set

Reproduced from Matthiessen (2010: 27).

to examine the meanings made in the teacher's semiotic choices. The meaning potential in the semiotic modes are organised according to the three metafunctions they serve. The ideational metafunction is the expression of ideas and experiences about the world. The interpersonal metafunction is the negotiation and enactment of social relations. The textual metafunction is the organisation of meaning into coherent and cohesive texts and units.

In the study of spatial semiotics, Maree Stenglin, a researcher at the University of Technology Sydney, has explored the metafunctional meanings in spaces such as museums, parks, public libraries as well as private homes (e.g. Martin & Stenglin, 2007; Stenglin, 2009a, 2009b, 2011; Djonov et al., 2018). Within the educational context, the study of spatial semiotics is charted by the work of Gunther Kress and his colleagues as they examined the meanings made in the spaces within an English Language classroom in the United Kingdom. Kress et al. (2005) propose that ideational meanings in classroom spaces are realised through the interaction of three factors. They are: firstly, the teacher's movement; secondly, the meaning of the space in which the teacher moves; and finally, how and where students may move. Significantly, Kress et al. (2005) also highlight the potential for the possible transformation in the meanings of the spaces in the classroom. They explained that the 'pedagogic space' in the classroom is regularly reconfigured 'by the placement of the teacher's desk in relation to the rows of tables; and produced by the transforming action of the teacher in his pacing' (Kress et al., 2005: 26).

In the review of the book *English in Urban Classrooms: A Multimodal Perspective on Teaching and Learning*, Peter Martin extols that Kress et al. (2005) 'persuasively argue for the complex pedagogic discourses which are realised by these different modes'. He adds that 'based on the layout of the classroom and the visual display, contradictions between the participative and authoritative pedagogy come across' (Martin, 2010: 92). Extrapolating from the ideational meanings that can be realised in the teacher's use of classroom spaces described by Kress and his colleagues, we argue that the use of space and the movement of the teacher expresses the pedagogy of the teacher and contributes to the design of the learning experience for the students.

The interpersonal meanings in spaces have been examined by Christian Matthiessen, Professor at the Hong Kong Polytechnic University. Matthiessen (2009) discusses the notion of interpersonal distance. He builds on Hall's (1966) work and argues, as Stenglin (2008) does, that material distance is a realisation of semiotic distance. Matthiessen (2009: 27) explains that interpersonal meanings in distance are determined by visual and aural contact. He argues that

> the more "intimate" the tenor of the relationship is, the wider the bandwidth of the channel of communication is – the widest bandwidth being associated with intimate face-to-face conversation … the greater the range of interpersonal meanings that can be expressed … since the face is a key resource for the expression of interpersonal meanings.
>
> (Matthiessen, 2009: 27)

The facial expressions of the teacher in the classroom are another way in which meanings can be expressed. While the affordances of facial expressions as a semiotic mode are not examined in this book, the recognition that the teacher's positioning in different spaces in the classroom can offer a range of interpersonal meanings will guide our discussion and understanding of the teacher's spatial pedagogy.

The textual meanings in space has been alluded to by Adam Kendon, Professor at the University of Cambridge, Kendon (2010) explains that physical space allows people to organise themselves spatially according to the nature of their interaction. He observes that 'environmental structuring partly constraints the kinds of formational structures of gatherings that can occur'. As such, the 'interrelations between the structuring of the environment and the structuring of the interaction' is a 'very complex and fascinating question' (Kendon, 2010: 14). In the context of the classroom, the textual meanings of the spaces are shaped by the arrangement of the furniture in the room as well as influence and, in turn are influenced, by the nature of teacher–students interactions.

Spaces in the classroom

The use of space through the positioning and movement of the teacher in the classroom expresses a 'spatial pedagogy'. Spaces in the classrooms are constantly negotiated and reconfigured (1) statically through the stationary position of the teacher in a specific location and (2) dynamically though the teacher's movement and pacing. The teacher's position in the classroom is also significant as the material site where the discourses in the classroom are expressed. As such, different spaces in the classroom acquire specific meanings due to the typical configuration of semiotic choices in the pedagogic discourse that occurs in that space, as well as the positioning and distance of the site relative to the students, other furniture, and teaching resources, such as the whiteboard and screen. In this section. we describe a taxonomy of four different types of space in the classroom which are situated within Hall's Social-Consultative Space based on Lim, O'Halloran, and Podlasov (2012). They are namely (1) Authoritative Space, (2) Supervisory Space, (3) Interactional Space, and (4) Personal Space.

Authoritative Space

The Authoritative Space in the classroom has been defined conventionally as the front centre area of the classroom. This is the space in which the teacher has full view of all the students and is in full view to them. The front centre area of the classroom is the area just in front of the whiteboard. This is usually the position where the teacher conducts the lesson. Occupying this position, even without the need for words, expresses meanings of formality, structure, and power. It also conveys a strong hierarchical stance and reflects the teachers' authority and control over the students. Another Authoritative Space in the classroom is the area around the teacher's desk, especially the space just in front of the desk. The teacher tends to occupy this space

when issuing instructions to the students. The teacher also often conducts didactic teaching when positioned in this space.

The Authoritative Space in the classrooms is where there is an evident assertion of the teacher's authority and power over the students. The semantics of the space are observed when the teacher often returns to this space to continue the lesson or give further instruction during Student Work or after an interruption. The semantics of the Authoritative Space are often reinforced through the use of language to express discourses associated with high power. However, even in the lesson microgenre of the discourse of Rapport-Building, the teacher's engagement in banter while occupying the Authoritative space suggests the teacher's friendliness and relatability are accented with the reminder that the teacher is ultimately an authority, and not a peer.

The Authoritative Space is situated at the boundaries of the Social-Consultative Space as it is positioned furthest away from the students, both materially, as well as semiotically, following from Matthiessen's (2009) discussion of distance sets. Interpersonally, a formal tenor between the teacher and students is expressed when the teacher positions himself in the Authoritative Space.

Supervisory Space

The Supervisory Space is where the teacher paces between the rows of the students' desks in a traditional classroom layout, or when she moves amongst the clusters of students' desks. The Supervisory Space could also be at the boundary of the classroom, such as the left and right flanks, as the teacher occupies the space for the purpose of watching the students as they are on task during the lesson microgenre of Student Work. The students could be engaged in independent work, pair work, or collaborative group discussion. Meanings of control and monitoring are expressed through the positioning and movement of the teacher as she moves through or positions herself in these spaces. These meanings are expressed multimodally through the teacher's movement and positioning in the use of space, but often without the use of language.

The exercise of power and dominance by the teacher in the Supervisory Space has also been observed by Gunther Kress and his colleagues in the study of the English classrooms in the United Kingdom. For example Kress and his colleagues use the term 'patrol' to describe a teacher's slow and deliberate movement as he invigilates the students when they are doing their work (Kress et al., 2005). Through the movement and positioning of the teacher in these spaces, the teacher expresses and reinforces the institutional authority of schooling. In the occupation and use of the Supervisory Space, the teacher takes on the role of the monitor who expects and ensures students' compliance to the tasks set.

A different label is used to describe the space behind the students' desks, located at the back of the classroom. While a part of the Supervisory Space, this area, when occupied by the teacher for the purpose of monitoring students, is described as the Surveillance Space. This is unlike the other Supervisory Spaces, where the teacher

is visible to the students. As the students can see when the teacher is approaching them, they could be more vigilant and (pretend to) be more 'on task', or they could enjoy a moment of respite when the teacher walks away. When the teacher occupies the Surveillance Space, however, she is not easily visible to the students. Unless the students deliberately turn their head back to look at the teacher, which is a very conspicuous move and may draw unnecessary attention to themselves, the teacher has effectively rendered himself 'invisible' to the students. The students know that they are being monitored, but do not know when exactly they are being looked at, or not.

There is high power asymmetry when the teacher occupies the Surveillance Space and again the meanings of regulation, authority, and monitoring are often expressed without words. The Surveillance Space operates essentially like a Panopticon, a system of institutional control designed by English philosopher Jeremy Bentham in the eighteenth century, for prisons. Renowned French philosopher and social critic Michel Foucault extends the notion of the Panopticon, which meant 'all seeing' in Greek, to describe the invisible surveillance we experience in contemporary daily lives. In his defining work, *Discipline and Punish: The Birth of Prisons*, Foucault explains that 'the major effect of the Panopticon is to induce in the inmate a state of conscious and permanent visibility that assures the automatic functioning of power' (Foucault, 1977 [1995]: 195). This metaphor is extended to the institution of schooling in this book, where the teacher's occupation of the back of the classroom allows him to exercise institutional power and conducts the surveillance of the students from a vantage position. This produces a sense of consciousness in the students of the permanent visibility of themselves to the teacher and, following Foucault (1977 [1995]), 'assures the automatic functioning of power' by the teacher.

Interactional Space

The Interactional Space is where the teacher is positioned next to a student or a group of students. While the teacher may be between the rows or amongst the clusters of desks, the close proximity with the students allows him to provide consultation to them on their work. The teacher usually occupies the Interactional Space during the lesson microgenre of the Discourse on Personal Coaching. This occurs during Student Work where they are working on a set task, either individually, in pairs, or in collaborative group work.

The Interactional Space is situated within the Social–Consultative Space, but borders on the Casual–Personal Space. While maintaining a professional distance, the teacher's position next to the students, expresses interpersonal meanings of solidarity and relatability. This is consistent with Matthiessen's (2009) argument that the material distance expresses semiotic distance. In this case, the close proximity between the teacher and students expresses a certain degree of relational closeness between them.

The low tenor expressed in the interpersonal meanings is expressed both with the teacher's positioning in the space and reinforced through the linguistic inter-action between the teacher and students. The linguistic interaction could be on providing guidance to the students, clarification of instructions, or even occa-sional banter between the teacher and students for rapport-building. In light of the nature of the interaction between the teacher and students, and the position and movement of the teacher, the spaces in the classroom can take on different, and sometimes opposing, meanings.

Personal Space

While the area in front of the teacher's desk has been described as the Authoritative Space, the area behind the teacher's desk can be described as the Personal Space for the teacher. In the Personal Space, the teacher usually organises her materials and prepares for the next stage in the lesson. This is the area in which the teacher sometimes retreats to after setting a task to the students. There is usually no inter-action with the students when the teacher occupies the Personal Space. In terms of meanings expressed, the students appear to respect and recognise that when the teacher occupies the Personal Space, there is an imaginary wall constructed between the teacher and them. As such, they will usually go about the tasks set, without engaging with the teacher, unless needed.

As discussed earlier, the spaces in the classroom can be transformed both by the nature of interaction, as well as the organisation of furniture and equipment. In this case, the area behind the teacher's desk can be transformed into an Authoritative Space when the teacher starts teaching in the space. The reconfiguration usually happens because the teacher needs to use the equipment, such as the laptop or visualiser, placed on the teacher's desk. In this case, the teacher would necessarily have to position herself, standing or sitting, behind the teacher's desk and conduct her lesson from that location. The teacher's desk then serves as a quasi-lectern for the teacher's textbooks or notes.

Like all Authoritative Spaces, high power is realised when the teacher teaches as she occupies the area behind the teacher's desk. The desk also serves as a phys-ical barrier separating the teacher and students. This material distancing serves to accentuate the semiotic distance between the teacher and students and reinforces the teacher's authority as an archetypical expert – having taken the stage and given the authority to speak behind a lectern.

This section has described the typology of classroom spaces and discussed the associated meanings, determined by conventional usage, when the teacher occu-pies these spaces. Notwithstanding, it is useful to be reminded that beyond the ascribed normative usage of these spaces, the meanings in the physical spaces in the classroom are also influenced by the nature of interaction between the teacher and students, such as the types of discourses by the teacher, and the layout of the classroom, such as the spatial organisation of the furniture and equipment in the room. Therefore, the same physical area in the classroom can take on new meanings

and may not always serve a consistent singular function. The spaces in the classroom are defined and can be redefined based on the pedagogic interactions and lesson activities. However, we argue that classroom spaces are always meaningful, and it is useful to recognise the teacher's positioning and movement in these spaces as one of the semiotic modes in the design of the learning experiences for the students.

A study on the spatial pedagogy of two teachers

In this section, we will use the data from the case study, described in Chapter 2, to illustrate how the spatial pedagogy of the two teachers, Lee and Mei, can be coded, visualised, analysed, and interpreted. The positioning and movement of the two teachers are mapped based on the spatial description of the areas in the classroom as well as the typology of classroom spaces discussed in the earlier section. Based on the analysis of Lee and Mei's choices in their use of space, we hope to illustrate how the teacher's movement and positioning in classroom space is a semiotic mode that contributes to their design of the learning experience for the students.

Coding and visualisation

Lee and Mei's use of the classroom space were coded at one-second intervals. The one-second interval coding timeframe allows for a fine-grained analysis of the meanings expressed through the teacher's positioning and movement in the lesson. The data was coded using an Excel Spreadsheet in Microsoft Office and the data was displayed as graphs on Pivot Charts. The frequency in the use of specific classroom spaces by Lee and Mei are represented in Figure 3.2 for further analysis and discussion.

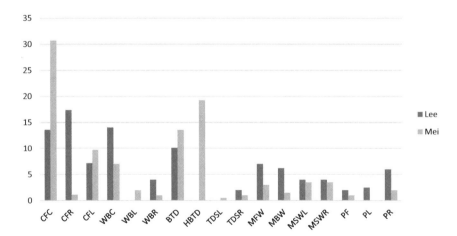

FIGURE 3.2 Comparisons of positioning and movement in Lee and Mei's lesson
Reproduced from Lim, O'Halloran, & Podlasov (2012: 241).

As described in Chapter 2, the software Cytoscape was also used to visualise the data. In the same way as how the lesson microgenres were visualised, the two teachers' use of space through their positioning and movement was visualised using network graphs. The visualisation of the two teachers' use of classroom space was based on the following dimensions:

1. Static or dynamic movement: static positions are represented as circles and movement and pacing are represented as rectangles.
2. Correspondence to the specific area in the classroom: the nodes are positioned in accordance to the layout of the classroom.
3. Frequency of occurrence: the larger the size of the node, the more frequent the space is selected.
4. Directionality of movement from one space to another: the arrows represent the directionality of the movement, and the size and tone of the arrows represent the frequency of the same directional movement.

Lee and Mei's use of space through their positioning and movement are represented in Figures 3.3a–b. In the next section, we will discuss some of the observations from their network graphs and consider how the visualisations reflect their different use of the classroom spaces as an expression of their spatial pedagogy.

Analysis of the teachers' positioning

The classroom layout in both lessons are identical as the same classroom was used. However, the two network graphs of Lee and Mei's spatial pedagogy reveal interesting differences in their use of classroom spaces. The visualisations in Figures 3.3a–b indicate that both teachers spent most of the time in the front areas of the classroom, in other words, the Authoritative Spaces. Less time was spent in the Supervisory and Interactional Spaces as indicated by their pacing in the smaller purple squares.

Both Lee and Mei spent most of the time in the Authoritative Spaces in the class-room. As described in the earlier section, one of the most common Authoritative Space is the front centre of the classroom. Teachers tend to occupy this space when they teach. The use of Classroom Front Centre (CFC) expresses meanings of power and authority and this is often reinforced by the types of discourses that take place when the teacher occupies this space. Mei spent a significant period, of about 30 per cent of the total lesson time, in the CFC, whereas Lee spent only about 13 per cent of the time in the CFC.

Both Lee and Mei also tend to position themselves slightly off centre. This can be interpreted as an attempt to moderate the high tenor and mute the overt display of authority they exercise over the students. While Classroom Front Left (CFL) and Classroom Front Right (CFR) can also be described as Authoritative Spaces as they are in front of the classroom and in full view of the students, their use often expresses lower tenor and the display of power is mitigated by the peripheral

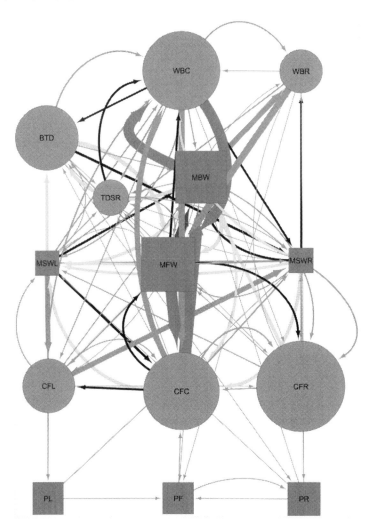

FIGURE 3.3a Lee's positioning & movement graph
Reproduced from Lim, O'Halloran, & Podlasov (2012: 242).

location of these spaces. Mei has a tendency to occupy CFL, whereas Lee spends a good amount of time both in CFL and CFR. In fact, Lee's use of CFR at 18 per cent of the lesson time is higher than the time he spends in the CFC. Overall, Lee is observed to spend more time occupying off-centred front area in the classroom, as compared to Mei's more regular use of CFC.

Both Lee and Mei tend to occupy the area surrounding the teacher's desk regularly. This is not surprising as the teacher's use of space is often shaped by the arrangement of furniture and the accessibility of the equipment. For instance, Carey Jewitt, Professor at the Institute of Education, University of London, has observed

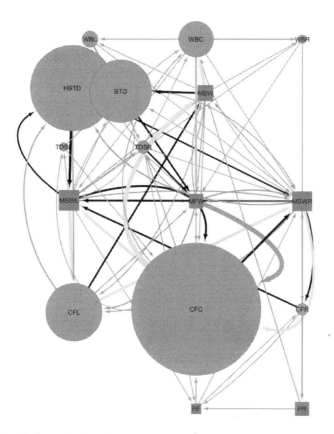

FIGURE 3.3b Mei's positioning & movement graph

Reproduced from Lim, O'Halloran, & Podlasov (2012: 242).

that in classes where teachers use the interactive whiteboards, there was a ten-
dency for them to limit their use of space in the area surrounding the interactive
whiteboards (Jewitt, 2011). Similarly, in both Lee and Mei's lesson, the access to
equipment, such as the teacher's laptop and the visualiser, tends to constrain their
use of space to the area surrounding the teacher's desk.

Lee spends about 11 per cent of the total lesson time Behind the Teacher's Desk
(BTD). He would usually occupy the space to operate the laptop, in order to show
videos and control his PowerPoint presentations. Mei would very often transform
the area surrounding the teacher's desk into Authoritative Spaces. She spends a sig-
nificant 13 per cent of the total lesson time in BTD, and another 19 per cent of the
total lesson time Half-Behind the Teacher's Desk (HBTD). While the BTD and
HBTD are typically the Personal Space in the classroom, Mei was able to redefine
the meanings in the classroom spaces through her discourses. Her use of the visu-
aliser on the teacher's desk could have confined her to BTD and HBTD. However,
even when she is not using the visualiser, Mei continues to occupy BTD and HBTD,

and uses the teacher's desk as a quasi-lectern as she teaches from that space. In addition, unlike Lee, Mei also sometimes occupies the side spaces of the Teacher's Desk and teaches from there. She spends 4 per cent of the total lesson time occupying both the left and right sides of the teacher's desk. Mei's transformation of the areas surrounding the teacher's desk into Authoritative Spaces indicates that she tends to relate to her students more formally and maintains a professional distance from them.

Overall, both teachers spend a significant amount of time in the Authoritative Spaces, with Lee spending 86 per cent of the total lesson time and Mei spending 96 per cent of her total lesson time. This is not surprising as in most conventional classrooms, where teaching is mostly didactic, Authoritative Spaces are often used to reinforce the power and status of the teacher. It is, nonetheless, useful to recognise that not all Authoritative Spaces are the same, and that sometimes the teachers can moderate the power differential between the students and themselves by occupying Authoritative Spaces that are off-centre. This is regularly used by Lee in his attempt to be more relatable to the students and mitigate the hierarchical power he exercises over them as a pedagogic authority. Mei's use of the areas surrounding the teacher's desk as Authoritative Spaces is interesting. We argue that teaching behind the teacher's desk reinforces her authority as the desk serves as a physical barrier and expresses her power as pedagogic authority over the students. However, it should also be noted that in the layout of the classroom, the teacher's desk is located at the left side of the classroom, so Mei is, arguably, positioned off-centre as well. The two sets of seemingly opposing meanings can perhaps counter and balance off each other, thus allowing Mei's spatial pedagogy to be interpreted as an assertion of her pedagogic authority, but in a less explicit manner.

Analysis of the teachers' movement

The movement of the teachers is also coded and visualised in the network graphs. Both Lee and Mei tend to move backwards and forwards from Classroom Front Centre (CFC) to the front centre of the whiteboard during the lesson. The movement is often used to emphasise specific teaching points to the students. For instance, Lee tends to take a step forward into the Authoritative Space in CFC as he expresses important teaching points which he wants his students to take note. Lee does this more frequently than Mei, as indicated by the larger squares and thicker arrows that his network graph shows.

Mei exhibits less movement than Lee. She tends to position herself in a space and stays mostly stationary as she conducts the lesson. This is evident from Mei's network graph, where there are fewer arrows indicating a lower frequency of movement. In contrast, Lee's network graph shows thicker and more arrows. The high density of arrows suggests that Lee is hardly stationary as he conducts the lesson. Instead, he moves forward and backwards, and from one space to another as he teaches. Lee spent about 21 per cent of the lesson time in motion, whereas Mei only spent about 10 per cent of the time moving from one space to another. In a sense, the spatial pedagogy that Lee expresses is highly dynamic.

Both teachers also occupy the Supervisory Space in their lesson, as evident in their pacing on the left and right sides of the classroom. Lee patrols in the Supervisory Space for about 8 per cent of the total lesson time as compared to Mei who spends about 4 per cent of the total lesson time in the Supervisory Space. The use of the Supervisory Space often highlights the power and authority of the teacher, as the teacher monitors the students' compliance to the task set. Lee's use of the Supervisory Space through his pacing up and down the class-room is consistent with his high frequency of movement that he exhibits, even when he is teaching in the Authoritative Space. While a sense of energy and dyna-mism is infused into the students' learning experience through the high amount of teacher's movement, there remains a risk that the action, if uncoordinated with the other semiotic modes, could potentially distract students from the meanings made with the other semiotic modes. For instance, the students may be overwhelmed by the frequency of movement and not pay attention to what the teacher says.

Discussion on the teachers' spatial pedagogy

From the analysis, Lee shows a preference to stand off-centre when he occupies the Authoritative Spaces. He also tends to move about the classroom very frequently, both pacing in the front of the classroom in the Authoritative Spaces as well as patrolling the sides of the classroom as he occupies the Supervisory Spaces. A sense of high power and control is expressed in his use of the Supervisory Spaces, though this is mitigated by his choice of not standing in the classroom front-centre as often as Mei.

Mei tends to occupy the Authoritative Spaces and spends time in the classroom front-centre and in the areas around the teacher's desk. Through this, Mei exercises high power over the students and asserts herself as the pedagogic authority. Through limited movement, and by remaining mostly stationary in the Authoritative Spaces as she conducts the lesson, Mei's spatial pedagogy conveys a sense of formality and professional decorum.

The use of classroom spaces through the positioning and movement is only one of the semiotic modes in the teacher's orchestration of the multimodal ensemble. While both teachers' spatial pedagogy expresses meanings of power and control in the classroom, it is useful to explore how they work together in combination with the other semiotic modes, such as language and gestures. Do the meanings con-verge and reinforce the teacher's message or the meanings diverge to bring about an additional layer of meaning in the expression of their pedagogy? These are the questions which we will turn to in Chapter 6 of this book.

Applications of spatial pedagogy

The concept of spatial pedagogy and the taxonomy of classroom spaces (Lim, 2011; Lim et al, 2012) have been productively applied and usefully extended by

researchers studying learning spaces across a range of contexts. In this section, we describe some of these recent studies as a way to review the utility of the ideas discussed in this chapter.

Within the primary school context in Greece, Eleni Gana and her colleagues adopted a multimodal analytical approach to study the semantic potential of classroom spaces in the Mathematics classroom (Gana, Stathopoulou, & Chaviaris, 2015). Adopting a social semiotic lens on teaching and learning, Gana et al. (2015) analysed two one-hour-long, video-recorded lessons from two primary mathematical classes. They applied the taxonomy of classroom spaces and coded the lesson videos in one-minute intervals based on the teacher's position, movement, language, and gaze. Their findings suggest that the teacher's use of space serves as 'material forces' that are subject to and are reflexive of the teacher's pedagogy. Gana et al. (2015) also observed that the teachers in both classes reshaped the spatial display of the classroom and hence reconfigured the semantics of the classroom space to express specific pedagogical discourse. In this, they affirm the argument that the teachers' use of classroom space is an integral part of their pedagogy.

Within the university context in Spain, Teresa Morell applied the taxonomy of classroom spaces to examine an English-medium instructor's spatial pedagogy in a lecture. For each stage of the lesson activity in the class, Morell (2018) mapped the classroom's setting with the positions of students and the instructor as well as the direction of the instructor's gaze. With this, she examined how the instructor made use of the classroom space through his positioning. She found that the instructor's language, gaze, gestures, and use of space enabled him to textually organise and interpersonally involve the students to elicit conceptual meanings. Morell's (2018) findings concur with the argument expressed in Lim et al. (2012) that the positioning and movement of a teacher in the classroom are integral to the pedagogical process.

Across Europe, comparisons between classrooms in Manchester and Copenhagen were examined by James Furlong. He applied the taxonomy of classroom spaces to observe the impact of the use of these spaces on the pedagogy of the teachers (Furlong, 2015). He observed that teachers seem to apply incongruent pedagogies with flexibility in standard classrooms and surveillance and control in open-plan environment. This is consistent with the argument that all semiotic modes, and the use of classroom space being one, work in combination, rather than in isolation, as part of the design of the learning experience for students. Some classroom layouts may offer more authoritative spaces that encourage a didactic pedagogy, whereas other classroom layouts may offer many interactional spaces that encourage a participative pedagogy. However, the teacher has the power to subvert the affordances of these layouts through exercising their control of the discourses in the classroom, and the orchestration of the other semiotic modes.

In Asia, Thomas Amundrud examined the feedback sessions between the teacher and students in the Japanese tertiary EFL (English as Foreign Language) classroom (Amundrud, 2015). He adopted the social semiotic lens on teaching and learning as the understanding that the teacher's use of classroom space is a semiotic mode for meaning-making. Amundrud (2015) applied the taxonomy of classroom spaces to

map the meanings made in the consultation sessions and presented implications of such research on SLA (Second Language Acquisition) studies.

In the Middle East, Perihan Korkut applied the taxonomy of classroom spaces to compare between pre-service teachers and in-service teachers' classroom management in Turkey (Korkut, 2017). He found that the differences between beginning teachers and experienced teachers, while not immediately observable to the casual observer, could be explicated through a study of their use of semiotic modes, including their use of space through positioning and movement. In so doing, he suggests implications on teachers' pre-service training and professional learning.

In Australia, Louise Ravelli, in her study of university learning spaces, argues that the movement of the teacher to control the visibility of learning resources and monitor students' work brings about different communicative patterns that create specific social relations (Ravelli, 2018). As such, the spatial pedagogy of the teacher serves to express specific metafunctional meanings in the design of students' learning experiences.

In New Zealand, Sean Sturm explored the possibilities presented in university learning spaces (Sturm, 2018). He applied the taxonomy of classroom spaces to explore the interaction between the teacher and students. Sturm (2018) argues that the study of these practices can advance a 'participatory pedagogy' in teaching and learning in institutes of higher education.

In Uruguay, Paula Cardellino and her colleagues also applied the concept of spatial pedagogy to study how classroom spaces can either facilitate or inhibit behaviours and relationships between the teacher and students. They argue that the nature and types of classroom spaces affect the quality and extent of visual interaction between the teacher and students (Cardellino, Araneda, & Alvarado, 2017), In this, they affirm the argument that the design of learning spaces as well as the movement and positioning of the teacher in these spaces can shape the learning experience of the students.

In Sweden, Tamara Mehdi and Hanna Fristedt explored the teacher's use of multimodal resources in a second language classroom (Mehdi & Fristedt, 2018). They applied the taxonomy of classroom space to code the teacher's use of space in relation to her choices made in language and gestures. They affirmed the argument that it was crucial for the teachers to be aware of the use of space, gestures, gaze, and language in their teaching.

The concept of spatial pedagogy can be applied to present insights on the students' learning experience in real classrooms as well as in virtual classrooms. Contrasting language teaching and learning between a conventional classroom and in 3D virtual worlds, Sabine Tan and her colleagues applied the taxonomy of classroom spaces, amongst other semiotic modes, such as gaze, facial expression, body posture, and gestures, to highlight the complexity of digital multimodal learning environment (Tan, O'Halloran, & Wignell, 2016). Through the comparison, they demonstrate how the orchestration of the teacher's semiotic modes is integral to facilitate language learning in an orderly, structured, and goal-oriented manner in the classroom. In contrast, the avatar teacher's uncoordinated use of semiotic modes

may pose problems for successful learning in the virtual learning spaces. Tan et al. (2016) argue that the findings have implications on CALL (Computer-assisted Language Learning) approaches in demonstrating that teaching and learning is more than just the dissemination of knowledge through language. Teaching involves an orchestration of a multimodal ensemble in the design of the learning experience, in which they posit – materiality makes a difference.

The argument that the use of spaces in the classroom has a profound impact on teaching and learning is affirmed by the work of Terry Byer and his colleagues (Byer, Imms, & Hartnell-Young. 2014). They recast the spatial pedagogy of the teacher as a part of 'built pedagogy' (Monahan, 2002; Thomas, 2010), which is the ability of the cultural, psychological, and behavioural attributes of the physical space to shape both teaching and learning. Byer et al. (2014) also propose an approach – single-subject, repeated measures design (SSRD) – to measure the effects of space on students' learning outcomes.

Taking the argument of spatial pedagogy further, Lara Sardinha and her colleagues posit that the classroom physical space could be construed as a learning ecosystem that brings together the social, cultural, architectural, and technological dimensions (Sardinha, Almeida, & Pedro, 2017). They apply the concept of spatial pedagogy to describe the social dimension in the classroom, where the meanings of the spaces are dependent on the nature of interaction between the teacher and students. Through their work, they hope to develop an innovative interior design strategy that can improve the use of classroom physical space across different dimensions.

The studies on the use of classroom space from around the world are evidence of an emerging and growing interest in how the teacher can design various learning experiences for their students through their use of space, as well as how the learning spaces in the classroom can be better designed. While the regularised use of space has led to conventional meanings being ascribed to the specific spaces, and that the use of these spaces can encourage certain pedagogies, the studies also suggest that the teacher has ultimate control and can exercise the choice to reshape the meanings of the spaces through their discourses. The studies affirm the importance for teachers to reflect on their use of classroom space as a part of their pedagogy. The utility of the concept of spatial pedagogy is also suggested through the implications a study of spatial semantics can offer to SLA instruction, CALL approaches, teachers' pre-service and professional learning, as well as on the design of learning spaces in both the general education and higher education contexts.

Space exploration

Space affects the social practices and shapes individual's identities and relationships within it (Allan & Catts, 2014). Spatial distances between individuals are socially and culturally defined (Hall, 1966). As Jewitt (2008: 262) observes, 'how teachers and students use gaze, body posture, and the distribution of space and resources produces silent discourses in the classroom that affect literacy'. The teacher's use of classroom space has implications on the production of social capital (Allan & Catts,

2014), the shaping of power relations between teachers and students in the classroom (Lim et al., 2012) and the improvement of student engagement and performance in the classroom (Bouchard, 2017). The spaces in the classroom in which the teacher moves and occupies are meaningful. The meanings in these spaces are influenced by the types of discourses and the nature of interaction between the teacher and students, as well as being shaped by the furniture and layout arrangements.

In this chapter, we have examined the meanings in the classroom spaces and described a typology used to map the meanings of these spaces. While the meanings in these spaces have been regularised over time due to conventional usage, they can still be redefined by the types of discourses made by the teacher in the use of the space. Meanings in the classroom spaces are negotiated statically through the teacher's positioning and dynamically through the teacher's movement through pacing. As such, a study of the teacher's use of classroom spaces can reveal their spatial pedagogy. For teachers, an awareness of how classroom spaces, as a semiotic mode, can be used with aptness and fluency, to help them design various learning experiences for their students.

This chapter also explored the possibilities offered by digital technology in the coding and visualisation of multimodal data. The collection of multimodal data in the classroom often produces a very large corpus, and the visualisation of these data is helpful to identify patterns and trends for analysis. In Chapters 2 and 3, we have introduced the use of Cytoscape, an open source software that can visualise the coding made of the data as network graphs. The usefulness of the network graphs in aiding in the comparisons between the teachers' lesson microgenres and their spatial pedagogy is illustrated with an analysis of the data from two teachers.

O'Halloran (2009: 113) observes that 'multimodal analysts from the social sciences appear to have much to gain by understanding and utilizing the expanded meaning potential afforded by computer technology to further multimodal analysis theory and practice'. For the educational researcher interested in the study of embodied semiosis, the use of computer technology as a tool for visualisation has become a necessity. With the advancement of technology, the automated annotation and basic analysis of big data is also fast becoming a reality (see e.g. Wiedemann, 2013; Bateman et al, 2016; Manolev et al., 2018). As such, educational researchers can possibly overcome the seemingly daunting amount of data collected in a multimodal corpus on embodied semiosis in the classroom by harnessing the affordances of new technologies in visualising, analysing, and explicating the semiotic choices made by the teachers.

REFLECTION QUESTIONS

1. How do the various spaces in the classroom which the teacher occupies express specific meanings?
2. How can teachers use the various classroom spaces in your lesson to design unique learning experiences for students?

References

Aliakbari, M., Faraji, E., & Pourshakibaee, P. (2011). Investigation of the proxemic behavior of Iranian professors and university students: Effects of gender and status. *Journal of Pragmatics* 43, 1392–1402.

Allan, J. & Catts, R. (2014). Schools, social capital and space. *Cambridge Journal of Education* 44(2), 217–228.

Amundrud, T. (2015). Individual feedback consultations in Japanese tertiary EFL: A systemic semiotic exploration. *English Australia Journal* 30(2), 40–64.

Bateman, J., Tseng, C-I., Seizov, O., Jacobs, A., Ludtke, A., Muller, M.G., & Herzog, O. (2016). Towards next-generation visual archives: Image, film and discourse. *Visual Studies* 31(2), 131–154.

Bouchard, D. (2017). Mutually Humble Collaboration in College Literacy Courses: Same Papers, Dialogical Responses. Unpublished doctoral thesis. University of Minnesota, America.

Byers, T., Imms, W., & Hartnell-Young, E. (2014). Making the case for space: The effect of learning spaces on teaching and learning. *Curriculum and Teaching* 29(1), 5–19.

Cardellino, P., Araneda, C., & Alvarado, R. (2017). Classroom environments: An experiential analysis of the pupil–teacher visual interaction in Uruguay. *Learning Environments Research* 20(3), 417–431.

Djonov, E., Torr, J., & Stenglin, M. (2018). Early language and literacy: Review of research with implications for early literacy programs at NSW public libraries. Sydney, NSW: State Library of NSW and Department of Educational Studies Macquarie University.

Foucault, M. (1995). *Discipline and Punish: The Birth of the Prison*. (A. Sheridan, Trans.). New York: Vintage Books. (Original work published 1977).

Furlong, J. (2015). Habits in Habitats: School Architecture and Teachers' Interactions with Space in Manchester and Copenhagen. Unpublished MA Thesis. Université Libre de Bruxelles (ULB), Brussels, Belgium. Retrieved from www.4cities.eu/wp-content/uploads/2016/06/MAthesis_4Cities_FURLONG_JAMES.pdf

Gana, E., Stathopoulou, C., & Chaviaris, P. (2015). Considering the classroom space: Towards a multimodal analysis of the pedagogical discourse. In U. Gellert, J. G. Rodriguez, C. Hahn, & S. Kafoussi (eds), *Educational Paths to Mathematics* (225–236). Switzerland: Springer.

Goffman, E. (1959). *The Presentation of Self in Everyday Life*. New York: Doubleday.

Hall, E. (1966). *The Hidden Dimension*. Garden City, NY: Doubleday.

Halliday, M.A.K. (1978). *Language as Social Semiotic: The Social Interpretation of Language and Meaning*. London: Edward Arnold.

Jewitt, C. (2008). Multimodality and literacy in school classrooms. *Review of Research in Education* 32, 241–267.

Jewitt, C. (2011). The changing pedagogic landscape of subject English in UK classrooms. In K.L. O'Halloran and B.A. Smith (eds), *Multimodal Studies: Exploring Issues and Domains* (184–201). London & New York: Routledge.

Kendon, A. (2010). Spacing and orientation in co-present interaction in development of multimodal interfaces: Active listening and synchrony. *Lectures Notes in Computer Science* 5967, 1–15.

Korkut, P. (2017). Classroom management in pre-service teachers' teaching practice demo lessons: a comparison to actual lessons by in-service English teachers. *Journal of Education and Training Studies* 5(4), 1–17.

Kress, G. (2010). *Multimodality: A Social Semiotic Approach to Contemporary Communication*. London & New York: Routledge.

Kress, G., Jewitt, C., Bourne, J., Franks, A., Hardcastle, J., Jones, K., & Reid, E. (2005). *English in Urban Classrooms: A Multimodal Perspective on Teaching and Learning*. London, UK: RoutledgeFalmer.

Lim, F.V. (2010). Language, gestures and space in the classroom of Dead Poets' Society. In Y. Fang & C. Wu (eds), *Challenges to Systemic Functional Linguistics: Theory and Practice. Proceedings of the Conference ISFC36 Beijing July 2009* (165–172). Beijing: 36th ISFC Organizing Committee. Tsinghua University and Macquarie University.

Lim, F.V. (2011). A Systemic Functional Multimodal Discourse Analysis Approach to Pedagogic Discourse. Doctoral thesis. National University of Singapore.

Lim, F.V., O'Halloran, K.L., & Podlasov, A. (2012). Spatial pedagogy: Mapping meanings in the use of classroom space. *Cambridge Journal of Education* 42(2), 235–251.

Manolev, J., Sullivan, A., & Slee, R. (2018). The datafication of discipline: ClassDojo, surveillance and a performative classroom culture. *Learning, Media and Technology* 44(1), 36–51.

Martin, J.R., & Stenglin, M. (2007). Materializing reconciliation: Negotiating difference in a transcolonial exhibition. In T.D. Royce & W. Bowcher (eds), *New Directions in the Analysis of Multimodal Discourse* (215–238). Mahwah, New Jersey and London: Lawrence Erlbaum Associates, Publishers.

Martin, P. (2010). Book review: Gunter Kress, Carey Jewitt, Anton Franks, John Hardcastle, Jill Bourne & Euan Reid, English in urban classrooms: A multimodal perspective on teaching and learning. *Language and Education* 90–94. Retrieved from http://courses.nus.edu.sg/course/ellbaozm/Papers/Bao2008b.pdf

Matthiessen, C.I.M.M. (2009). Multisemiosis and context-based register typology: Registeral variation in the complementarity of semiotic systems. In E. Ventola & A.J.M Guijarro (ed.), *The World Told and the World Shown: Multisemiotic Issues* (11–38). Hampshire: Palgrave Macmillan.

Mehdi, T. & Fristedt, H. (2018). What Multimodal Resources Are Used by a Second Language Teacher while Giving Instructions? MA Thesis. Malmö University, Sweden.

Monahan, T. (2002). Flexible space and built pedagogy: Emerging IT embodiments. *Inventio* 4(1), 1–19.

Morell, T. (2018). Multimodal competence and effective interactive lecturing. *System* 77, 70–79.

O'Halloran, K.L. (2009). Historical changes in the semiotic landscape: From calculation to computation. In C. Jewitt (ed.), *Handbook of Multimodal Analysis* (98–113). London: Routledge.

Ravelli, L.J. (2018). Towards a social-semiotic topography of university learning spaces: Tools to connect use, users and meanings. In R. Ellis & P. Goodyear (eds), *Spaces of Teaching and Learning. Understanding Teaching-Learning Practice* (63–80). Springer, Singapore.

Sardinha, L., Almeida, A.M.P., & Pedro, N. (2017). Bridging approaches: Classroom physical space as a learning ecosystem. *Interaction Design and Architecture(s) Journal – IxD&A* 35, 56–74.

Stenglin, M. (2008). Binding: A resource for exploring interpersonal meaning in three-dimensional space. *Social Semiotics* 18(4), 425–447.

Stenglin, M. (2009a). From musing to amusing: Semogenesis and western museums. In E. Ventola & A.J.M Guijarro (eds), *The World Told and the World Shown: Multisemiotic Issues* (245–265). Hampshire: Palgrave Macmillan.

Stenglin, M. (2009b). Space odyssey: Towards a social semiotic model of three-dimensiona space. *Visual Communication* 8(1), 35–64.

Stenglin, M. (2011). Spaced out: an evolving cartography of a visceral semiotic. In S. Dreyfus, S. Hood, & M. Stenglin (eds), *Semiotic Margins: Meaning in Multimodalities* (73–100). London & New York: Continuum.

Sturm, S. (2018). An art of orientation: The possibilities of learning spaces. In L.W. Benade & M.L. Jackson (eds), *Transforming Education: Design and Governance in Global Contexts* (135–148), Singapore: Springer Nature Singapore Ptd Ltd.

Tan, S., O'Halloran, K.L., & Wignell, P. (2016). Multimodal research: Addressing the complexity of multimodal environments and the challenges for CALL. *ReCALL* 28(3), 253–273.

Thomas, H. (2010). Learning spaces, learning environments and the displacement' of learning. *British Journal of Educational Technology* 41(3), 502–511. http://dx.doi.org/10.1111/j.1467-8535.2009.00974.x

Wiedemann, G. (2013). Opening up to Big Data: computer-assisted analysis of textual data in social sciences. *Historical Social Research* 38(4), 332–357.

4

PEDAGOGIC GESTURES

Performing teaching

Teaching is a performance. The very act of teaching involves the entire physical being of the teacher. From the moment the teacher steps into the classroom, the spaces in the classroom transform into a stage for the teacher. With the eyes of the students trained on the teacher, every move, every gesture, and every look express meanings together with, and often, extend beyond words.

Embodied teaching involves an awareness of how the teacher can make meaning across a range of semiotic modes, such as the use of space, and gestures, as part of designing the learning experience for their students in the lesson. With this understanding, teachers are invited to reflect on their use of these semiotic modes in their teaching and develop an aptness and fluency in their use of space and gestures in expression of their pedagogy – that is the way they represent knowledge, relate to students, and organise the learning experience in the classroom.

An experienced teacher, such as Miss Gan, described earlier in Chapter 1, knows and does this almost intuitively. She chooses not just her words, but also the most apt semiotic modes, to make meanings in the classroom. Gestures are often used independently without language, to correct student's misbehaviour, direct their attention back to her lesson, and express permission towards student's requests to visit the toilet. In this way, gestures are used to express the regulative discourse in the lesson. Gestures are also used with language to communicate, such as making explicit with gestures an abstract idea described with language as well as reinforcing what is said with language through repetition and redundancy with gestures (Bateson, 1973; Lemke, 1984; Christie, 2002). As such, gestures are also used as part of the instructional discourse in the lesson. This is further discussed in Chapter 6.

The apt use of gestures, particularly to express regulative discourse in the classroom, such as on the maintenance of discipline, can mitigate the extent of high

power and possible unpleasantness experienced by the students in the classroom, if the discourse on discipline had been expressed with language. Gestures, accompanied by a pregnant pause in language, can be directed at the specific errant student, whereas a switch in the teacher's language to reprimand one student would affect all students in the class, even if the misbehaving student is singled out by name. The teacher's strategic use of gestures can bring about a swift restoration to pedagogic order, in perhaps a shorter time, than what the use of language can achieve in a time-pressed classroom.

Studies on the interaction between teacher and students in the classroom typically focus on the use of language in classroom discourse. However, with the easy availability and accessibility of video recording technologies, data on the teacher's use of embodied semiosis can now be easily collected. Educational researchers may be concerned about the ways in which the teacher's gestures can be coded and analysed. What are the types and nature of gestures in the pedagogic setting? And how do the teacher's use of gestures fit into the ensemble of multimodal semiotic modes in the orchestration of pedagogic meanings? These are some of the questions and issues which will be discussed from a social semiotic lens in this chapter.

Gesture studies

The use of gestures has long been recognised for making both integral and important contributions to communication. The word 'gesture' stems from the Latin root 'gerere' which means to carry, manage, or conduct. In other words, gestures have always had the meaning of it being a semiotic mode, a bearer of meaning.

Roman orators pay attention not just to the use of language in the art of persuasion, but also to their use of gestures in their rhetoric. In recorded history, Marcus Tullius Cicero (106–43 BC), a Roman orator and philosopher, was amongst the first in pioneering the study of gestures in classical rhetoric. Cicero describes the orator's effective use of gestures in her rhetorical performance as 'eloquentiacorporis' or the eloquence of the body. Through his work, Cicerio introduces the role of the 'sermocorporis' or body language, in communication.

Marcus Fabius Quintilianus (AD 35–100), another Roman orator and educator, developed the theory and practice of rhetoric in his 12-volume textbook *Institutio Oratoria* or *Institutes of Oratory*. Building on the foundations laid by Cicero, Quintilian distinguished rhetorical delivery into 'vox' or voice and 'gestus' or gestures. Drawing his data from Roman orators of his time, Quintilian highlighted how the effective use of gesture can lend emphasis and weight to their argumentation.

While linguistics flourished as a discipline in academia since the early twentieth century with the seminal work of Swiss linguist and semiotician, Ferdinand de Saussure (1857–1913), interest in the study of gestures surfaced later with the emergence of the field of non-verbal communication during the Cold War era in the second half of the twentieth century. Pioneers in charting the field include British psychologist, Adam Kendon, whose lifework on the study of gestures as visible action charted the field (Kendon, 1996, 2004), American anthropologist, Ray Birdwhistell,

who introduced the term 'kinesics' to describe a person's use of facial expression, gestures, posture and gait, and movements in communication (Birdwhistell, 1952, 1970), and American psychologist Paul Ekman, who studies facial expression and gestures, particularly in detecting deception (Ekman & Friesen, 1969, 1974).

In developing the definition and nature of gesture, researchers in the field of non-verbal communication have classified gestures into various types. For instance, Ekman and Friesen (1969, 1974), Scherer and Ekman (1982), and others propose the categories of Emblems, Illustrators, Regulators, Adaptors, and Affect Displays. The precise nomenclature may vary from one researcher to another. Also, not all of them may identify all the categories described here. Nevertheless, the general principles behind the classification remain mostly consistent and similar across the theorists adopting this frame.

Emblems are considered as speech-independent gestures that can possibly have direct verbal translation. For instance, the 'OK' sign made by the joining of the thumb and index finger is the classic example of an Emblem. Illustrators are speech-dependent gestures. The degree of intent exercised by the enactor is uncertain. Illustrators include signals for turn-taking in conversations (pointing with palm), signals for referents (using fingers for numbering of ideas), baton (slamming of hand), ideographs (snapping of fingers while thinking), and pictograms (tracing the movement of signing a cheque when requesting for the bill). Regulators or Gesticulations, as described by Kendon (2004), are gestures that are habitual and mostly unintentional. They are mostly speech-dependent gestures and are categorised as Communicative Gestures.

Adaptors, as described by Ekman and Friesen (1969), are highly unintentional behaviour and are usually responses to boredom or stress. Self-Adaptors involve the manipulation of the enactor's body such as hair twisting or scratching. Alter Adaptors are designed to psychologically or physically protect the enactor from others. This includes the folding of arms or unconscious leg movements. Object-focused Adaptors involve the unconscious manipulation of objects such as the twisting of rings and the tapping of pens. Affect Displays include facial expressions, postures, reflex actions, and involuntary movements such as shivering. Adaptors are not strictly considered as gestures in the field of non-verbal communication as they are usually not wilful and may not be recognisably communicative.

Over the years, the study of gestures has been further developed by scholars such as Goldin-Meadow and Singer (2003) and McNeill (1992, 2005) in psychology, Haviland (2004) in anthropology, and Roth (2001) and Cienki (2008) in cognition and the learning sciences. Within linguistics, work on gesture, from the conversation analysis perspective, is represented in the seminal work of Goodwin (1979) and Schegloff (1984), and Ochs, Schegloff, and Thompson (1996) and more recently by Streeck, Goodwin, and LeBaron (2011), and Broth and Mondada (2013).

Nevile (2015) describes an 'embodied turn' in the study of linguistics, where there is an emerging focus on multimodal communication. Mondada (2016: 338) also observes a similar surge of interest in multimodality within the field of conversation analysis. There is a focus beyond verbal resources to 'also embodied ones, within

a more global and holistic approach of multimodality, comprising language, gesture, gaze, head movements, facial expressions, body posture, body movements, and embodied manipulations of material objects'. She argues that the interest in research on multimodality paves ways in 'which the multimodal dimension of understanding can be empirically and analytically considered' (Mondada, 2011: 550).

Other recent work include Dreyfus's (2011) description of how a child with intellectual disability uses gestures to communicate, Taylor's (2014) study of children's use of gestures as part of multimodal meaning-making in the classroom, as well as Norris's (2016) analysis of gestures as embodied modes from the perspective of multimodal (inter)action analysis. Applying Systemic Functional Theory, scholars, such as Hood (2007, 2011), Martinec (2000, 2001, 2004), Cleirigh (2011), Lim (2011; 2019a; 2019b), and Martin and Zappavigna (2019) have developed studies in systematising gestures. Given the social semiotics orientation in this book, the conceptions proposed by the scholars working within the Systemic Functional theoretical paradigm will be discussed in the following sections and applied to develop analytical categories for the analysis of pedagogic gestures in this chapter.

Gestures in the classroom

The teacher's use of gestures in the classroom has been studied by various scholars in recent years across a range of subjects. These include Mathematics (Cook, Duffy, & Fenn, 2013), Physics (Carlson, Jacobs, Perry, & Church, 2014), Chemistry (Abels, 2016), Language (Inceoglu, 2015; Matsumoto & Dobs, 2017) and Music (Simones, Schroeder, & Rodger, 2015). The studies suggest that the teacher's apt use of gestures as a mode of meaning-making can enhance students' learning (Klooster, Cook, Uc, & Duff, 2015; Novack & Goldin-Meadow, 2017; Cook, 2018) as well as maintain and regulate the students' behaviour in the classroom (Sime, 2006; McCafferty & Rosborough, 2014).

Sime (2006) explored how students learning English as a Foreign Language (EFL) at a Scottish university perceived and interpreted their teacher's gestures in their EFL class. The students were asked to review a video clip of an earlier lesson they had. They were to identify and comment on their teacher's nonverbal behaviours such as gestures, eye contact, and facial expressions. They observed that the teacher would use gestures to regulate and organise the students during class activities and the management of speech turns. For instance, the teacher would point to a specific student as an indication that he was to respond, and deny a student's turn to speak by wagging their index finger or pointing their palm(s) to another student.

McCafferty and Rosborough (2014) studied the classroom interaction between the teacher and students in a second-grade classroom in America. Specifically, the researchers examined the teacher's use of gestures and found that they were used to serve a regulative function in the classroom as well. For instance, when a student waited to walk between the teacher and another student in conversation, the teacher swept her right arm in a deictic gesture without disrupting her talk with the second student, sending a private message to the first student that he could take the path between them.

Classroom management literature has also highlighted the importance of the teacher's use of gestures as part of regulating the class (see e.g. Kounin, Gump, & Ryan, 1961; Galloway, 1976; Neill, 1991; Neill & Caswell, 1993). In particular, Neill (1991) and Neill and Caswell (1993) offer practical suggestions to teachers when and how to use their gestures as well as other types of nonverbal behaviours to direct students' attention, regulate students' behaviours, and build a positive relationship with their students. Where the focus in these books were on the teacher's use of gestures simply as a technique in classroom management, these works pave the way for a recognition and deeper appreciation amongst teachers that they can use gestures with aptness and fluency, together with the other semiotic resources, in the design of students' learning experience.

A systemic functional approach to gesture

A typology of gesture

In this section, and the following sub-sections, the Systemic Functional Multimodal Discourse Analysis (SFMDA) approach to gestures is outlined. The purpose is to offer analytical categories in the systematising of gestures in the classroom, which will allow the teacher-practitioner to reflect on her use of gestures as a semiotic mode in embodied teaching, and to support the educational researcher with a coding scheme to annotate and analyse the types of gestures and the nature of meanings made.

In the study of actions, Radan Martinec, an independent researcher and consultant, working from the SFMDA theoretical orientation, proposes that actions, can be described as Presenting Action, Representing Action, and Indexical Action. This is based on formal observable criteria. Martinec formulates the systems for action which include movement and proxemics as 'they all express the same broad kind of meaning' (Martinec, 2001: 144). Martinec (2000: 243) defines Presenting Action as 'most often used for some practical purpose' and 'communicates non-representational meanings'. Representing Actions 'function as a means of representation' and are strongly coded representations. Indexical Action usually only co-occurs with speech and 'in order to retrieve its full meaning, one has to have access to the second-order context which is represented simultaneously in indexical action and concurrent speech' (Martinec, 2000: 244).

Lim (2011, 2019a) extends Martinec's descriptions of action as a taxonomy for the classification of gestures in relation to its communicative intent and its relationship with language (Figure 4.1). Presenting Action involves Performative Gestures – gestures that serve a practical function, such as picking up an object or scratching an itch, and are primarily non-communicative in nature. Representing Action and Indexical Action involve Communicative Gestures. While the intent of the Performative Gestures is not to communicate, they may, at times, be construed to convey meaning, thus serving also as Communicative Gestures. For instance, the action of scratching one's head is a Performative Gesture as a reflex to an itch. However, it can also be interpreted as a Communicative

Gesture to suggest uncertainty. As observed, the boundary between the classification of Communicative Gestures and Performative Gestures is, at times, nebulous. Nonetheless, the meanings are usually disambiguated when the gesture is interpreted in context, including in its co-text and inter-text. Hence, it is arguably useful not to disregard Performative Gestures, despite them being not primarily communicative in nature.

Communicative Gestures can be Speech Dependent, such as in Indexical Action; or either Speech Independent or Speech Correspondent, such as in Representing Action. Speech Dependent Gestures are gestures which co-occur with language and require the accompanying language to fully access and interpret their meanings. Speech Independent Gestures make meaning in the absence of speech, whereas Speech Correspondent Gestures co-occur with speech and its meanings are contextualised with what is said. The typology in Figure 4.1 can be described in relation to the classical categories of gestures, that are emblems, regulators, adaptors and affect display. Emblems, such as the thumb-up sign, are Communicative Gestures that are Speech Independent. Illustrators, such as numbering ideas expressed verbally with the fingers, are Communicative Gestures that are Speech Dependent. Regulators, such as moving the hand in beat with the speech rhythm, are Communicative Gestures that are Speech Dependent, and usually signal importance of what is being said. Adaptors and Affect Display, such as scratching and shivering, are Performative Gestures that have no wilful communicative intent.

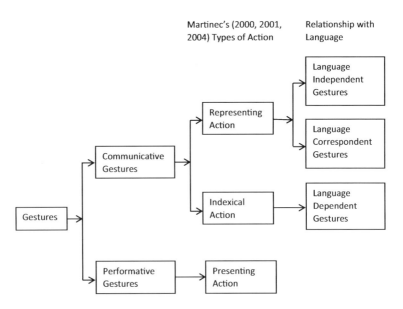

FIGURE 4.1 Classification of gestures
Reproduced from Lim (2019: 87).

A diachronic view on gesture

Chris Cleirigh, a scholar of Systemic Functional Theory, explored the development of gestures, as body language, over time. Cleirigh (2011) proposes the categories of Protolinguistic, Linguistic, and Epilinguistic to describe the types of semiotic modes from a diachronic perspective.

Cleirigh (2011) explains that Protolinguistic body language is a development from infant protolanguage and 'does not function as a means of representation'. This refers to the systems left behind in the transition to the mother tongue. It is similar to what Kendon (2004) and other scholars have described as Adaptors. Protolinguistic body language, such as fidgeting due to discomfort, includes Performative Gesture and is both non-communicative and speech-independent.

Linguistic body language includes gestures that occur only during speech. As such, these gestures are either Speech Correspondent or Speech Dependent. Hood (2011: 33) explains that '[t]hese movements synchronise with the rhythm and intonation of prosodic phonology in language and so express salience and tone, co-instantiating textual and interpersonal meanings'. Building on Cleirigh (2011) and Hood (2011), Martin and Zappavigna (2019) describe linguistic body language as paralanguage. Based on their research in children's early language development, Martin and Zappavigna (2019) propose a distinction between sonovergent resources and semovergent resources within paralanguage. Sonovergent resources co-occur in sync with or are in tune with the prosodic phonology of spoken language. Semovergent resources co-occur with speech primarily to support the ideational, interpersonal, and textual meaning resources of spoken language.

Cleirigh (2011) also proposes the category of Epilinguistic body language, which may or may not co-occur with speech, and is not systematically related to the lexicogrammar of language when it does. Hence, Epilinguistic body language expresses meanings rather than wordings. Epilinguistic body language 'functions as a means of representation and thus can be used to communicate about a context displaced from the here-and-now'. Epilinguistic body language includes Communicative Gestures that are either Speech Independent or Speech Correspondent. Cleirigh (2011) suggests that the development of Epilinguistic body language was due to the evolution from protolanguage to language in a child's early language development. Hood (2011: 34) elaborates that '[w]hen accompanying speech, Epilinguistic body language makes visible the semantics of speech. Without speech it constitutes mime. Epilinguistic body language can instantiate all three metafunctions: ideational, interpersonal and textual.' As such, when it co-occurs with speech, Epilinguistic body language constitutes the semovergent resources described by Martin and Zappavigna (2019).

Metafunctional meanings in gesture

Gestures, from the SFMDA approach, are classified according to the metafunctions they express. Gestures are described in terms of the (1) interpersonal meaning,

that is how they can contribute in the enactment of social relations; (2) ideational meaning, that is how they can represent ideas and knowledge about the world; and (3) textual meaning, that is how they can serve to organise the – often multimodal – discourse.

The meanings in gestures are described in metafunctional terms for both Performative Gestures and Communicative Gestures. While Performative Gestures, within Presenting Actions, are primarily non-communicative, they are nonetheless meaningful, and can be described metafunctionally. The metafunctional meanings in Communicative Gestures are categorised according to whether they are Representing Action or Indexical Action.

This chapter draws on Martinec's (2000, 2001, 2004) development of systems for ideational meanings in gestures. Martinec (2000: 243) defines Presenting Action as 'most often used for some practical purpose' and 'communicates non-representational meanings'. As such, Presenting Action expresses ideational meaning through processes analogous to language, and as such are analysed as Material, Behavioural, Mental, Verbal, and State processes. Representing Actions 'function as a means of representation' and are strongly coded representations. Representing Action expresses ideational meaning through representations of participants, processes, and circumstances as well as congruent entities and metaphorical concepts. Indexical Action expresses ideational meaning in relation to the meanings made by the accompanying language. Indexical Action also adds another layer of semantics, such as the representations of importance, receptivity or relations to it, thus realising interpersonal and textual meanings as well.

However, as the systems Martinec (2001) proposes for the interpersonal meanings in actions tend towards a discussion on proxemics, body postures, and facial expressions, Sue Hood's (2007, 2011) systems for interpersonal meanings, formulated specifically for gestures, are adopted instead. Sue Hood, Associate Professor at the University of Technology Sydney, builds on the foundational work in gesture from McNeill (1992, 1998, 2000) and Enfield (2009) in cognitive studies as well as Kendon (2004) in psychology and describes the meanings made in gestures in terms of the three metafunctions. For ideational meanings, Hood (2007) develops Martinec's (2000) description of Representing Action and identifies Congruent Entities and Metaphorical Concepts in gestures. In terms of interpersonal meanings, Hood (2011) identifies types of gestures which embody Attitude, Engagement, and Graduation. For textual meanings, Hood (2011) describes the identification, waves of interaction, salience, and cohesion in gestures. These descriptions are discussed more fully in the following sections in this chapter.

The forms of gesture

Adam Kendon defines a gesture as 'phases of bodily action that have those characteristics that permit them to be 'recognized' as components of willing communicative action' (Kendon, 1996: 8). He explains that a prototypical gesture passes through three phases – the preparation, the stroke, and retraction. The stroke phase

is the only obligatory element in a gesture. McNeill (1992: 375) describes the stroke phase as 'the phase carried out with the quality of "effort" a gesture in kinesics term'. He argues that '[s]emantically, it is the content-bearing part of the gesture' (McNeill, 1992: 376).

The definition of a gesture as being '"recognised" as components of willing communicative action' is not unproblematic. In particular, the subjectivity of recognition, be it by the audience, or the analyst, can be contested. Alan Cienki, Professor of English Linguistics, at Amsterdam University, however, defines a gesture from the perspective of the communicator. He describes gestures as 'any wilful bodily movement' (Cienki, 2008: 6). Notwithstanding, the question of the subjectivity involved in determining what is recognised as 'wilful' remains.

In this light, this chapter proposes an inclusive approach where all bodily movements made with the arms and hands are described as gestures, and coded as either Performative Gestures or Communicative Gestures. This is because at the preliminary stage of data annotation and transcription, it may be premature, and difficult, without the context to conclude certain movements as simply performative and non-communicative without imposing a certain degree of researcher's interpretive subjectivity.

From the SFMDA perspective, the principle of stratification can be applied to the analysis of gestures, where gestures possess both an expression stratum and a content stratum, and where the expression expresses the content. Gestures, as a semiotic mode, also expresses metafunctional meanings through the formal and functional systems described in the following sections. The expression stratum of gesture is the form of the gesture, that is the physical enactment of the movement with the arms and hands. The content stratum of the gestures has a 'grammatics' that can be represented through a system network of choices. The content stratum is also afforded and constrained by the musculoskeletal physiology of the human being. This determines what movements, and thereby what meanings can or cannot be realised. The content stratum expresses the metafunctional meanings as either sonovergent or semovergent resources.

Also from the SFMDA perspective, the principle of constituency can be applied to the study of gestures. Analogous to the ranks of word, group, phrase, and clause in language, gestures are organised according to the ranks of the finger, hand, arm, and upper body. The formal features of the gestures are described and the various selections, such as Direction, Level, and involvement of Arms, Hands, and Palms, can be annotated.

Other systems include those such as the dynamic aspects of frequency, speed, force, and muscular tension. Altogether, they operate to produce rhythm, gradation, and tempo. These dynamic aspects can be explored through proxy indicators such as the system of Beat in Indexical Action. This is discussed in the section on textual meaning in gestures.

The form of gestures used by the teacher in the classroom can be identified and analysed according to the coding categories in Figure 4.2. The form of gestures include the movement of the hand, the direction of the gesture, the palm direction,

Coding Categories for Gesture
Form • Directionality of Gesture • Description of Hand • Hands Level • Use of Hand • Contact with Object Function • Types of Action (Presenting, Representing, Indexical) • Processes in Presenting Action • Representing Entity • Indexical Representation • Attitude (Representing and Indexical Action) • Graduation (Representing and Indexical Action) • Engagement (Representing and Indexical Action) • Specificity (Representing and Indexical Action) • Beat (Representing and Indexical Action)

FIGURE 4.2 Coding categories for gesture

Reproduced from Lim (2019: 89).

the level of the gesture, the use of hand, and the object with which the hands are in direct contact. With the codes for the forms of gestures made, it is productive to co-relate them with the functions of these gestures, so as to identify usage patterns and trends of the teacher's use of gestures in specific lesson microgenres.

The functions of gestures to be coded include the Types of Action, the Representations in Indexical Actions, the Entities in Representing Actions, and the Processes in Presenting Actions, and are also represented in Figure 4.2. Interpersonal meanings coded in the aspects of Attitude, Engagement, and Graduation were annotated as well. Textual meanings coded in the aspects of Specificity, Directionality, and Beat were also annotated. This is discussed more fully in the next section.

The functions of gesture

Ideational meanings in performative gestures

The ideational meanings in gestures are expressed differently in different types of gestures. Following Martinec's (2000) proposal for ideational meanings in presenting action, the ideational meanings in performative gestures are expressed through the transitivity processes analogous to language. Representing Action, which involves communicative gestures that are speech independent, as well as communicative gestures that are speech correspondent, expresses ideational meanings through Congruent Entities and Metaphorical Concepts. Indexical Action, which involves Communicative Gestures that are speech dependent, expresses ideational meaning in relation to the accompanying speech. Specifically, it adds another layer of semantics such as the representations of importance, receptivity, or relation to it in the multimodal discourse.

According to Martinec (2000: 247), Presenting Action can be 'seen as part of our experience of reality, formed in our interaction with it by means of our perceptions and motor actions'. Of the transitivity processes identified for language, Martinec (2000) argues that only the Material process, Behavioural process, State process, and Verbal process are relevant for action. Given that verbal processes are realised both visually and auditorily through lip movement and speech sounds (Martinec, 2000: 248), they are not considered as part of gestures. As such, only the Material process, Behavioural process, State process, are identified for Performative Gestures. This is represented in Figure 4.3.

Material processes in performative gestures are identified through an obvious expansion of effort. In the classroom context, this includes the teacher's act of writing on the whiteboard, handing out forms to the students and re-arranging the tables and chairs. A high amount of material processes in performative gestures in the classroom suggests dynamism and action, although it can potentially be distracting for the learning, if too many performative gestures are used, as they are primarily non-communicative movements.

Behavioural processes in performative gestures are similar to material processes as they also involve an expenditure of energy. Martinec (2000) describes the acts of holding a weight and kicking a ball as Material processes and the acts of grooming such as combing, shaving, and washing as Behavioural processes, which are mainly actions directed to self. Other types of behavioural processes are related to affect. Examples of Behavioural process can include the gestures accompanying crying, laughing, moaning, and physiological processes like coughing, that might involve the use of gestures. In the classroom context, the teacher's use of her hand to cover her mouth as she laughs at the antics of the students could be coded as a performative gesture expressed through a behavioural process.

State processes describe processes that have no significant movement and have no obvious expenditure of energy. This can be used to describe the person's arms and hands at rest. The arms may be hanging by the sides if the person is standing or resting on the legs if the person is sitting. Martinec (2000) argues that the human experience of exerting and not exerting effort in action is ultimately the difference

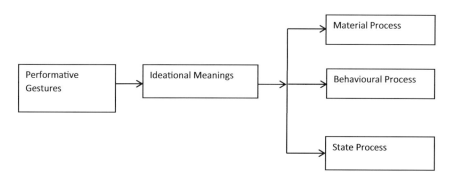

FIGURE 4.3 Ideational meanings in performative gestures

between material and state processes. State processes can arguably be categorised as not a gesture as there is no movement involved. However, it can be useful to analysts to identify and code them as such. State processes can be identified when there is a conspicuous absence of movement, and when the arms and hands are in a still and dormant position. A high amount of state processes identified in the teacher may suggest that the teacher is not using many gestures as a semiotic mode for meaning-making in the lesson.

Ideational meanings in Communicative Gestures (speech independent or speech correspondent)

Communicative Gestures that are Speech Independent or Speech Correspondent are part of the Representing Action described by Martinec (2000). They are usually gestures with a conventional signifying function and their meanings have been defined and used within specific cultures. For instance, the thumbs up sign to represent good, and the number one sign formed by raising the index finger. Cleirigh (2011) observes that some Communicative Gestures have evolved naturally from Performative Gestures. Instead of serving a practical function of performing a task, they now serve a signifying function to communicate an idea. For instance, the stop sign is formed by the hand outstretched with a front-facing open palm. This may have evolved from a Performative Gesture to forcibly restrain a person. As a Communicative Gesture used by the teacher in the classroom, it now embodies the abstract process of stopping, waiting, or slowing down. Martinec (2000: 251) argues that the semantics of Representing Action are realised through 'formal categories which are directly observable and have to do with the shape of the signs'. As such, the relationship between form and function in the gestures are conventionalised though not always arbitrary.

Communicative Gestures that are speech independent express ideational meanings that are not made verbally in language. As Hood (2011: 41) explains, '[a]t times, however, the representation of ideational meaning is made only in gestures, and is not expressed in the verbiage. In other words, the teachers' gestures carry the full ideational load.' In the classroom context, within the instructional discourse, the teacher could enumerate her points by making the 'two' sign with her index and middle finger without saying the word 'two'. The teacher could also use speech independent gestures to express the regulative discourse in the classroom. For instance, the teacher could place a finger over her lips to hush the class, or wave with her hand to beckon a specific student to come towards her.

Communicative Gestures that are speech correspondent may replicate semantically an entity expressed concurrently in language. Speech correspondent gestures are distinguished from speech dependent gestures in that the meanings are recoverable without the need of inference from language. For instance, when a teacher describes a circle, she can also trace the outline of a circle gesturally with her finger in the air. While the speech may help to disambiguate gestures that may be

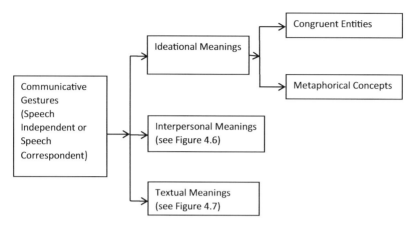

FIGURE 4.4 Ideational meanings in communicative gestures (speech independent or speech correspondent)

polysemous, it is arguable that the gesture of tracing an outline of a circle in the air can express the representation of a circle in itself.

The ideational meanings in communicative gestures can be described in terms of the functional semantic categorisation proposed by Hood (2007) as shown in Figure 4.4. They are Congruent Entities which represent concrete meanings and Metaphorical Concepts which represent abstract meanings. Congruent Entities describe objects such as books and houses. Metaphorical Concepts describe ideas such as success and happiness. Extending the research by Roth and Lawless (2002), Hood (2007: 6) explains that 'gestures function to visually represent abstract, metaphoric or semiotic concepts'. Hood (2007: 6) argues that '[o]ne very apparent function of teachers' gestures in language classrooms is deliberately to construct visual representations of entities and processes, to provide a visual representation of a lexical item.' For example Hood (2007: 6) cites Lazaraton (2004) who investigates the ways in which teachers act out lexical meaning of verbs such as 'sweep' and 'dig'.

Ideational meanings in Communicative Gestures (speech dependent)

Communicative Gestures that are speech dependent necessarily accompany the verbiage and require it for interpretation. The ideational meanings made in speech dependent gestures may not replicate the meanings made with language. Instead, an additional layer of meaning is added to the multimodal discourse, involving both speech and gestures. Based on the analysis of classroom data (Lim, 2019a), three major types of meanings can be identified in the teacher's use of speech dependent gestures. They are the representation of Importance expressed through rhythmic beat, the representation of Receptivity expressed through open palms, and the representation of Relation expressed through pointing. This is represented in Figure 4.5.

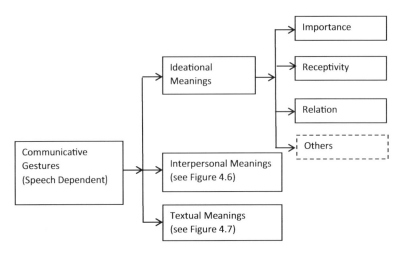

FIGURE 4.5 Ideational meanings in communicative gestures (speech dependent)

The representation of Importance is expressed through the repetitive and rhythmic swing or beat of the arm in tandem with speech. In themselves, the gestural beats do not have any ideational meaning. However when accompanied by speech, the gestural beats are used to signal an emphasis on parts of the speech that are important. Multimodally, the speech dependent gestures reinforce what is said by adding on the meaning of importance.

The representation of Receptivity is expressed by open palms along with the regular rhythmic movement of the arm. The speech dependent gestures expressing the representation of receptivity convey a sense of welcome and openness. It also expresses the interpersonal meaning of attitude through positive affect. In addition, it signifies an expansion of negotiation space in Engagement as described by Hood (2011). This is discussed further in the section on interpersonal meaning in gestures.

The representation of Relation is expressed through pointing as an Indexical Action. The act of pointing at an object or a person is a communicative gesture that can be speech independent, speech correspondent, or speech dependent. In the former two, pointing can communicate specific regulative discourse, such as identifying an individual for response, which could occur, with or without language. However, the act of pointing in the classroom can also be a speech dependent gesture where the accompanying verbiage is needed to disambiguate its meaning. Pointing as a Communicative Gesture also expresses an additional layer of ideational meaning, that is the representation of relation. Speech dependent gesture can, both physically and vectorally by extension, mediate between the enactor to the object and goal that it is referencing. This connectivity draws attention to the goal which the enactor points to. In a classroom, the goals are usually the students, the whiteboard or the projection screen. Pointing is also discussed further in the section on textual meaning in gestures.

In addition to the three types of ideational meanings made, Speech Dependent Gestures may also express other meanings. For example the act of scratching one's head can be a Performative Gesture of easing an itch, but can also be a Communicative Gesture to express uncertainty. When the accompanying speech disambiguates the meanings of the act of scratching, with words such as 'I am not sure', the movement can be identified as a Speech Dependent Gesture expressing uncertainty.

Similarly, the act of folding one's arms across the chest could be construed as a Performative Gesture, to warm oneself up against the cold. However, when accompanied by speech, with words such as, 'I have a different view', the act can be construed as a Speech Dependent Gesture expressing defensiveness or signalling disagreement. In the classroom, this tends to be observed when the teacher expresses the Discourse of Rapport-Building, where she may share a personal anecdote about her life. Moderating the vulnerability and openness through the verbal sharing, the teacher may adopt the gesture of folded arms across the chest as a part of a defensive instinct.

Likewise, the gesture of hands on waist could be a State Process when the gesture is non-communicative in intent and functions as a Performative Gesture. However, when this gesture is accompanied by speech, such as when a teacher issues instructions during the lesson, the gesture can be construed as a Speech Dependent Gesture expressing an additional ideational meaning, that is an assertion of authority, in the multimodal discourse. As such, examining the context in which the gesture is used, particularly in relation to speech, can help to distinguish gestures that have communicative meanings from gestures that only serve a practical function.

Interpersonal meanings in gestures

Performative Gestures are not coded for interpersonal and textual meanings as they do not serve primarily a signifying function. Also, unlike for ideational meanings, the relationship between gestures and speech is not a determining factor in the expression of interpersonal meanings. As such, all Communicative Gestures, regardless of whether they are Speech Independent, Speech Correspondent, or Speech Dependent, are described collectively in terms of the ways by which they express the interpersonal meanings.

The interpersonal meanings made with Communicative Gestures are described with reference to the Appraisal Theory developed by Jim Martin and Peter White. The Appraisal Theory was developed to more comprehensively describe the interpersonal meanings made in language (Martin, 1995, 2000; Martin & White, 2005). The productivity of Appraisal Theory is demonstrated in its application to a range of other semiotic modes apart from language. This includes Macken-Horarik (2004) on images, Stenglin (2008) on Three-Dimensional Space, and Hood (2011) on gestures. In particular, Hood (2011) proposes that the three aspects of interpersonal meanings in appraisal: Attitude, Graduation, and Engagement, are embodied in gestures as well. Hood (2011) argues that gestures can express feelings and values

in Attitude, they grade meaning along various dimensions in Graduation, and they expand or contract space for others during interaction in Engagement.

Notwithstanding, it is recognised that the interpersonal meaning of Attitude is more usually expressed with facial expressions rather than with gestures. Ekman and Friesen (1978), Ekman and Rosenberg (2005), Hood (2011), and others, have observed that facial expression is the primary means by which Attitude, in particular, the sub-categorisation of Affect, is expressed. For gestures, the extent of affect expressed may be less nuanced than that of facial expressions. In this light, a simple polemic set of values that broadly classifies the attitudes in gestures as Positive and Negative are proposed. The distinction in polarity lies in the assumption that gestures generally express positive attitude. As such, negative attitude is encoded when a contrary point is made, when negation is expressed or where adversarial meanings are represented. For example negative attitude can be expressed in the gesture of the hand thrusted forward with the palms shaking to signify 'No'.

The interpersonal meaning of Graduation in gestures in 'grading an objective meaning… [can offer] a subjective slant to the meaning, signalling for the meaning to be interpreted evaluatively' (Hood, 2011: 43). This can be extended to the meanings of intensity, size, quantity, scope (Graduation as Force) or of specificity or completion (Graduation as Focus). Martinec (2001) discusses the other aspects where the interpersonal meanings of graduation are expressed, namely size, specificity, speed, and muscle tension. In particular, Speed, as a broader category, can also be taken as a proxy reference, to some extent, for intensity and muscle tension. An elementary three-point scale indicating Fast, Medium, and Slow can be used as an approximate measure for the gesture. Gestures with slow graduation connote emphasis and deliberateness. Gestures with fast graduation convey urgency, energy, and dynamism.

The interpersonal meaning of Engagement is expressed through the positioning of the hands to expand and contract negotiation space for the other voices in the discourse. Following the categorisation proposed by Hood (2011: 46), an open palm or palms up position 'embodies an elicitation move on the part of the teacher, enacting an expansion of heteroglossic space, inviting student voices into the discourse'. This is frequently observed during class discussion when the teacher asks questions and invites responses from the students. The palms-down position contracts the space for negotiation. It deters contribution and involvement from the other party. It usually serves to assert the authority of the teacher and is often used when the teacher gives instructions. Beyond the expansion and contraction of interactional space, the modality of possibility can also be expressed through an oscillating gesture, where the hand rotates or traces a circular movement. Oscillating gestures represent possibility and usually co-occur with the linguistic expression of modality. The interpersonal meanings of engagement made through gestures serve to coordinate and regulate the ebb and flow of the discussion. The nature of interpersonal meanings in gestures is shown in Figure 4.6.

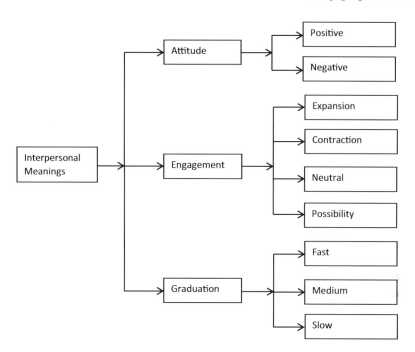

FIGURE 4.6 Interpersonal meanings in gestures
Reproduced from Lim (2019: 105).

Textual meanings in gestures

The textual meanings in gestures are only coded for Communicative Gestures and not for Performative Gestures as the latter do not have a signifying function. The textual meanings in gestures serve as an organisational resource for the ideational and interpersonal meanings made. All three metafunctional meanings are expressed simultaneously in Communicative Gestures. The textual meanings in Communicative Gestures are described in terms of the Wavelength (Martinec, 2004), and in the cases of pointing – Directionality and Specificity (Hood, 2011). The nature of textual meanings in gestures is shown in Figure 4.7.

The textual meaning of Wavelength follows from Martinec's (2004) argument that gestures embody the rhythmic flow of information according to different wavelengths. Each wavelength presents a peak where prominence is given to the meaning made. Martinec (2004) also proposes a hierarchy of wavelengths where the shorter wavelengths correspond to peaks in a longer wavelength. The dimension of rhythm can be coded through approximating the rhythmic beat or repetitive motion of a particular gesture. This is especially so with Speech Dependent Gestures, where beats are used to express the representation of Importance in the ideational meanings made by language.

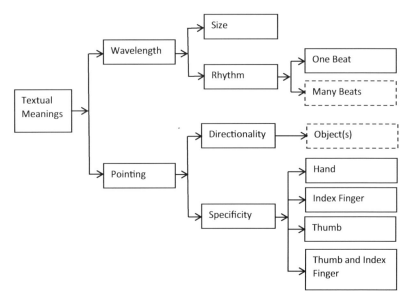

FIGURE 4.7 Textual meanings in gestures
Reproduced from Lim (2019: 105).

The textual meaning of Directionality can be expressed through Communicative Gestures of pointing. Within the classroom context, the gesture of pointing is usually towards the interfaces which are displaying information. This includes the laptop's projection on the screen, the whiteboard, and through the visualiser, where the notes and gestures are projected on the screen. Such directional goals can signify a physical mediation between the enactor, in this case, the teacher and the information presented. This demands and draws attention to the representations on the interface which can consist of written language, images, figures, and symbols as well.

The textual meaning of Specificity can also be expressed through Communicative Gestures of pointing. Hood (2011: 38) argues that variation in bodily resources can be interpreted 'as varying along a cline of specificity'. As such, the 'smallest body part that enables the highest degree of specificity is the little finger'. Specificity can be expressed in terms of pointing with the index finger, with the entire hand, a fist or with specific fingers. The teacher may also point towards the students, sometimes collectively as a class and sometimes as individuals. In addition to having high specificity through the act of pointing with the index finger, the gesture also functions ideationally as an imperative and interpersonally to demand engagement. The intensity of these meanings is reduced when an entire hand, of lower specificity, is used to point instead.

Towards a description of pedagogic gestures

Embodied teaching is about the orchestration of the range of semiotic modes that the teacher can use to design the learning experience for the students. The

teacher's use of gestures is one powerful way in which both instructional and regulative discourses in the classroom can be expressed. Teaching is a performance that involves the embodiment of meanings across corporeal resources. In the performance of teaching, it can be instructive for the teacher to reflect on her use of gestures to make meaning and to use gestures with aptness and fluency to express specific meanings in her lessons. The challenges are to develop ways of knowing how gestures make meaning and to develop ways of thinking about what constitutes an apt use of gestures in designing specific learning experiences for our students.

This challenge is addressed in this chapter, where an extensive description of how gestures can make different types of meanings in the pedagogic settings is offered. This understanding can bring about a semiotic awareness in teachers as they develop an aptness and fluency in the use of gestures, language, as well as of positioning and movement in the classroom in a multimodal orchestration.

Adopting a social semiotic lens on teaching and learning, and drawing from existing research done from the SFMDA approach to gestures, the aim of this chapter is to provide teacher practitioners with a deeper understanding of how gestures make meaning. Pedagogic gestures can be categorised as Performative Gestures and Communicative Gestures. The relationships that pedagogic gestures have with speech may afford or constrain the nature of the meanings made. The meaning potential in different types of gestures is described in terms of the choices within system networks and organised systematically according to the metafunctions. The hope is that the teacher practitioner will develop a greater semiotic awareness of the ways in which gestures make meaning, reflect on their current practices in their classrooms, and design for a more apt and fluent use of gestures for teaching and learning.

The description of pedagogic gestures in this chapter also hopes to offer analytical categories for the educational researcher in the identification, annotation, and analysis of multimodal classroom data. The meanings made in the classroom and the discourses in the classroom are expressed across a range of embodied semiotic modes, along with language. In the study of multimodal meaning-making, it is useful to adopt theoretical apparatus that applies the same principles across the description of all the modes for ease of comparison and integration. Systemic Functional Theory has been, by far, most extensively developed and has proven, over the years, to be productive in the study of language. As such, there is value in extending the principles and knowledge from the Systemic Functional Theory to the study of the other semiotic modes. This is not to impose a linguistic model on other semiotic modes. Rather, there is always recognition and a sensitivity to the understanding that while the same metafunctional meanings are made, they are realised differently, given the affordances of each unique semiotic mode. In this chapter, the ways in which gestures express different meanings are described according to the metafunctional meaning systems. These analytical categories, while rudimentary, are offered to educational researchers to explore, apply, and improve as we work towards developing better ways of describing and making sense of multimodal pedagogic discourse.

REFLECTION QUESTIONS

1. What are the different ways that teachers can use gestures to express specific meanings in the classroom?
2. How can teachers use gestures more aptly to help students learn better?

References

Abels, S. (2016). The role of gestures in a teacher-student-discourse about atoms. *Chemistry Education Research and Practice* 17(3), 618–628.

Bateson, G. (1973). *Steps to an Ecology of Mind: Collected Essays in Anthropology, Psychiatry, Evolution and Epistemology*. London: Paladin, Granada.

Birdwhistell, R.L. (1952). *Introduction to Kinesics: An Annotation System for Analysis of Body Motion and Gesture*. Washington, DC: Department of State: Foreign Service Institute.

Birdwhistell, R.L. (1970). *Kinesics and Context: Essays on Body Motion Communication*. Philadelphia: University of Pennsylvania Press.

Broth, M. & Mondada, L. (2013). Walking away: The embodied achievement of activity closings in mobile interaction. *Journal of Pragmatics* 47(1), 41–58.

Carlson, C., Jacobs, S.A., Perry, M., & Church, R.B. (2014). The effect of gestured instruction on the learning of physical causality problems. *Gesture* 14(1), 26–45.

Christie, F. (2002). *Classroom Discourse Analysis: A Functional Perspective*. London & New York: Continuum.

Cienki, A.J. (2008). Why study gesture?. In Alan Cienki and Vincent C. Muller (eds), *Metaphor and Gesture* (5–25). Amsterdam: John Benjamins.

Cleirigh, C. (2011). Tokens of the Sensor's Sensing: Pictures, Protolanguage, Phylogenesis and Pedagogy. Paper presented at the Friday Afternoon Seminars at the University of Sydney. Retrieved from www.interstrataltension.org/wp-content/uploads/2011/02/TokensOfTheSensersSensing.ppt and www.lingo.info/interstrataltension/ChrisxPeter2/2011-03-04@1600.mov.

Cook, S.W. (2018). Enhancing learning with hand gestures: Potential mechanisms. *Psychology of Learning and Motivation* 69, 107–133.

Cook, S.W., Duffy, R.G., & Fenn, K.M. (2013). Consolidation and transfer of learning after observing hand gesture. *Child Development* 84(6), 1863–1871.

Dreyfus, S. (2011). Grappling with a non-speech language: Describing and theorizing the nonverbal multimodal communication of a child with an intellectual disability. In S. Dreyfus, S. Hood, and M. Stenglin (eds), *Semiotic Margins: Meaning in Multimodalites* (53–69). London: Continuum.

Ekman, P. & Friesen, W.V. (1969). The repertoire or nonverbal behaviour: Categories, origins, usage, and coding. *Semiotica* 1, 49–98.

Ekman, P. & Friesen, W.V. (1974). Nonverbal behaviour and psychopathology. In R. J. Friedman & M.N. Katz (eds), *The Psychology of Depression: Contemporary Theory and Research* (203–232). Washington, D.C.: J. Winston.

Ekman, P. & Friesen, W.V. (1978). *Facial Action Coding System: A Technique for the Measurement of Facial Movement*. Palo Alto, California: Consulting Psychologists Press.

Ekman, P. & Rosenberg, E.L. (eds) (2005). *What the Face Reveals: Basic and Applied Studies of Spontaneous Expression using the Facial Action Coding System (FACS)*. New York: Oxford University Press.

Enfield, N.J. (2009). *The Anatomy of Meaning: Speech, Gesture, and Composite Utterances.* Cambridge: Cambridge University Press.

Galloway, C. (1976). *Silent Language in the Classroom.* Bloomington, IN: Phi Delta Kappa Educational Foundation.

Goldin-Meadow, S. & Singer, M.A. (2003). From children's hands to adults' ears: Gesture's role in teaching and learning. *Developmental Psychology* 39(3), 509–520.

Goodwin, C. (1979). The interactive construction of a sentence in natural conversation. In G. Psathas (ed.), *Everyday Language: Studies in Ethnomethodology* (97–121). New York: Irvington Publishers.

Haviland, J.B. (2004). Gesture. In Alessandro Duranti (eds), *A Companion to Linguistic Anthropology* (197–221). Malden, MA: Blackwell.

Hood, S.E. (2007). Gesture and Meaning Making in Face-to-Face Teaching. Paper presented at the Semiotic Margins Conference, University of Sydney.

Hood, S.E. (2011). Body language in face-to-face teaching: A focus on textual and interpersonal meaning. In E.A. Thompson, M. Stenglin, & S. Dreyfus (eds), *Semiotic Margins: Meaning in Multimodalities* (31–52). London: Continuum.

Inceoglu, S. (2015). Teacher gesture and lexical focus on form in a foreign language classroom. *Canadian Modern Language Review* 71(2), 130–154.

Kendon, A. (1996). Reflections on the study of gesture. *Visual Anthropology* 8, 121–131.

Kendon, A. (2004). *Gesture: Visible Action as Utterance.* Cambridge: Cambridge University Press.

Klooster, N.B., Cook, S.W., Uc, E.Y., & Duff, M.C. (2015). Gestures make memories, but what kind? Patients with impaired procedural memory display disruptions in gesture production and comprehension. *Frontiers in Human Neuroscience* 8, 1054.

Kounin, J.S., Gump, P.V., & Ryan, J.J. (1961). Explorations in classroom management. *Journal of Teacher Education* 12, 235–246.

Lazaraton. A. (2004). Gesture and speech in the vocabulary explanations of one ESL teacher: A microanalytic inquiry. *Language Learning* 54, 97–112.

Lemke, J.L. (1984). Semiotics and Education. Monograph in Toronto Semiotic Circle Monographs Series. Victoria University, Toronto.

Lim, F.V. (2011). A Systemic Functional Multimodal Discourse Analysis Approach to Pedagogic Discourse. Doctoral thesis. National University of Singapore.

Lim, F.V. (2019a). Analysing the teachers' use of gestures in the classroom: A Systemic Functional Multimodal Discourse Analysis approach. *Social Semiotics* 29(1), 83–111.

Lim, F.V. (2019b). Investigating intersemiosis: A systemic functional multimodal discourse analysis of the relationship between language and gesture in classroom discourse. *Visual Communication* 0(0), 1–25.

Macken-Horarik, M. (2004). Interacting with the multimodal text: Reflections on image and verbiage in ArtExpress. *Visual Communication* 3(1), 5–26.

Martin, J.R. (1995). Interpersonal meaning, persuasion, and public discourse: Packing semiotic punch. *Australian Journal of Linguistics* 15, 3–67.

Martin, J.R. (2000). Beyond exchange: APPRAISAL systems in English. In S. Hunston & G. Thompson (eds), *Evaluation in Text* (142–175). Oxford: Oxford University Press.

Martin, J.R. & White, P.R.R. (2005). *The Language of Evaluation, Appraisal in English.* London & New York: Palgrave Macmillan.

Martin, J.R. & Zappavigna, M. (2019). Embodied meaning: A systemic functional perspective on paralanguage. *Functional Linguistics* 6(1). Retrieved from https://functionallinguistics. springeropen.com/articles/10.1186/s40554-018-0065-9 (accessed: 24 Aug. 2019).

Martinec, R. (2000). Construction of identity in Michael Jackson's 'Jam'. *Social Semiotics* 10(3), 313–329.

Martinec, R. (2001). Interpersonal resources in action. *Semiotica* 135, 117–145.

Martinec, R. (2004). Gestures that co-occur with speech as a systematic resource: The real-ization of experiential meaning in indexes. *Social Semiotics* 14(2), 193–213.

Matsumoto, Y. & Dobs, A.M. (2017). Pedagogical gestures as interactional resources for teaching and learning tense and aspect in the ESL grammar classroom. *Language Learning* 67(1), 7–42.

McCafferty, S.G. & Rosborough, A. (2014). Gesture as a private form of communication during lessons in an ESL-designated elementary classroom: A sociocultural perspective. *TESOL Journal*, 5, 225–246.

McNeill, D. (1992). *Hand and Mind: What Gestures Reveal About Thought.* Chicago: University of Chicago Press.

McNeill, D. (1998). Speech and gesture integration. In J.M. Iverson & S. Goldin-Meadow (eds), *The Nature and Functions of Gesture in Children's Communication. New Directions for Child Development*, 79 (pp. 11–27). San Francisco: Jossey-Bass Inc., Publishers.

McNeill, D. (Ed.). (2000). *Language and Gesture: Window into Thought and Action.* Cambridge: Cambridge University Press.

McNeill, D. (2005). *Gesture and Thought.* Chicago: University of Chicago Press.

Mondada, L. (2011). Understanding as an embodied, situated and sequential achievement in interaction. *Journal of Pragmatics* 43, 542–553.

Mondada, L. (2016). Challenges of multimodality: Language and the body in social inter-action. *Journal of Sociolinguistics* 20(3), 336–366.

Neill, S. (1991). *Classroom Nonverbal Communication.* London & New York: Routledge.

Neill, S. & Caswell, C. (1993). *Body Language for Competent Teachers.* London & New York: Routledge.

Nevile, M. (2015). The embodied turn in research on language and social interaction. *Research on Language and Social Interaction* 48, 121–151.

Norris, S. (2016). Concepts in Multimodal Discourse Analysis with Examples from Video Conferencing. Yearbook of the Poznań Linguistic Meeting 2 (pp. 141–165). doi:10.1515/yplm-2016-0007

Novack, M.A. & Goldin-Meadow, S. (2017). Gesture as representational action: A paper about function. *Psychonomic Bulletin & Review* 24(3), 652–665.

Ochs, E., Schegloff, E.A., & Thompson, S.A. (1996). *Grammar and Interaction.* Cambridge: Cambridge University Press.

Roth, W.-M. (2001). Gestures: Their role in teaching and learning. *Review of Educational Research* 71(3), 365–392.

Roth, W-M. & Lawless, D. (2002). Science, culture and the emergence of language. *Science Education* 86(3), 368–385.

Schegloff, E.A. (1984). On some gestures' relation to talk. In A. Maxwell & J. Heritage (eds), *Structures of Social Action* (pp. 266–296). Cambridge: Cambridge University Press.

Scherer, K. & Ekman, P. (eds) (1982). *Handbook of Methods in Nonverbal Behavior Research.* New York: Cambridge University Press.

Sime, D. (2006). What do learners make of teachers' gestures in the language classroom? *International Review of Applied Linguistics in Language Teaching*, 44(2), 211–230.

Simones, L., Schroeder, F., & Rodger, M. (2015). Categorizations of physical gesture in piano teaching: A preliminary enquiry. *Psychology of Music* 43(1), 103–121.

Streeck, J., Goodwin, C., & LeBaron, C.D. (2011). *Embodied Interaction: Language and Body in the Material World: Learning in Doing Social, Cognitive and Computational Perspectives.* New York: Cambridge University Press.

Stenglin, M. (2008). Binding: A resource for exploring interpersonal meaning in three-dimensional space. *Social Semiotics* 18(4), 425–447.

Taylor, R. (2014). Meaning between, in, and around words, gestures and postures: multi-modal meaning making in children's classroom communication. *Language & Education* 28(5), 401–420.

5

SEMIOTIC TECHNOLOGIES

Semiotic technologies for learning

What ways of pedagogic meaning-making are missed when the whiteboard is gradually replaced by PowerPoint presentations in classroom teaching and learning? What is the value in the use of digital semiotic technologies, and what is now made possible when the affordances of new digital semiotic technologies, like learning analytics, learning platforms, and educational apps, are made available in a personal computing environment?

Embodied teaching involves a heightened consciousness towards the range of semiotic resources that the teacher can use in designing the lesson. This includes the use of embodied semiotic modes, such as the teacher's positioning and movement in the classroom spaces, the teacher's use of gestures in expressing specific discourses in the classroom, which have been discussed in the previous chapters in this book. It also includes the meaningful use of semiotic technologies that the teacher can harness in designing their students' learning experiences.

Semiotic technologies involve tools, and social practices, that is, what they are and how they are used. Examples of semiotic technologies include the use of computer software and applications, ranging from the ubiquitous PowerPoint to learning management platforms, and digital textbooks to the use of nascent technologies, such as augmented and virtual reality wares for learning. The notion of semiotic technology was developed by Theo van Leeuwen, Emilia Djonov, and Kay O'Halloran, within social semiotics, as they explored the design and use of Microsoft PowerPoint in higher education and corporate settings in a research project (2009–2011). The project has led to subsequent publications on how PowerPoint as semiotic technology can express texture (Djonov & van Leeuwen, 2011), layout (Djonov & van Leeuwen, 2013), as well as creativity and artistry within the limited set of resources (van Leeuwen, Djonov, & O'Halloran, 2013).

More recently, Djonov and van Leeuwen (in press) propose a social semiotic model for studying semiotic technologies, that is technology for making meaning, which includes consideration of the design, use, and sociocultural context in which the semiotic practice is situated within.

Semiotic technologies, however, need not be digital in nature. They can also include familiar tools such as the pencil, which are used for meaning-making in the classroom (Djonov & van Leeuwen, 2012). Semiotic technologies for learning that are traditional include resources such as the good old blackboard, now incarnated in the form of the ubiquitous whiteboard, as well as printed textbooks and workbooks. These semiotic technologies are used to facilitate both the teachers and students' meaning-making, in particular, their representation of knowledge and an expression of the pedagogic relations. With the trend towards the use of the screen in the classroom for the projector and interactive whiteboards, which are essentially big screens serving as computer interfaces, the presence and use of the whiteboard in the classroom are observed to be gradually diminishing. Adopting the social semiotic lens of what is gained and lost (Kress, 2005) in relation to the whiteboard in the classroom, this chapter discusses how the whiteboard, as a semiotic technology, can enable the teacher to make specific meanings during the lesson, which arguably is lost without its use.

Central to the notion of semiotic technology is the recognition that these technologies are not just channels for meaning-making, but in themselves are artefacts of semiosis and an enactment of social practice (Poulsen, Kvale, & van Leeuwen, 2018). In the case of the classroom, the semiotic technologies are a means of communicating ideas and experiences, an expression of the pedagogic relationships between the teacher and students as well as a contribution to the organisation of the learning experience. As such, the social semiotic approach to the semiotic technologies available to the teacher in the classroom invites an engagement with the ideational, interpersonal, and textual meanings expressed through the use of these resources as part of designing the students' learning experiences.

Another key idea within semiotic technologies is the concept of affordances, in terms of its value and opportunity cost. The notion of affordances in semiotic technologies is appropriated from the original conception of affordances by American psychologist James Gibson in his book *The Senses Considered as Perceptual System* (1966) where he describes affordances in terms of 'what is offered' by the environment to the animal. An affordance, to Gibson, is not premised on whether it is recognised or exploited by the user, but it is present as part of what the resource offers. Donald Norman, cognitive scientist at the University of California, extends, and popularises, Gibson's term to explore human-machine interaction, in his seminal work *The Design of Everyday Things* (1988), where affordances are described as 'action possibilities', that is what can you do, and not do, with a (digital) tool. Within social semiotics, Gunther Kress (2003, 2010) applies the concept of the affordances of semiotic modes, such as what writing and images can and cannot do. Kress explains, 'So different modes allow you to do different things, and not only allow you to do different things, but insist that different things are done' (2015: 88).

This chapter is about the semiotic technologies that teachers can use in the classroom to design students' learning experiences. In every classroom, there are semiotic technologies that are available. This includes the teacher's computer, the whiteboard, and the screen for the projector. While there are default set-ups in the classrooms, it is hoped that a greater sensitivity to the meaning-making potential of these semiotic technologies can encourage teachers to think about, reflect on their meaningful use, and initiate changes from the default set-up, when helpful. This chapter aims to develop a deeper awareness amongst teachers on how the affordances in the environment within the classroom can be exploited to design learning environments most apt for different types of learning.

Popular digital semiotic technologies

'Death by PowerPoint' is a term from the title of the book by public speaker David Greenberg (2000), who was one of the earliest to use the phrase. The metaphor is immediately relatable to everyone who has to endure a boring slideshow presentation and the phrase has captured the imagination of many. When it comes to the use of digital technology in the classroom, Microsoft PowerPoint seems to be the popular semiotic technology that comes immediately to mind.

Emilia Djonov and Theo van Leeuwen, in their research on PowerPoint presentations, uncovered that the bullet points used prevalently in PowerPoint presentations were invented by a manager at Exxon Mobil (Djonov & van Leeuwen, 2014). They were first called 'Korky Dots' after his namesake, A.F. (Korky) Kaulakis. Korky recommended his colleagues to use bullet points to highlight key ideas in company presentations, and pitch sales messages more effectively. This was in 1958 in the context of business meetings in America. More than half a century later, the use of bullet points is now an integral feature in PowerPoint, used prevalently across situations and cultures.

Does it matter that PowerPoint was not designed for teaching and learning, but for selling in mind? Does the appropriation of a way of communicating in bullet points on PowerPoint presentations for selling yesterday to teaching and learning today work? How does this appropriation change the nature of pedagogic communication in the classroom? On a broader scale, this alludes to the marketisation of pedagogic discourse, as the ways of teaching and learning in the classroom become increasingly conformed to the nature in the discourse of economic transactions as similar semiotic technologies are used in both settings. A question for educators to ponder is what is ultimately gained and lost through the dominant use of PowerPoint as a semiotic technology in the classroom.

This is not to say that resources that are not designed for learning in the first place cannot be appropriated for pedagogical purposes. It is both impractical and perhaps also rather unimaginative to expect all semiotic technologies used in the classroom to be designed for teaching and learning, and if the argument is extended, to be customised for the particular students' profile, ability level, and disciplinary subject. Building a customised tool from scratch will likely ensure that it serves the

function it is built for, but such a decision usually involves trade-offs, in terms of cost, time, and sometimes quality.

From a social semiotic perspective, semiotic technologies, whether they have been designed for learning in mind or have affordances that can be exploited for learning, can all be used by skilful teachers as part of their repertoire of resources to design for meaningful learning experiences. It is ultimately about fitness for purpose. Nevertheless, regardless of whether the semiotic technologies have been designed for learning or whether they have been subsequently appropriated for learning, it is critical to reflect on their fit and value in communicating knowledge, enabling and enacting specific pedagogic relations between the teacher and students, as well as their contribution in organising the learning experience. Fundamentally, it is also critical to evaluate the value and cost for teaching and learning intrinsic to the semiotic technologies.

In this chapter, the reference to PowerPoint presentation is used to imply both the PowerPoint software and the PowerPoint presentation following the work of Zhao, Djonov, and van Leeuwen (2014), and Zhao and van Leeuwen (2014). In particular, the semiotic artefacts of PowerPoint software and PowerPoint presentation are 'to regulate semiotic practices' (Djonov & van Leeuwen, in press) in the dimensions of software design, software composition, and presentation. The latter two are the focus of the discussion in this section on PowerPoint as digital semiotic technology for learning.

The use of PowerPoint presentation, and by extension all semiotic technologies that predominantly represent and communicate knowledge through the teacher's computer onto the projected big screen in the classroom, is that it takes up space. Simply put, the use of the screen can limit the space and scope for the use of other knowledge representations and in other ways. Materially, the screen in the classroom usually often occupies the centre front area of the entire room. When pulled down for use, it obscures much of the whiteboard space, and leaves little, and often no space to be used for the whiteboard. While the screen can be pulled up when it is not in use, the time and effort it takes for the teacher to set up the PowerPoint presentation to be used for the lesson usually deter any further meddling with the set-up, just in order to use the whiteboard. As such, it is not unusual to have teachers delivering the entire lesson using the screen as a main medium of communicating knowledge, and with that, a corresponding limited use of the whiteboard in the classroom. The central question remains: what is the value and opportunity cost in the use of a specific semiotic technology? The cost in the use of the whiteboard as a semiotic technology for teaching and learning will be discussed in the next section.

Value of PowerPoint

What then is gained by the teacher's use of PowerPoint presentation in the classroom? Undoubtedly, the fact that the PowerPoint slideshow is popular amongst teachers suggests that teachers must have found it useful and therefore there is a

high adoption in its use across subjects and school levels. The use of presentation slides has a number of affordances. In addition to the teacher's talk, the slideshow allows for the visualisation of knowledge multimodally, through language, images, animation, and sound. This can facilitate the students' learning of the ideational content and comprehension of specific concepts. As such, the affordance of the semiotic technology of PowerPoint presentation is that it supports the collective and multimodal visualisation of knowledge.

The use of PowerPoint presentation also allows for a clear structuring and sequencing of the subject knowledge to be communicated. It serves to organise and order the stages of the lesson, such as signalling the time in the lesson for group work, class discussion, and check-out activities. Multimedia, such as video clips, can be embedded and played seamlessly, through the PowerPoint presentation. These contribute to the organisation in the logogenesis, or logical unfolding of the lesson, and support the teachers by serving as an aide memoire such that all points prepared during the lesson planning are delivered to the students. In this light, the affordance of the semiotic technology of PowerPoint presentation is that it provides for a logical sequencing of knowledge and explicit ordering of lesson stages.

Related to this affordance of the PowerPoint semiotic technology is that it ensures a certain baseline and a consistency in the content, at least on the slides, delivered by different teachers using the same deck of slides. From an administrator's perspective, this affordance presents a systemic value in evening out the disparities in teaching, to some extent. The learning experience of the students will no doubt ultimately differ based on how the teachers use the other semiotic modes to express their pedagogy. However, there may be assurance to the administrators, and perhaps parents, that the same teaching resources with a generally consistent set of content are used across teachers teaching the same level of students. In other words, the affordance of the semiotic technology of PowerPoint presentation is that it allows the ease of replicability of teaching resources and potential dissemination of quality teaching content.

Cost in PowerPoint

What then is the opportunity cost in the semiotic technology of PowerPoint presentation? In a word, what is lost is flexibility. The teacher may be less responsive to the developments in the lesson such as answering questions from students to clarify specific ideas. In responding to students' questions, the teacher would tend to reply using only speech, especially if the screen obstructs the easy access to and use of the whiteboard. Discussion of students' questions that may divert to different learning pathways and knowledge trajectories are also not as easily accommodated when the teacher is constrained by the fixed content and pre-set learning sequence in the PowerPoint presentation. As such, the use of the PowerPoint presentation as a semiotic technology necessarily involves a certain

surrender of teacher's agency in the classroom, inhibiting the teacher's spontaneous responses to the students' questions, in-class discussion and unplanned lesson developments.

The use of PowerPoint presentation also tends to privilege a particular way of teaching and learning, where there is a focus on the accuracy and comprehensiveness in the transmission of canonical knowledge and ideas, represented through the fairly immutable content of the slides during the lesson. With the use of PowerPoint semiotic technology, the teacher tends to rely on the presentation slides in the lesson and often ends up presenting knowledge to students, almost to the extent of 'selling the content' rather than facilitating a more inquiry-based approach to learning. This has implications on the nature of teaching and learning realised in the lesson. In particular, the pedagogic relations enacted between the teacher and students through the use of the semiotic technology in PowerPoint presentations is one that is authoritative, teacher-centred, and socially distant.

Making meaning with PowerPoint

Through the expression of the ideational and interpersonal meanings, the use of the semiotic technology of PowerPoint presentation serves the textual metafunction in contributing to the organisation of the learning experiences designed by the teacher. The learning experience of the students is limited to the teacher's didactic presentation of content knowledge, through multimodal representations mediated by the PowerPoint presentation on the screen. Unless this is complemented with other lesson activities that facilitate a more inquiry-based approach to learning, the pedagogy, expressed by the teacher, tends to default to a rather transmissionist model of learning.

While the discussion on the evaluation of semiotic technologies in this section is illustrated with the example of the PowerPoint presentation given that it is one of the most popular semiotic technologies for learning, many of the implications are relevant for big screen-mediated semiotic technologies. For instance, when the teacher uses educational videos or learning platforms, and projects these platforms on the big screens in the classroom, similar opportunity costs occur. The affordances of the specific semiotic technologies can often enhance current instructional practices, by making them more efficient. For instance, there are digital platforms, such as Google docs and YouTube, that can enhance students' social learning through their features for collaborative annotations with linguistic texts and video clips. Affordances of other semiotic technologies may also enable new forms of instructional practices, such as immersive learning through the use of virtual reality software and headsets, or in the use of educational games to gamify the learning experience through rewards and badges to make it more motivating and engaging for students. Notwithstanding, even as these digital semiotic technologies are harnessed to expand the repertoire of the teacher's resources, it is useful to be mindful of the opportunity cost that each semiotic technology inevitably brings, and to also recognise the implications they have on the students' learning experience.

New digital semiotic technologies

Moore's Law states that computing processing power tends to double every two years, and will likely to continue increasing exponentially. Named after Gordon Moore, former Chief Executive Officer of Intel, who wrote a paper in 1965 on his observation of the trend in the doubling of transistors in a dense integrated circuit over every two years, Moore's Law accounts for the rapid advancement in technological prowess in this digital age. New digital semiotic technologies are regularly introduced by innovative teachers keen to explore possibilities in new ways of teaching and learning through harnessing the affordances of these technologies. In their pioneering applications of these new digital semiotic technologies, these teachers endeavour to chart the way forward in how the use of such resources and practices can design novel learning experiences for their students. An example of such new digital semiotic technologies discussed in this section is the use of learning analytics.

Phil Long, professor turned educational technology consultant, and George Siemens, founding president of the Society for Learning Analytics Research, were amongst the first to define learning analytics 'as the measurement, collection, analysis and reporting of data about learners and their contexts, for purposes of understanding and optimising learning and the environments in which it occurs' (Long & Siemens, 2011). Since then, the world's fascination with the applications of artificial intelligence in education has led to the concept of learning analytics being promulgated in forward-looking schools and education systems globally. Along with the proliferation of learning platforms, as well as the increasing popularity of flipped learning and MOOCs (Massively Open Online Courses), learning analytics has become a new digital semiotic technology touted by technology forecast reports, such as the New Media Consortium's Horizon Report and the Open University's Innovating Pedagogies Report, that holds the power to re-shape the education of the future.

What does the digital semiotic technology of learning analytics look like in the context of the classroom? An example of a technology trialed in Singapore schools is the WiRead platform, which I serve as one of the co-principal investigators. WiRead is a web-based collaborative reading platform, with scaffolds based on Paul's Wheel of Reasoning (1997), provided for students in their discussion of the text. According to the researchers from the National Institute of Education, Nanyang Technological University, who developed the platform, the aims of WiRead were about 'motivating and scaffolding students to develop richer dialogue and quality interactions with peers around multimodal texts, thereby deepening their personal connection to and appreciation of collaborative and critical reading as a highly relevant, generative, and meaningful social practice' (Tan, Koh, Jonathan, & Yang, 2017: 119).

Value of WiRead

The WiRead platform requires a learning environment where every student has access to a personal computing device. The student accesses the multimodal

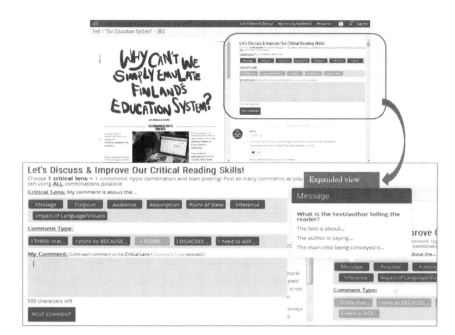

FIGURE 5.1 Interface of WiRead

Reproduced from Tan, Koh, Jonathan, & Yang (2017: 120).

text, which may consist of videos, on the platform and input their questions and comments. In turn, they also read and comment on their peers' feedback on the text. The interface of WiRead platform is represented in Figure 5.1.

WiRead offers a Learning Analytics Dashboard, where the actions of the students on the platform are recorded, quantitatively analysed, and presented in their annotated categories through statistical visualisation. A personalised report is offered to the student, with information on class average performance, and an aggregated report is offered to the teacher. An example is shown in Figure 5.2. For example students are informed of their level of participation, based on the comments and replies they have contributed. They are also provided with information on how substantial their comments were, based on a simple indicator of word count. Students categorise the nature of comments based on Paul's Wheel of Reasoning as they input them into the system. With this, a compilation of the overall types of comments they have made as a proxy indicator of 'critical thinking' is also visualised.

In addition, the WiRead platform purports to offer a glimpse of the nature of relationship and interaction amongst the students in the class. To achieve this, a social network analysis based on interaction patterns (giving and responding of comments amongst students) as well as their peer relationship (based on students' nomination of who and how often they approach other classmates for discussions) can be

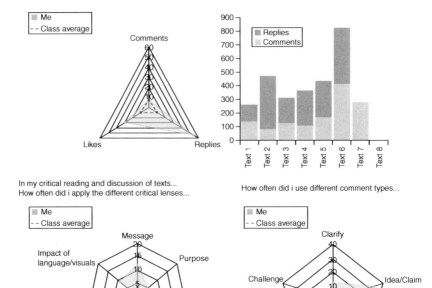

FIGURE 5.2 Statistical visualisations of students' actions

Reproduced from Tan, Koh, Jonathan, & Yang (2017: 120).

performed automatically, and a Social Network Learning Map can be generated. Figure 5.3 shows the report for the teacher, which is also accessible to students.

WiRead represents a new digital semiotic technology that offers learning analytics based on artificial intelligence. In terms of the metafunctional meanings, the students' knowledge and ideas are expressed within the environment of the platform. The semiotic technology of WiRead serves to enhance the current practice of students' reading and discussion of a multimodal text. In addition, the requirements of having students tag their comments according to Paul's Wheels of Reasoning, encourage students' metacognition, by having them pause and reflect on what category their comments come under. While this way of learning can arguably be also achieved by pen and paper, the use of a digital semiotic technology allows the input data to be analysed and subsequently visualised in a radar chart for the student. The set of visualisations, as well as others, from the learning analytics adds to the layer of learning in facilitating metacognitive awareness and practice in students. In a sense, the rendering of data into visualisations for post-activity is the main value proposition of WiRead, and a key affordance of learning analytics.

FIGURE 5.3 Social network analysis

Reproduced from Tan, Koh, Jonathan, & Yang (2017: 120).

The digital semiotic technology should also be evaluated in light of the affordances that it offers. A key affordance of learning analytics is that it provides a set of visualisations that can be used by the students to reflect on their performance, monitor their progress and growth, as well as serve as a consolidation of their input, actions and interactions during their digital learning experience. These big data are automatically collected and can be made sense of based on analytical categories designed by the software producer.

The semiotic technology of learning analytics thus has the affordances for the profiling of students based on the data they generate through their activities on the platform. This can be informative for the teachers to design timely intervention and targeted remediation efforts to help the students, not possible without its use.

Cost in WiRead

While this affordance of profiling is valuable, the usefulness of the analysis is premised on the meaningfulness of the analytical categories developed. For instance, while the quantity of words does allow for more substantial comments to be made, it is theoretically possible to have long comments that are not substantial in the quality of content. As such, it can potentially be misleading to have the analytical category of substantiality of the comments to be based on the proxy indicator of word count alone. In addition, when students are aware that their connections with their peers are measured, they may be tempted to game the system by making connections with others, without sincere and meaningful interaction.

Profiling might also lead to the Pygmalion effect, where higher expectations result in better outcomes, and lower expectations result in worse outcomes. Psychologists Robert Rosenthal and Lenore Jacobson described the phenomenon where teachers' expectations of students can become self-fulfilling prophecies (Rosenthal & Jacobson, 1968). For instance, Prinsloo and Slade (2013) report how teachers' gender biases have a positive effect on boys' academic achievements and negative effect on that of girls. As such, a worrying implication in the use of the semiotic technologies of learning analytics is that it may affirm or create new prejudices and stereotypes to the detriment of marginalised students. In addition, the profile of students, if generated through using students' data that might not fully reflect the accuracy of the analytical categories, can exacerbate the concerns of the Pygmalion effect. Even worse, it could wrongfully, but categorically, ascribe weaknesses and flawed characteristics to students. As such, the basic question integral to the use of such semiotic technologies is: what are the questions that the data collected and visualised within the system can reasonably answer? Related to this is whether what teachers hope to know and measure in terms of the students' learning and disposition can be appropriately and adequately answered by the available data.

Making meaning with WiRead

The pedagogic relations between the teacher and students through the use of WiRead is mainly mediated through screen interfaces. When the teacher uses this digital semiotic technology, most of the interaction happens between the student and the computing devices. Notwithstanding, the students interact with the multi-modal texts, as well as engage with more peers and more frequently, than would have been achieved in a regular lesson. There is also a conspicuous lower extent of direct engagement with the teacher as a result. This shifts the dynamics of the peda-gogic relations from being teacher-centred to one that appears more student-centric. In terms of WiRead's contribution to the organisation of the learning experience, through the use of this digital semiotic technology, the teacher steps more fully into the role of a facilitator of learning and a designer of the learning experience, and less as a sage on a stage.

Personal computing devices in the classroom

Like popular digital semiotic technologies, new digital semiotic technologies can also be evaluated from the social semiotic lens of the metafunctional meanings made as well as the affordances they offer. Unlike the PowerPoint, where a big-screen is used to project the screen from the teacher's computer, the use of WiRead as a semiotic technology affords a different learning environment – one-to-one student computing device provision. The evolution in the classroom learning environment towards one where students have access to a personal computing device for use, especially at the secondary and post-secondary level, is gradually increasing with greater device affordability and a more compelling range of semi-otic technologies, in terms of tools, practices, and resources.

Studies have examined the impact of the use of personal computing devices. For example a meta-analysis of literature by Zheng, Warschauer, Lin, & Chang (2016) reported that there were many studies which pointed to the positive impact of the use of a personal laptop on teaching and learning. For instance, Bebell and O'Dwyer (2010) found that more frequent computer use in classroom with students having personal computing devices tended to result in higher mathematics scores for students. Rosen and Beck-Hill (2012) and Shapley, Sheehan, Maloney, and Caranikas-Walker (2011) also observed that students with personal computing devices in the classroom had more opportunities to develop learning autonomy and collaborative learning skills.

Regardless, in the teacher's design of the learning environments with semi-otic technologies, it is important to be mindful of the observation from the 2015 OECD Report on 'Students, Computers and Learning: Making the Connection'. The report concluded that while the impact of technology on students' perform-ance is mixed, it noted that 'technology can amplify great teaching'. A confluence of factors impact the effective use of technology and personal computing devices in

teaching and learning. These factors include teachers' capacity and readiness, as well as the access and effective use of quality semiotic technologies – the digital tools, practices, and resources.

Artificial intelligence in the classroom

The advances made in artificial intelligence in today's digital age have presented exciting and innovative semiotic technologies for teachers to design new learning experiences for their students. Learning analytics is but one of the many new digital semiotic technologies that are explored by teacher innovators. Other forms of digital semiotic technologies gaining increasing popularity amongst teachers, especially those with students that have access to personal computing devices in the classroom, include language feedback technological tools, educational apps, and digital games (Selander, Lim, Wiklund, & Fors, 2018).

New digital semiotic technologies are usually met with scepticism by teachers. It is thus important to develop ways of appropriate and meaningful usage of these new tools, in consideration of how they represent knowledge, enact pedagogical relations, and contribute to the organisation of the learning experience, as well as the affordances they offer. For example the teacher's use of language feedback technology in the English Language classroom has been controversial, with the National Council of Teachers of English (NCTE) putting up a strong position statement against the use of machine scoring in education (NCTE, 2013). Convinced that one should not throw out the proverbial baby with the bathwater, Jean Phua, lead specialist at the Educational Technology Division, at the Ministry of Education in Singapore, and I set out to explore how to design meaningful learning experiences for students with the use of a Linguistic Feedback Tool (LiFT) to teach writing.

Lim and Phua (2019) introduce the term 'Linguistic Feedback Tool' as a 'type of automated marking tool [that] focuses only identification and feedback on students' writing rather than the provision of a score on the students' content quality and rhetorical effectiveness'. As such, artificial intelligence in the LiFT complements the role of the teacher by correcting the grammar, spelling, and syntax, while the teacher focuses on the ideas and style in the students' writing. In light of the affordances of the LiFT discussed in the paper, Lim and Phua (2019) argue that such a semiotic technology of the LiFT should be used within the process writing approach, specifically during the drafting and revising stage or process writing.

Educational apps in the classroom

Likewise, educational apps, as a fairly nascent semiotic technology, have been controversial amongst educators. As such, it can be of interest to explore how a social semiotics approach can provide teachers with a way to evaluate the usefulness of these semiotic technologies for learning. Drawing from the work of an ongoing research project, 'Harnessing Transmedia Narratives for Literacy Development: Drawing Pedagogical Principles from Approaches in Multimodality', we explored ways of

describing the metafunctional meanings as well as the affordances in educational apps. In this endeavour, Lim and Toh (submitted for publication a) proposed a framework, organised around the metafunctions, to explore the meanings made through the educational apps, as well as the nature of pedagogic relations they facilitate. This framework is extended into a set of questions for the evaluation of educational apps in Lim and Toh (submitted for publication b). The questions for the use of educational apps as semiotic technologies are reproduced in Figure 5.4. They are organised by metafunctions and are expressed as a series of questions for the teacher to use as she reflects on how the educational app represents knowledge, enacts pedagogic relations, and contributes to the learning experiences. Through the series of questions, the teacher also reflects on the affordances of the educational app, in light of how it can be used appropriately in the students' learning experience.

The questions for educational apps evaluation are structured in terms of the representation (for ideational meanings), engagement (for interpersonal meanings) and composition (for textual meanings). Representation consists of purpose, learning assumptions, values, and socioemotional learning. The purpose refers to the educational value of the app and the types of learning it offers. Some of the different types of learning that a well-designed educational app could offer include vocabulary, multimodal semiotic awareness, cultural and moral values, socioemotional skills, decision-making, creativity, communication, collaboration skills, logical thinking, critical thinking and problem-solving skills. The learning assumptions refer to the methods that the educational app uses to promote the different types of learning. These methods could be based on transmissionist, behaviourist, or social constructionist learning theories. The values refer to the intended and incidental lessons promoted in the app that reflect the societal ideologies. The values and ideologies are transmitted to children by educational apps to socialise

Representation

1. Consider the Purpose: What learning does the app offer?
2. Consider the Learning Assumptions: Does it offer connected learning? Does it offer meaningful feedback and practice if it is rote learning?
3. Consider the Values: What are the intended and incidental ideas promoted?
4. Consider the Socio-Emotional Learning: Does it build emotional awareness?

Engagement

5. Consider the Interactivity: Does it encourage active interaction rather than passive viewing?
6. Consider the Interaction: Does it encourage co-learning with the caregiver and co-play with others?
7. Consider the Motivation: Does it motivate continual engagement and learning beyond the app?

Composition

8. Consider the Ease of Use: Is it intuitive to use?
9. Consider the Adaptivity/ Personalisation: Does it support st(age) appropriate learning?
10. Consider the Design: Is it attractive?

FIGURE 5.4 Educational apps evaluation

Reproduced from Lim & Toh, submitted for publication b.

them and develop their socioemotional skills to function as members of a social community. The socioemotional learning is intended to support children's literacy development, creativity, critical thinking, and emotional awareness. In particular, learning how to recognise and express emotions is important in developing children's socioemotional competency.

Engagement consists of interactivity, interaction, and motivation. Interactivity refers to the app's promotion of active interaction rather than passive viewing. Children can learn through action, movement, and play. Educational apps that optimise children's learning could be designed around the affordances of technological devices such as iPad, tablets, and smart phones to incorporate physical activity and other interaction modes to foster children's minds-on (Hirsch-Pasek et al., 2015), physical engagement, and embodied learning with app content. Interaction refers to social interaction, active participation (Hirsch-Pasek et al., 2015), and guided play (Dickinson et al., 2013; Nicolopoulou et al., 2018), which are important aspects supporting children's learning in educational apps. A good educational app should allow and support co-learning with caregivers and co-play with other peers. Motivation refers to the app's potential to motivate continual engagement and learning beyond the app. Some of these app's features that can motivate children include gamified elements and connected learning in formal and informal contexts.

Composition includes ease of use, adaptivity, or personalisation and the app's design. Ease of use is facilitated by the app's simple and intuitive user-friendly interface. Simple and intuitive app design features directly impact on the user experience and satisfaction when using the app as they reduce cognitive demands and minimise the learning curve required to master the functions of the app's user interface. Adaptivity refers to the app's ability or features that can support st(age) appropriate learning. Children's learning is supported when the app design or architecture adapts or can be personalised (Kucirkova, 2019) to the knowledge level and (st)age appropriateness of children based on interactive feedback loops (Chew & Mitchell, 2019). The app's design matters as aesthetics have strong influences on the learner's emotions which can affect their cognitive and learning processes (Wang, Chen, & Yue, 2017).

Traditional semiotic technologies

The word 'technology' originates from the Greek words, 'techne' and 'logos'. 'Techne' refers to craft, and 'logos' to words. As such, technology literally means how words can be expressed through craft, that is, the ways in which knowledge can be expressed through the tools we use. As technology for meaning-making, semiotic technologies need not always be digital. In this section, we examine the traditional semiotic technologies of the whiteboards, ubiquitous in every classroom and arguably indispensable in most pedagogic contexts. Rather than dismissing the whiteboard as just an interface for meaning-making, a social semiotic lens of the whiteboard as a semiotic technology, which serves as both

an enabling semiotic resource for the teacher and in regulating the semiotic processes between the teacher and students, can be productive. As such, this section will discuss the ways in which knowledge is represented, the pedagogic relations enacted, and the contribution to the organisation of the students' learning experience, as well as the affordances of the whiteboard as a traditional semiotic technology for learning.

The whiteboard, and its previous incarnation as the blackboard, has been in the classroom since time immemorial. The difference between the whiteboard and the blackboard lies mainly in the tool for inscription – the marker or the chalk. While the chalk has the unfortunate by-product of producing dust, which can be uncomfortable for the teacher, and students, the marker presents a cleaner and perhaps healthier but perhaps less environmentally friendly, alternative. The earliest version of the whiteboard within ancient pedagogic settings in Babylonia and Sumeria is the clay tablet, where an inscription tool was used by the teachers to write. The clay tablet can then be wetted and reused for another lesson. The big board typically situated in the front centre of the classroom for the teachers' inscription has endured the test of time over the centuries.

Some might suggest that the latest incarnation of the whiteboard is the interactive whiteboard. However, given that the interactive whiteboard functions more as a touchscreen computer and only appears to be like the traditional whiteboard in form, it is considered as a fundamentally different semiotic technology, with different meaning-making potential. It is, nonetheless, of interest to note that the use of the interactive whiteboard has been controversial. This is unsurprising: as discussed in the preceding section of this chapter, new semiotic technologies usually attract criticisms; see for example Beauchamp and Parkinson (2005); Smith, Higgins, Wall, and Miller (2005); and Dostal (2011).

Representing knowledge with the whiteboard

The social semiotics lens of examining the use of the whiteboard in pedagogic meaning-making and its affordances is applied in the following discussion. In terms of the ideational function of knowledge representation, the whiteboard can be used by the teacher to represent knowledge in several ways. They include the (1) reinforcement of knowledge, (2) reformulation of knowledge, (3) explanation and elaboration of knowledge, (4) organisation of knowledge, (5) disambiguation of knowledge, (6) demonstration of knowledge, and (7) assessment of knowledge.

Reinforcement of knowledge occurs when the same words said by the teacher or students are written on the whiteboard. The words that are written on the whiteboard can be a repetition of all that is said, although very often only the key points are written down. This repetition is similar to what Lemke (1984) described as 'redundancy', which he argues is a necessary process in teaching and learning, particularly in the acquisition of new knowledge and understanding.

A way of learning specialist vocabulary can be facilitated using the whiteboard for the reformulation of knowledge. This is similar to the reinforcement of

knowledge except that the words written on the whiteboard are not a repetition of what is said. Instead, the meanings are translated in appropriate, specialised, and often technical language. The reformulation of knowledge follows from Christie's (2002) observation that the teacher will regularly recast the students' answers into the specialised jargon that is privileged in the discipline. Christie (2002) argues that the shift from everyday lexis to the specialised language of a subject is a mark of successful apprenticeship in the learning of a discipline. One manner in which this is achieved is in the multimodal reformulation through the medium of the whiteboard. While reformulation can be most commonly observed in the Initiation, Response, Feedback (IRF) sequence (Sinclair & Coulthard, 1975) of classroom conversations, teachers may also use the whiteboard in the reformulation of knowledge from the verbal to the written mode.

The whiteboard can also be used for the explanation and elaboration of knowledge. This is when the teacher uses the whiteboard to develop a teaching point, such as a concept, to the students. Instead of just explaining the knowledge verbally, the teacher uses the whiteboard to add detail and clarify the knowledge that she has introduced through her speech. Kress (2003) describes the differences in what speech, writing, and drawing are pre-disposed to and are best at uniquely doing in terms of their affordances. For instance, speech and writing are better at expressing categorical meanings, whereas drawings are better at expressing spatial meanings. As such, learning is optimised when all three semiotic modes are co-deployed in the teacher's explanation and elaboration of knowledge through the use of the whiteboard.

The whiteboard also supports the teacher in the organisation of knowledge. For instance, during a class discussion, the whiteboard can be used by the teacher as a diagrammatic table with headings to organise the points which the students are offering. Hence, the whiteboard is used to visibly structure and classify the knowledge in the lesson. The whiteboard also enables the teacher to develop link maps, commonly described as mind-maps, as a way to organise the knowledge learnt from the lesson or course. This is where the teacher uses the whiteboard to position items of knowledge at specific sections on the whiteboard in order to draw the linkages and show the relationship between the points. Link maps are a pedagogical strategy where the organisation of knowledge is foregrounded and the interconnectivity between different points are made explicit and prominent. The productivity of link maps as an organisational template for teaching and learning has been reported in studies by Lindstrøm (2010) and Lindstrøm and Sharma (2009). Whiteboards, given their size and prominence, in the classroom provide a natural site for the production of link maps.

The whiteboard can also be used for the disambiguation of knowledge. This is where the knowledge item expressed verbally is made clear and unambiguous in the written form. In a sense, this is similar to the function of reinforcement of knowledge. However, in this case, the main purpose is to draw attention to the orthography of the word, specifically its spelling. For instance, when a teacher mentions a technical or difficult word in speech, she can write the word on the whiteboard so

that the students will know clearly how it is spelled. This is particularly common in the English language classroom, where there is naturally a strong focus on language, but can be a useful instructional practice in other subject classrooms across disciplines as well. The whiteboard can facilitate the learning of specialised lexis, by reinforcing it through repetition across modes, that is speech and writing, as well as disambiguating its orthography.

In addition, the whiteboard can also be used for the demonstration of knowledge and the assessment of knowledge. The former suggests that the teacher is using the whiteboard to demonstrate the solution to a particular problem. The detailed working out of the processes by the teacher on the whiteboard is usually found in the Mathematics lessons, where knowledge is taught and learnt through a problem being presented. Similarly, assessment of knowledge is where students are called up to the whiteboard to write down their answer to a question posed by the teacher. In a sense, an informal assessment of the students' understanding is enabled by the whiteboard. Such use of the whiteboard can be more common in the Mathematics classroom but can occur in language lessons as well. For instance, when the teacher uses the whiteboard to analyse a particularly complex sentence into its component word classes to explain its meaning and when a student is asked to come up to the whiteboard and write out the spelling of a word.

Enacting pedagogic relations with the whiteboard

The pedagogic relations between the teacher and students when the whiteboard is used can be described as authoritative, high in power relationship and socially distant. When the teacher uses the whiteboard as a semiotic technology, it is often to represent knowledge in the ways described earlier, hence adopting the role of the knowledge authority. The pedagogic focus in the communication of knowledge pedagogy is often realised within a transmissionist approach As such, the interpersonal meanings in terms of the pedagogic relations between teacher and students, when the whiteboard is used, is marked with formality, and is usually high in tenor. The use of the whiteboard also tends to confine the teacher within the authoritative spaces in the front of the classroom.

This is mostly similar to the pedagogic relations made when the teacher presents using PowerPoint slides and with the screen as semiotic technologies. However, unlike the use of PowerPoint slides, where the teacher, more often than not, would deliver a lecture, the teacher using the whiteboard can lead a class discussion and respond promptly to 'teachable moments' and make changes to her teaching based on the trajectory of questions from the students. As such, in the use of a whiteboard, the teacher is actively co-constructing the knowledge with the students, where the process of knowledge building is evident from what and when the teacher writes on the whiteboard. In contrast, the knowledge represented on PowerPoint slides is the product of what the teacher has already prepared, and hence the process of knowledge-building is rendered invisible to the students.

Organising learning with the whiteboard

The use of the whiteboard as semiotic technology by the teacher also contributes to the organisation of the learning experience for the students. Like the use of PowerPoint and the screen, the use of the whiteboard facilitates teaching activities that are more didactic and teacher-oriented, rather than student centred. Didactic teaching has recently developed negative associations in light of the trend towards the social constructivist approach to learning. However, overt instruction is not always bad. Cope and Kalantzis (2015) propose a 'reflexive pedagogy' which advocates the value of didactic and inquiry-based pedagogy and that they both can be appropriate for different stages of the lesson. As such, the teacher, as a learning designer, could develop an awareness and understanding of how certain semiotic technologies can support didactic pedagogies, and make a conscious effort to explore other semiotic technologies, such as students' use of personal computing devices, that can support inquiry-based pedagogies.

Designing learning with semiotic technologies

Semiotic technologies are tools that are used in particular ways as part of social practices. From a social semiotic perspective, semiotic technologies can be used by the teacher to represent knowledge, define pedagogic relations, and contribute to the organisation of the learning experience for students. Inherent to a semiotic technology are its affordances. The use of a semiotic technology will commit the teacher to the nature of the pedagogy enacted and influence the design of the students' learning environment and their experience.

There are common and popular semiotic technologies, both digital and traditional, that are now present in the classrooms of most urban schools. These include the whiteboard, screen, and projectors, as well as computing devices used by teachers and sometimes students. This chapter hopes to provoke teachers to reflect on the gains and losses in the use of these semiotic technologies, and in a more productive enterprise, to consider how the affordances of these resources can be harnessed to design for meaningful learning experiences.

Technologies for learning are advancing rapidly, with new tools and applications fast emerging that promise novel ways of teaching and learning in the classroom. These include the use of social media, analytics, augmented and virtual reality, immersive worlds, as well as forms of robot(ic)s harnessing artificial intelligence for educational purposes. The growing list is expected to get more interesting and exciting with time. While the material technological products will continue to change, the theoretical perspective of understanding these resources as semiotic technologies can help us have a consistent set of lenses in understanding the types of metafunctional meanings that these semiotic modes offer as well as reflect on what they can or cannot do. This chapter discusses the value of understanding these new and emerging digital tools as semiotic technologies for learning, which can be harnessed, or resisted, in the classroom, based on their pedagogic value. The ultimate aim is to invite the teacher to think about the range of semiotic technologies she

has at her disposal, and what she can bring into the classroom, in her role as a learning designer.

REFLECTION QUESTIONS

1. What are the ways in which a semiotic technology used can facilitate the expression of knowledge?
2. How does a semiotic technology used shape the pedagogic relationship between the teacher and students?

References

Beauchamp, G. & Parkinson, J. (2005). Beyond the wow factor: Developing interactivity with the interactive whiteboard. *School Science Review* 86(316), 97–103.

Bebell, D. & O'Dwyer, L. M. (2010). Educational outcomes and research from 1:1 computing settings. *Journal of Technology, Learning and Assessment* 9(1), 4–15.

Chew, E.C. & Mitchell, A. (2019). Bringing art to life: Examining poetic gameplay devices in interactive life stories. *Games and Culture*, 1–28.

Christie, F. (2002). *Classroom Discourse Analysis: A Functional Perspective*. London & New York: Continuum.

Cope, B. & Kalantzis, M. (2015). The things you do to know: An introduction to the pedagogy of multiliteracies. In B. Cope & M. Kalantzis (eds), *A Pedagogy of Multiliteracies: Learning by Design* (pp. 1–36). London: Palgrave Macmillan.

Dickinson, D.K., Hirsh-Pasek, K., Golinkoff, R.M., Nicolopoulou, A., & Collins, M. F. (2013, April 19). The Read-Play-Learn intervention and research design. Paper presented at the biennial meeting of the Society for Research in Child Development in Seattle, WA.

Djonov, E. & van Leeuwen, T. (2011). The semiotics of texture: From tactile to visual. *Visual Communication* 10(4), 541–564.

Djonov, E. & van Leeuwen, T. (2012). Normativity and software: A multimodal social semiotic approach. In S. Norris (ed.), *Multimodality and Practice: Investigating Theory-in-Practice-through-Method* (pp. 119–137). New York: Routledge.

Djonov, E. & van Leeuwen, T. (2013). Between the grid and composition: Layout in PowerPoint's design and use. *Semiotica* 197, 1–34.

Djonov, E. & van Leeuwen, T. (2014). Bullet points, new writing, and the marketization of public discourse: A critical multimodal perspective. In E. Djonov & S. Zhao (eds), *Critical Multimodal Studies of Popular Discourse* (pp. 232–250). New York and London: Routledge.

Djonov, E. & van Leeuwen, T. (In press). Semiotic software through the lens of systemic functional theory. In J.R. Martin, J.S. Knox, & D. Caldwell (eds) (In press) *Appliable Linguistics and Social Semiotics: Developing Theory from Practice*. London: Bloomsbury Academic.

Dostál, J. (2011). Reflections on the use of interactive whiteboards in instruction in international context. *The New Educational Review* 25(3), 205–220.

Gibson, J. (1966). *The Senses Considered as Perceptual Systems*. Santa Barbara, CA: Praeger.

Greenberg, D. (2000). *Avoiding Death by PowerPoint: 45 Proven Strategies to Breathe Life into Dull Presentations*. Georgia: Goldleaf Publications.

Hirsh-Pasek, K., Zosh, J.M., Michnick, G., Gray, J.H., Robb, M.B., & Kaufman, J. (2015). Putting education in 'educational' apps: Lessons from the science of learning. *Psychological Science in the Public Interest* 16(1), 3–34.

Kress, G. (2003). *Literacy in the New Media Age.* London: RoutledgeFalmer.

Kress, G. (2005). Gains and losses: New forms of texts, knowledge and learning. *Computers and Composition* 22(1), 5–22. https://doi.org/10.1016/j.compcom.2004.12.004

Kress, G. (2010). Multimodality – A Social Semiotic Approach to Contemporary Communication. London & New York: Routledge.

Kress, G. (2015). Gunther Kress. In T.H. Andersen, M. Boeriis, E. Maagerø, & E. Seip Tønnessen (eds), *Social Semiotics: Key Figures, New Directions* (pp. 69–92). London: Routledge.

Kucirkova, N. (2019). Children's agency by design: Design parameters for personalization in story-making apps. *International Journal of Child-Computer Interaction , 21,* 112-120. https://doi.org/10.1016/j.ijcci.2019.06.003.

Lemke, J.L. (1984). Semiotics and Education. Monograph in Toronto Semiotic Circle Monographs Series.Victoria University,Toronto.

Lim, F.V. & Phua, J. (2019).Teaching writing with language feedback technology. *Computers and Composition,* 54, 1–13.

Lim, F.V. & Toh,W. (submitted for publication a). Digital Play for Learning: A Multimodal Discourse Analysis Approach to Educational Apps.

Lim, F.V.,& Toh,W. (submitted for publication b).What is a 'Good' Educational App? A Social Semiotic Approach to Evaluating Educational Apps.

Lindstrøm, C. (2010). Link Maps and Map Meetings: A Theoretical and Experimental Case for Stronger Scaffolding in First Year University Physics Education (unpublished doctoral dissertation). University of Sydney, Australia. Retrieved from https://sydney.edu.au/science/physics/pdfs/research/super/Christine_Lindstroms_PhD_thesis.pdf (accessed: 26. Sep 2019).

Lindstrøm, C. & Sharma, M.D. (2009). Using link maps to navigate through the physics landscape. *Higher Education Research and Development Society of Australasia* 31(3), 15–17.

Long, P. & Siemens, G. (2011). Penetrating the fog: Analytics in learning and education. *Educause Review.* Retrieved from https://er.educause.edu/articles/2011/9/penetrating-the-fog-analytics-in-learning-and-education (accessed: 25 Sep. 2019).

NCTE (2013). NCTE position statement on machine scoring [Web log post] Apr. 20. Retrieved from www2.ncte.org/statement/machine_scoring/ (accessed: 25 Sep. 2019)

Nicolopoulou, A., Toub, T.S., Hassinger-Das, B., Nesbitt, K.T., Ilgaz, H., Dickinson, D.K., Weisberg, D.S., Hirsh-Pasek, K., & Golinkoff, R.M. (2018). The language of play: Developing preschool vocabulary through play following shared book-reading. *Early Childhood Research Quarterly* 45, 1–17.

Norman, D. (1988). *The Design of Everyday Things.* New York: Basic Books.

OECD (2015). *Students, Computers and Learning: Making the Connection.* Pisa: OECD Publishing.

Paul, R. & Elder, L. (April 1997). Foundation for Critical Thinking. Available from www.criticalthinking.org (accessed: 25 Sep. 2019).

Poulsen,V.S., Kvale, G., & van Leeuwen, T. (2018). Special issue: Social media as semiotic technology. *Social Semiotics* 28(5), 593–600.

Prinsloo, P. & Slade, S. (2013).An evaluation of policy frameworks for addressing ethical considerations in learning analytics. *Proceedings of the Third International Conference on Learning Analytics and Knowledge – LAK 13.* doi:10.1145/2460296.2460344

Rosen, Y. & Beck-Hill, D. (2012). Intertwining digital content and a one-to-one laptop environment in teaching and learning: Lessons from the Time to Know Program. *Journal of Research on Technology in Education* 44, 225–241.

Rosenthal, R. & Jacobson, L. (1968). *Pygmalion in the Classroom: Teacher Expectation and Pupils' Intellectual Development.* Bancyfelin, Carmarthen, Wales: Crown House Pub (1992 new edition).

Selander, S., Lim, F.V., Wiklund, M., & Fors, U. (2018). Digital games and simulations for learning. In H.C. Arnseth, T. Hanghoj, T.D. Henriksen, M. Misfeldt, S. Selander, & R. Ramberg (eds), *Games and Education: Designs in and for Learning* (25–35). Rotterdam: Sense Publishers.

Shapley, K., Sheehan, D., Maloney, C., & Caranikas-Walker, F. (2011). Effects of technology immersion on middle school students' learning opportunities and achievement. *Journal of Educational Research* 104, 299–315.

Sinclair, J. & Coulthard, M. (1975). *Towards an Analysis of Discourse: The English Used by Teachers and Pupils.* London: Oxford University Press.

Smith, H.J., Higgins, S., Wall, K., & Miller, J. (2005). Interactive whiteboards: Boon or band-wagon? A critical review of the literature. *Journal of Computer Assisted Learning* 21(2), 91–101.

Tan, J.P.L., Koh, E., Jonathan, C., & Yang, S. (2017) Learner dashboards a double-edged sword? Students' sense-making of a collaborative critical reading and learning analytics environment for fostering 21st century literacies. *Journal of Learning Analytics* 4(1), 117–140. doi: 10.18608/jla.2017.41.7

van Leeuwen, T., Djonov, E., & O'Halloran, K.L. (2013). 'David Byrne really does love PowerPoint': Art as research on semiotics and semiotic technology. *Social Semiotics* 23(3), 409–423.

Wang, Y., Chen, J., & Yue, Z. (2017). Positive emotion facilitates cognitive flexibility: An fMRI study. *Frontiers in Psychology*, 8(1832). doi: 10.3389/fpsyg.2017.01832. Retrieved from www.ncbi.nlm.nih.gov/pmc/articles/PMC5671657/

Zhao, S. & van Leeuwen, T. (2014). Understanding semiotic technology in university classrooms: A social semiotic approach to PowerPoint-assisted cultural studies lectures. *Classroom Discourse* 5(1), 71–90.

Zhao, S., Djonov, E., & van Leeuwen, T. (2014). Semiotic technology and practice: A multi-modal social semiotic approach to PowerPoint. *Text & Talk* 34(3), 349–375.

Zheng, B., Warschauer, M., Lin, C.-H., & Chang, C. (2016). Learning in one-to-one laptop environments: A meta-analysis and research synthesis. *Review of Educational Research* 86, 1052–1084.

6

MULTIMODAL CLASSROOM ORCHESTRATION

Orchestrating teaching and learning

In this book, we have, so far, explored the different ways that the teacher can make meaning in the classroom through a repertoire of semiotic resources – both embodied semiotic modes and semiotic technologies. In addition to the teacher's use of language, where she stands and moves in the classroom, how she uses gestures, and what semiotic technologies she uses, are all resources at her disposal to design students' learning experiences.

In the previous chapters, we have discussed how each specific semiotic resource makes meaning and contributes to the design of the learning experiences for the students. In this chapter, we will attempt to bring it all together by examining the teacher's multimodal orchestration of these semiotic resources. We will reflect on how the combination of multimodal semiotic resources can express the teacher's specific pedagogy that influences and impacts students' participation, experience, and learning. This speaks directly to practitioners, especially teachers, who are interested in the ways and effects in which their classroom multimodal orchestration of semiotic resources have on students.

This chapter will also discuss the interplay, described as intersemiosis, across the teacher's use of multimodal semiotic resources. In particular, the nature of contextualising relations amongst the different semiotic resources is described. This is pertinent especially to educational researchers who are interested in developing ways of describing and systematising the operations of intersemiosis and how the meanings are made in the teacher's multimodal orchestration of semiotic resources.

Multimodality involves 'how different kinds of meaning making are combined into an integrated, multimodal whole' (Jewitt et al., 2016: 2). As such, the essence of multimodality is about the interactions and integration across the semiotic resources in the constellation of meanings made. As Iedema (2003: 31) argues 'semiosis is not

analysed in terms of discrete building blocks or structures, but in terms of socially meaningful tensions and oppositions which could be instantiated in one or more ways'. In this light, multimodal classroom orchestration is about how the teacher uses a combination of semiotic resources, with awareness and fluency, to express her pedagogy and design meaningful learning experiences for the students.

The teacher's use of multimodal embodied semiotic resources in the classroom is concomitant to her very physical presence in the classroom. The teacher would necessarily have to position herself somewhere in the classroom, move around or choose not to move – either choice can be described as semantically significant. The teacher would use language and gestures in her communication, and may also use commonly available semiotic technologies, such as the whiteboard or the PowerPoint presentation, in her teaching. The teacher's use of multimodal semiotic resources is implicit and inevitable in all pedagogic discourses. These sometimes unconscious, but always motivated, choices, from the social semiotic lens, are always meaningful and lend themselves to analysis and interpretation. The analysis, performed by a researcher, with methodological tools such as the use of the lesson microgenre approach described in Chapter 2, can reveal the meanings made from the teacher's choices, support teacher's reflection, and inspire teacher's professional growth.

In this book, the notion of the teacher's multimodal classroom orchestration carries with it the qualities of aptness and fluency. This is unlike the teacher's use of multimodal semiotic resources in an unmindful and oblivious manner. In a multimodal classroom orchestration, the teacher has a heightened semiotic awareness in the ways to express specific meanings as well as the effects these meanings have on the students. Semiotic awareness (Towndrow, Nelson, & Yusuf, 2013; Lim & Toh, submitted for publication) is described as the 'critical attention to relational, multimodal aspects of meaning design' (Towndrow et al., 2013: 328). Lim (submitted for publication) extends the notion of semiotic awareness and argues for the importance of teachers also developing a fluency in multimodal orchestration to harness the affordances of meaning-making resources. As such, the meanings made in the teacher's multimodal classroom orchestration arise from the teacher's semiotic awareness. There is a discernible aptness and fluency in the teacher's multimodal classroom orchestration to express her pedagogy and design for meaningful learning experiences.

In the earlier chapters, we have discussed the multimodal nature of pedagogic discourses and suggested ways in which the meanings made by various semiotic resources by the teacher can be analysed and interpreted. This is built on advances that have also been made by leading scholars in the study of the teacher's use of multimodal semiotic resources across various subject classrooms, such as Moschkovich (2002), Greiffenhagen (2008), O'Halloran (1998; 2011, 2015) in the Mathematics classroom, Kress et al. (2001) and Roth and Jornet (2014) in the Science classroom and Kress et al (2005) in the English classroom. With the recognition of the multimodal nature of pedagogic discourses, and the ease, through the use of technology, in the collection and analysis of multimodal classroom data in educational research

today, an increasing number of scholars in the field of multimodality are also applying the multimodal lens to look at meaning-making in the classroom. (see, e.g. Jewitt, 2013; O'Halloran, Podlasov, Chua, Tisse, Lim, & Smith, 2013; O'Halloran, forthcoming; Takahashi & Yu, 2017; Taylor, 2014). Notwithstanding these efforts, a continuing challenge for researchers working with multimodal discourse is to develop the theoretical apparatus for describing and discussing the interaction and integration across various semiotic resources used and the emergent meanings made multimodally.

This chapter picks up from the discussion of the case study of the two teachers, Lee and Mei, introduced in Chapters 2 and 3. In particular, the discussion centres on the teachers' use of language, gestures, positioning, and movement, as well as the semiotic technologies, to express unique pedagogies, despite teaching similar lesson content. The chapter also discusses the notion of 'structured informality' (Lim, 2011; Lim, O'Halloran, & Podlasov, 2012; Lim, 2019), which offers a way for teachers to consider how to orchestrate the multimodal semiotic resources in the classroom to design various learning experiences for their students.

Intersemiosis

Intersemiosis in the classroom

The study of the teacher's multimodal classroom orchestration entails the examination of the ways in which the various embodied semiotic modes, such as language, gestures, positioning, and movement, as well as semiotic technologies, combine in their interaction and integration, that is, in their intersemiosis. O'Halloran (2005: 159) proposes the term 'intersemiosis' to describe 'the meaning arising across semiotic choices'. Intersemiosis has also been observed by Royce (1998, 2006) as 'intersemiotic complementarity' where 'visual and verbal modes semantically complement each other to produce a single textual phenomenon' (Royce, 1998: 26). Lemke (1998) notably describes the meanings arising from the combination of semiotic resources in scientific discourse in textbooks as a 'multiplying of meanings'. Hence, the 'emergent meaning' (Lim, 2004) arising from the combined use of the semiotic resources is more profound than the meaning made by an individual semiotic resource. While this is generally recognised, what is of interest in intersemiosis is the ways, or mechanisms, in which the semiotic resources work in combination to produce the emergent meaning.

As described in Chapter 1, the approach to the study of multimodal pedagogic discourse in this book is informed by the work in linguistics, in particular, of Michael Halliday's Systemic Functional Theory. Halliday (1978, 1994[1985]) conceives language as a social semiotic system and has developed a robust theoretical apparatus, the systemic functional grammar, to systematise the meaning potential of language and foreground the notion of choice in meaning-making.

The extension of Systemic Functional Theory as a productive approach to investigate other semiotic resources has been shown through its extension through

the Systemic Functional Multimodal Discourse Analysis (SFMDA) approach (O'Halloran & Lim, 2014; Jewitt, Bezemer, & O'Halloran, 2016) as well as the social semiotics lens on teaching and learning (Kress, 2009; Kress & Bezemer, 2015) adopted in this book. The SFMDA approach focuses on the 'grammatics' of semiotic resources in fulfilling specific functions and how the semiotic choices work in combination to make meaning over space and time. A key aspect in the SFMDA approach is its study of 'multimodal grammatics, where interacting systems of meaning are a key motif' (Jewitt et al., 2016: 39). As such, how the semiotic resources in intersemiosis interact and integrate are of particular interest and are central to the SFMDA approach.

In this section, we will discuss the ways in which intersemiosis across various semiotic resources happen. In particular, we will consider the basis of the combination, that is the contextualising relations across the resources. The purpose of this is to provide a language for educational researchers to describe the patterns of meanings made, as well as understand the interaction and integration of the repertoire of semiotic resources, used by the teacher in her multimodal classroom orchestration.

Thibault (2004) explains that different semiotic resources are organised according to different principles. Thibault (2004: 26) observes that for example 'language is predominantly typological-categorical; it is based on discrete categorical contrast or difference. Gesture, on the other hand, is topological-continuous; it is based on continuous variation of visual and spatial relations'. As such, language and gesture 'do not simply express the same meanings by alternative means of expression. Instead, they make different meanings on the basis of their different principles of organization'. Baldry and Thibault (2006: 4) also explain that 'different modalities adopt different organisational principles for creating meaning'. Hence, it is necessary to examine the specific semiotic resources in focus within the multimodal text and explore the unique ways in which they combine and interact in their joint co-deployment.

Matthiessen (2009) describes the orchestration of multimodal semiotic resources as 'semiotic harmony'. Matthiessen (2009: 11) observes that 'one interesting – and critical – aspect of the division of semiotic labour among the denotative semiotic systems is the extent to which they operate in semiotic harmony with one another'. Nonetheless, like Baldry and Thibault (2006), Matthiessen (2009) acknowledges that how this is accomplished is unique to different resources. Specifically of interest is 'how the different resources for creating meaning complement one another and how the semiotic labour (the work of creating meaning in context) is divided among them' (Matthiessen, 2009: 23).

The intersemiosis between the semiotic modes of language and images has been most theorised to date. Systems and theories have been proposed by many researchers to investigate language–image relations (see, for example Lim, 2004; Royce, 2006; Lim, 2007; O'Halloran & Lim, 2009; Daly & Unsworth, 2011; Painter et al., 2011; Lim & O'Halloran, 2012; Bateman, 2014). In particular, Unsworth and Cleirigh (2009) argue that 'advancing understanding of how images and language

interact to construct meaning seems crucial in seeking to reconceptualise literacy and literacy pedagogy from a multimodal perspective'. In Lim (2011; 2019), the intersemiosis between language and gestures is examined and discussed with reference to the intersemiosis between language and images. Jiang and Lim (submitted for publication) extend the study beyond the intersemiosis of two semiotic modes to investigate the interaction and integration across three semiotic modes, examining the meaning patterns across language, images, and gestures.

Contextualising relations

Intersemiosis between semiotic resources arises from the contextualising relationships, which are the meanings made from the spatial co-occurrences or temporal co-occurrences of the semiotic resources. As Thibault (2000: 362) explains, it is 'on the basis of co-contextualizing relations that meaning is created'. Extending this idea, Lim (2004: 239) distinguishes two types of contextualising relations:

> In cases where the meaning of one modality seems to 'reflect' the meaning of the other through some type of convergence, the two resources share co-contextualizing relations. On the other hand, in cases where the meaning of one modality seems to be at odds with or unrelated to the other, their semantic relationship is one that creates divergence or dissonance. In the latter case, the resources share re-contextualising relations.

The intersemiosis between language and images has been studied from the perspective of contextualising relationships (O'Halloran & Lim, 2009; O'Halloran et al., 2019). In examining the contextualising relationships in mathematical discourse, O'Halloran (2007: 95) explains that '[i]ntersemiosis creates new semantic layers where the meaning of the re-contextualised ideational relations extend beyond that possible with language… Co-contextualising textual and interpersonal relations enable the new ideational content to be foregrounded' (O'Halloran, 2007: 95). Co-contextualising relations bring about semantic convergence, where through the similar meanings made across the various semiotic resources, the emergent meaning is that of reinforcement, through repetition and redundancy. For example the teacher may signal gesturally a thumbs-up sign when praising a child for the good work done.

Re-contextualising relations, on the other hand, create new semantic layers through the reconciliation of the divergent meanings made. This emergent meaning usually carries new semantic layers such as irony, sarcasm, dilemma, and ambivalence. Thibault (2000: 321) explains that 'ideological disjunction' results from 'the complex, often intricate, relations of inter-functional solidarity among the various semiotic resource systems that are co-deployed'. Re-contextualising relations lead to semantic divergence. However, the semantic divergence can be reconciled when the additional layer of meaning is recognised as sarcasm. For example the teacher may shake her head in mock disapproval, when she says 'yes' to a child seeking permission to be excused from the class to visit the restroom.

For communication to be successful, both semantic convergence and divergence through the combination of semiotic selections must be reconciled in the emergent meaning to ultimately serve the intent of the message. Re-contextualising relations leading to a semantic divergence that cannot be reconciled result in ambiguity, confusion, and a consequent breakdown in communication.

The notion of semiotic cohesion can be helpful to describe the combination of semiotic resources in their co-deployment in multimodal classroom orchestration. Semiotic cohesion was first proposed by O'Halloran (2008) to describe language–image relations. Semiotic cohesion is where 'system choices function to make the text cohesive' (O'Halloran, 2008: 453). Liu and O'Halloran (2009) argue that it is important to recognise 'a coherent multimodal message, rather than a co-occurrence of language and images' (Liu & O'Halloran, 2009: 367). They explain that 'from the perspective of logogenesis, semiotic cohesion can be regarded as the ongoing process of contextualization, in which meanings are made across different semiotic resources in multimodal discourse' (Liu & O'Halloran, 2009: 385).

The pedagogies of Lee and Mei

In this section, we revisit the case study of Lee and Mei introduced earlier in Chapter 2, and whose spatial pedagogies are discussed in Chapter 3. In particular, we will discuss how their use of a range of semiotic modes and semiotic technologies in the classroom express their unique pedagogies and result in different learning experiences for their students.

The case studies of Lee and Mei are based on data from an earlier study by Lim (2011), and draws from a corpus of authentic classroom data collected from two teachers, teaching in a pre-university setting in Singapore. Discussions of the linguistic analysis, gestural analysis, and their use of classroom space through positioning and movement, as well as their use of semiotic technologies are summarised in the sub-sections below.

Thereafter, the intersemiosis across Lee and Mei's use of language, gestures, positioning, and movement, as well as semiotic technologies, are discussed, with examples of semiotic cohesion and intersemiotic operations. The analysis of the lesson microgenres, gesture, use of space and language reveal two distinct pedagogical styles embodied by Lee and Mei. Lee expresses an authoritative pedagogy whereas Mei expresses a participative pedagogy through what is described in this study as the construction of 'structured informality'. The emergent meaning of structured informality, as a way that teachers orchestrate various semiotic resources to design for meaningful learning, is proposed and discussed in the last section of this chapter.

Lesson microgenres analysis

A summary of the distinctiveness in both Lee and Mei's lesson, in terms of the lesson microgenres, discussed in Chapter 2, is shown in Table 6.1. The sequence of lesson microgenres in Lee's lesson indicates that Lee takes a longer time to arrive at the same lesson peak as Mei due to the frequent and lengthy diversions.

TABLE 6.1 Lesson microgenres comparisons

	Lee	*Mei*
Structure	Arbitrary, random	Ordered, structured
	Focus on content knowledge	Focus on application question structure
	Less discourse on greetings	More discourse on greetings
	Less discourse on instructions	More discourse on instructions
	Less discourse on issuing of homework	More discourse on issuing of homework
	Less discourse on homework check	More discourse on homework check
Rapport	Less discourse on rapport	More discourse on rapport
	Less discourse on philosophy	More discourse on philosophy
Higher order skills	Less discourse on skills	More discourse on skills
	More discourse on general knowledge	Less discourse on general knowledge
Content knowledge	More discourse on content	Less discourse on content
	More video-screening	No video-screening
	More discourse on personal consultation	Less discourse on personal consultation
Personal	More discourse on motivation	Less discourse on motivation
	More discourse on discipline	Less discourse on discipline
Motivation and control	More discourse on external distraction	Less discourse on external distraction
	More discourse on attendance	Less discourse on attendance

Mei also has a significantly longer period of lesson closure which enables her to summarise and conclude her lesson appropriately. In contrast, Lee's lesson closure was short.

The sequence in the categories of lesson microgenre, shown in Figures 2.3a–b in Chapter 2, also appears more orderly in Mei's lesson as compared to Lee's lesson. A major reason for Lee's more irregular sequence is his attempt to introduce new knowledge in the form of a template he developed in a Review Lesson in the Curriculum Genre. As such, a proper review of the knowledge and skills taught earlier is sidelined to teach the new template. The structuring of the lesson is important in the organisation of knowledge and skills in the lesson. From the analysis, Mei appears to have more apt control over the presentation and development of the lesson as evident from the analysis of the categories of lesson microgenre.

Table 6.1 displays the differences in the duration spent on each lesson microgenre realising distinct foci in both lessons. Mei focuses more on the structure and organisation of the lesson as well as on the sequence in the presentation of skills and knowledge. This is evident in the significant time she spends on the Discourse

on Greetings, Discourse on Instructions, Discourse on Homework Check and Discourse on the Issuing of Homework. However, she balances the structure with a strong rapport built with the students through her use of Discourse on Rapport-Building. Coupled with the substantially shorter time spent on the Discourse on Discipline, the exercise of overt power and authority in Mei's lesson is mitigated.

In contrast, Lee provides less scaffolding for his lesson and does not spend much time framing the lesson and the activities. However, despite the flexibility in structure, he emphasises discipline and order in the classroom as indicated by the time spent on Discourse on Discipline. The control he attempts to exert over the students is also signalled in the time spent on Discourse on Motivation, Discourse on External Distraction and Discourse on Attendance. In relation to the Skills and Content Topics, Mei focuses mainly on Application Question Structure as reflected by the time spent on the Discourse on Skills. This is appropriate given that this is the primary Skills and Content Topic in the Review Lesson as articulated by both Lee and Mei. In addition, she focuses on higher order thinking skills through Discourse of Skills and Discourse on Philosophy. As mentioned earlier, this is empowering as it trains students to be critical thinkers.

Lee focuses primarily on the Skills and Content Topic of Content Knowledge as indicated by the long duration of time spent on Discourse on General Knowledge, Discourse on Content and Video-Screening. This is despite the espoused focus on the Skills and Content Topic of Application Question Structure he mentions in the Discourse of Learning Objectives at the beginning of the lesson.

In all, Mei's lesson seems more typical of a regular Review Lesson. The clear structure she has in the ordering of the lesson is complemented with the rapport she builds with the students. In this, she constructs a sense of structured informality, where ideational and textual meanings in the lesson are realised in a structured manner and where interpersonal meanings are realised through choices that convey solidarity and affability with the students. Lee's lesson, while less structured ideationally and textually than Mei, tends towards expressions of power and authority in the interpersonal choices made. This emerges more clearly in the discussion on the semiotic modes of language, gesture and use of space by Lee and Mei.

Spatial analysis

Lee and Mei's use of space through their positioning and movement have been described in Chapter 3. As such, the discussion here will be brief, and serve primarily to summarise the key differences in their use of space, as shown in Table 6.2.

Mei's preference to stand in the authoritative space contrasts with Lee's use of space. Mei's use of authoritative space conveys clarity of intent and formality as a teacher. In contrast, Lee tends to position himself in different spaces in the classroom during his lesson, rather than mainly in the authoritative space. Even when Lee spends time in the authoritative space, he has a proclivity to position himself off-centre. Altogether, Lee's spatial selections convey a sense of informality. This casualness appears contradictory, at times, to the explicit display of power and

TABLE 6.2 Use of space comparisons

Lee	Mei
Less use of authoritative space	More use of authoritative space
Off centre in authoritative space	Conventional authoritative space
More use of supervisory space	Less use of supervisory space
More movement	Less movement

authority he exercises through choices made in the other semiotic resources, as will be discussed later.

In comparison, Lee uses more supervisory space than Mei. In particular, he usually paces around the students during their self-directed activities. In doing that, he makes himself available and accessible to them should they have any questions. However, this is also construed as control in terms of ensuring that they are on task as he invigilates the activity through his pacing.

Overall, Lee makes more movement in the class than Mei. This suggests a certain dynamism, liveliness, and energy in his lesson. Mei is more formal and conventional in her spatial pedagogy. She conveys a sense of formality through her positioning in the central authoritative space as well as in her low use of movement.

Linguistic analysis

The linguistic choices made by Lee and Mei are analysed using Systemic Functional Grammar and the summary of their choices and the meanings they expressed are presented in Table 6.3.

In Systemic Functional Grammar, linguistic choices in the mood system express interpersonal meanings, that is, to enact social relationships with language. In terms of the mood system, both Lee and Mei typically use more finite mood choices. The frequent use of modality represents a modulation of power through the use of low modality such as in words like 'could' and 'might' and an assertion of power through the use of high modality such as in words like 'should' and 'must'. Words that indicate power, such as 'don't' and 'need' are used very frequently by Lee and to a lesser extent by Mei. The frequent use of high modality, coupled by the frequent use of imperatives represented in the non-finite selections, suggests more instances where Lee asserts his authority during the lesson.

Linguistic choices in the transitivity system express ideational meanings, that is to construct our experience of the world with language. Both Lee and Mei use mostly relational processes in the classroom. Halliday (1994[1985]: 119) explains that 'relational processes are a process of being ... a relation is being set up between two separate entities'. Relational clauses are also a regular feature in pedagogic discourse as they contribute to the scaffolding of understanding and knowledge construction. The category of relational process is represented in the sub-classification of Relational-Attributive and Relational-Identifying.

TABLE 6.3 Use of language comparisons

Lee	Mei
Use of imperatives and high modality to indicate power and authority	Use of adjuncts and low modality to indicate possibility and solidarity
More relational-identifying	More relational attributive
More mental process	More mental-affective
More mental-cognitive	
Less laughter	More laughter

Martin et al. (1997: 106) explain that 'the fundamental difference between attributive and identifying is the difference between class membership (attributive) and symbolization (identifying)'. Lee uses more relational-identifying clauses whereas Mei uses more relational-attributive clauses. For instance, Lee tends to formulate Relational-Identifying clauses such as 'That is one of the points' and 'This is not in the context of our discussion'. These are examples of Lee's preference towards relating two different levels of abstraction – token and value, symbolically. Mei uses more Relational-Attributive clauses in comparison to Lee. For instance, Mei tends to use Relational-Attributive clauses such as 'We have three points' and 'They are too self-centred'. These are examples of Mei's preference towards relating 'carrier and attribute, of the same level of abstraction, but differ[ing] in generality as member to class, subtype to type' (Martin et al., 1997: 106). In the first comparison, the choice made by Mei using the Relational-Attributive process of 'We have three points' creates a sense of solidarity and shared ownership of learning with the students. This contrasts with Lee's more references of 'That is one of the points' and 'This is not in the context of our discussion'. In the second comparison, a more direct comparison is made between 'they' and 'self-centred' through the Relational-Attributive process. This contrasts with an equivalent recast into the Relational-Identifying process of 'They are self-centred people'.

The 'clauses of feeling, thinking and perceiving' are described by Halliday (1994[1985]: 114) as the mental process. These clauses are sub-classified as Mental-Affective, Mental-Cognition, and Mental-Perception. Given the nature of teaching and learning, it is unsurprising that these processes are featured prominently in Lee's and Mei's lessons. Lee also uses more mental cognitive processes as opposed to Mei's usage of mental-affective processes. Lee tends to represent entities through the cognitive processes, whereas Mei evokes greater affect in her linguistic choices. The high amount of these processes is a result of Lee's tendency to use the words 'think' and 'look', respectively. Significantly, Mental-Affective is the only type of mental process that Mei has which is almost twice as much as Lee. This is a result of Mei's more regular use of the word 'feel'. For example in her question, 'Do you feel it will worsen?', as opposed to Lee's 'Do you think this problem can be resolved?', the use of the Mental-Affective invokes an emotional element into the question

and encourages the students to engage with the issue, not just cognitively but also emotionally. The connection with issues on a personal and emotional level, as well as on the intellectual level, is tacitly encouraged through the use of the Mental-Affective process.

Behavioural and Existential processes are used very rarely by both teachers. Mei seems to have slightly more of these processes than Lee. Behavioural processes 'construe human behavior' (Martin et al., 1997: 109). Arguably, the presence of behavioural processes such as in Mei's questions of 'Why are you smiling' and later 'Why are you laughing', conveys an affective dimension to the professional nature of teacher–students' interaction.

In summary, Lee uses more relational-identifying clauses whereas Mei uses more relational-attributive clauses. Lee also uses more mental-cognitive processes as opposed to Mei's usage of mental-affective processes. Lee tends to represent entities through the cognitive processes. Lee also uses more imperatives and high modality to indicate his power and authority. In contrast, Mei prefers adjuncts and low modality to build solidarity with the students. It is also observed that Mei has more occurrences of students' laughter during her lesson. This suggests a bond between the students and her as well as their enjoyment of the lesson.

Gesture analysis

Applying the framework to analyse the teacher's pedagogic gestures described in Chapter 4, the comparisons between the types of gestures used by Lee and Mei are shown in Table 6.4.

From the analysis, we observe that Lee uses more Presenting Actions (Martinec, 2000) than Mei. As described earlier, Presenting Actions do not have any signifying function. While non-communicative, an effect of presenting action is to bring a sense of energy and liveliness in the lesson. In comparison, Mei uses more Indexical Actions and Representing Actions. These actions serve a signifying function as Language Correspondent Gesture or Language Independent Gesture. It has been observed that Lee tends to rest his hands by the side of his legs whereas Mei tends to hold her hands at the waist level. The former expresses a sense of ease and comfort and the latter conveys a sense of readiness to engage.

Textually, the gestures made by Lee are usually fast and often of a single beat. In comparison, Mei makes her gestures more slowly and, almost deliberately, to advance her pedagogic point. She does this regularly with the aid of rhythmic beats for emphasis. Students are usually the directional goals to whom Lee points to with his hand. This usually draws the students' prompt attention. However, the act of pointing at students is also an exercise of authority and power that Lee carries as a teacher. This is despite his deictic gesture being moderated frequently by the option to point more generally with the hand, rather than with a finger. In contrast, Mei usually points to the screen with her index finger and often through the visualiser. This suggests precision and focus on the lesson materials projected on the screen.

TABLE 6.4 Gestures comparisons

Lee	Mei
More presenting action	Less presenting action
More presenting action: state	Less presenting action: state
More presenting action: material	Less presenting action: material
More presenting action: mental	Less presenting action: mental
Less indexical action	More indexical action
Less indexical action: importance	More indexical action: importance
Less indexical action: receptivity	More indexical action: receptivity
Less indexical action: relation	More indexical action: relation
Less representing action	More representing action
More representing action: participant	Less representing action: participant
Less representing action: process	More representing action: process
More palms-down gesture	More palms-open gesture
More lean forward position	Less lean forward position
More hands at leg level	More hands at waist level
More negative attitude	More positive attitude
More fast graduation	More slow graduation
More contraction of negotiation space	More expansion of negotiation space
Less possibility	More possibility
More single beat	More beats
More point with hand	More point with index finger
More point at students	Less point at screen
More handling of laptop	Less handling of laptop
Less handling of notes	More handling of notes
No handling of visualiser	More handling of visualiser

Semiotic technologies

Notably, both Lee and Mei neither used new semiotic technologies nor popular semiotic technologies, such as PowerPoint presentations, in their lessons. This could be because during the time when the data was collected, in 2009, the widespread usage of these semiotic technologies was not as prevalent as compared to the present state of classrooms, now more than a decade later. Notwithstanding, Lee used a laptop and screened three videos using the projector screen during his lessons. Mei also used the projector screen and the visualiser to display her annotated notes on the passage for reading. Both teachers also used traditional semiotic technologies, that is the whiteboard, with Mei using it more frequently than Lee. The comparisons between Lee and Mei's use of semiotic technologies is shown in Table 6.5.

Lee spends a significant portion of time in his lesson on video-screening. Video-screening takes up almost 16 minutes (15.62%) and is ranked second highest amongst all the lesson microgenres in his class. Lee used the laptop to project three

TABLE 6.5 Semiotic technologies comparisons

Lee	Mei
Use of videos	No use of videos
Use of laptop	No use of laptop
No use of visualiser	Use of visualiser
More use of projection screen	Less use of projection screen
Less use of whiteboard	More use of whiteboard

video clips obtained from YouTube in his lesson and screened the three videos consecutively. For Lee, video-screening contributes to the acquisition of content knowledge. Lee refers to the video in his subsequent discussion on two occasions. The first is when he asks, 'Did watching the few video clips help us to understand that?' and the second is when he mentions, 'as we saw in the short video'.

The affordances of using videos is that they have the potential to impart detailed content knowledge with clarity and authentic examples, in a visually stimulating and multimodally engaging manner. However, one of the limitations of using videos is the significant time investment and the inclusion of extraneous details that are not pertinent to the lesson's objectives.

The regular use of the semiotic technologies of the projector screen, laptop, visualiser, and whiteboard tend to restrict the teacher's use of classroom space. This observation is consistent with Jewitt's (2011) study of the use of interactive whiteboards in the classroom, where the tendency is for the teachers to limit their movement and stand around them. While there are functional affordances offered in the use of semiotic technologies, teachers should be aware of their opportunity cost as well as how these semiotic technologies can be used most aptly in the lesson.

Both teachers inhabit the space around the teacher's desk regularly, for practical reasons, which are to use the visualiser and operate the laptop. The main reason Lee enters that space behind the teacher's desk is to operate the laptop, but he almost never teaches from that position. Mei, on the other hand, spends a significant part of the lesson teaching behind teacher's desk. Mei's use of the visualiser to display her notes confines her to this space and reconfigures the personal space into an authoritative space.

Semiotic cohesion

Despite the similarities in the lesson microgenres, the lesson objectives and materials, the multimodal analysis conducted in the previous sections revealed very different use of semiotic resources by the two teachers. Through their multimodal classroom orchestration, specific pedagogies are expressed, and unique classroom experiences are designed for the students. In this section, the contextualising relations across the range of semiotic resources used by Lee and Mei are examined more closely to explore their semantic convergence and divergence.

The organisation of Lee's lesson is more complex as compared to Mei's. This is co-contextualised with his less structured use of space and movement where he tends to stand off-centre at the front of the classroom. He also tends to move around the classroom during the lesson more frequently than Mei. These semiotic choices bring about a semantic convergence where a sense of dynamism and informality is expressed through Lee's pedagogy.

This sense of casualness expressed in Lee's spatial pedagogy is re-contextualised with his use of the semiotic resources of language and gestures. Lee's uses of imperatives and high modality, such as 'should' and 'must' express a sense of power and authority through his language. In his gestures, Lee tends to express more negative attitude, more contraction of negotiation space, as well as less possibility. Lee's use of language and gestures form co-contextualising relations to bring about semantic convergence, where an authoritative pedagogy is expressed. This is also co-contextualised with Lee's use of semiotic technologies of videos screened on a projector for a significant part of the lesson. The use of a screen-based semiotic technology affords for a more teacher-centred learning experience where the representation of knowledge is privileged over the more organic negotiation of knowledge amongst students in a more participative pedagogy.

Lee's use of language, gestures, and semiotic technology to assert and express his pedagogic authority enters into a re-contextualisng relationship with his use of positioning and movement and the loose ordering of the lesson microgenres. The overall effect of this re-contextualisation is that of semantic divergence, which leads to an expression of an authoritative pedagogy, mitigated by instances of casualness.

Mei's lesson has a clear structure evident in the sequencing of the lesson microgenre. This co-contextualises with her spatial pedagogy, where she uses the authoritative space regularly, and displays few movements in the classroom. Mei tends to limit her positioning and movement to the front of the classroom. This also co-contextualises with her use of gestures, where she tends to adopt a formal poise of hands at waist level. In addition, Mei's use of semiotic technologies, that is her frequent use of the whiteboard and visualiser also co-contextualises with her use of space and movement. Mei's use of semiotic modes and semiotic technologies bring about a semantic convergence, where the ideational meanings made through a structured unfolding of knowledge representations are expressed.

This is re-contextualised in light of Mei's use of language and gestures. Linguistically, Mei uses adjuncts and words that express low modality through words like 'might' and 'could' to indicate tentativeness and openness. The interpersonal meanings made are that of low power and foster a sense of solidarity with the students. Mei's use of language is co-contextualised with her use of gestures, where there is a high amount of indexical action to express receptivity, as well as gestures that expand the negotiation space and express possibilities. The use of language and gestures together brings about semantic convergence of a sense of relatability and informality.

Semantic divergence is expressed when Mei's spatial pedagogy, use of semiotic technologies, and logical organisation of her lesson as evident in the lesson microgenres, are re-contextualised with her use of language and gestures. Through

Mei's spatial pedagogy, use of semiotic technologies, and logical organisation of her lesson, she asserts a clear pedagogic authority and facilitates a structured representation of knowledge. Through Mei's use of language and gestures, she expresses the interpersonal meanings of a sense of relatability and informality. This works well for Mei as she is able to achieve her lesson objectives, encourage students' participation, and bring about overall enjoyment of her lesson. This is also indicated through the frequent occurrences of her students' laughter. Mei's use of semiotic modes and semiotic technologies is an example of a multimodal classroom orchestration. It appears that Mei has expressed a participative pedagogy through orchestrating a sense of structured informality in her use of multimodal semiotic resources.

It should be acknowledged here that the descriptions of Lee and Mei's unique pedagogies are based solely on the researcher's interpretation of how they have used the various semiotic resources during the lesson. This follows from the multimodal discourse analysis approach where the pedagogic discourse expressed by the teachers are coded, analysed, visualised, and interpreted by the researcher to explore the meanings communicated. This follows the principle within social semiotics in the recognition that every act of meaning-making, regardless of intent and consciousness, is motivated, and can be studied to identify the meanings made.

One evident limitation of the approach adopted in the study is that neither the teacher nor students were interviewed to elicit their perspectives on the lesson. The reflections from the teachers on their intentions and from the students on their experience could yield insights that might affirm or challenge the analyst's interpretations. It is increasingly recognised that multimodal discourse analyses can be enriched with approaches from ethnography and reception studies. See for example the recent arguments made by Bateman, Wildfeuer, & Hiippala (2018) on the need for empirical research methods for multimodality.

Structured informality

The notion of 'structured informality' is proposed in Lim (2011, 2019) and Lim, O'Halloran, and Podlasov (2012), based on observations from Mei's lessons. Structured informality is where a specific combination of semiotic choices made in the classroom is coordinated to construct a conducive learning environment for students where explicit display of power dynamics between the teacher and students are managed. Through specific semiotic choices which function to maintain a didactic structure for learning, other semiotic choices are made to mitigate the hierarchical distance between the teacher and students. This achieves a degree of rapport building and solidarity between teacher and students uncommon in more traditional authoritative classrooms.

Savery and Duffy (1995) propose that a teacher should structure the learning experience just enough to make sure that the students get clear guidance and parameters within which to achieve the learning objectives. However, the learning experience should be open and free enough to allow for the students to discover, enjoy, interact, and arrive at their own understanding and construction of knowledge.

In Systemic Functional Theory terms, structured informality is constructed in the classroom when the teacher projects a range of interpersonal meanings which are juxtaposed against an organised presentation of ideational and textual meanings in the knowledge structure of the lesson. The ideational meanings in the classroom, which are how knowledge is represented in the lesson, are cogently expressed in a well-structured manner. The textual meanings in the classroom are expressed in the organisation of the knowledge via well-designed stages as they unfold progressively in the lesson microgenres to structure the learning experience. However, the interpersonal meanings in the classroom, specifically the teacher–student relationship, are kept generally informal, with overt authority and power avoided, in order to construct a collegial learning environment.

Structured informality is especially relevant for the Pre-University level, where this study is conducted, because the students are adolescents. As the Ministry of Education commissioned study in Singapore explains, adolescence 'is a time of identity formation, of asserting independence and of changing relationships' (Ministry of Education, Singapore, 2010: 23). As such, '[t]his generally leads to adolescents showing less deference to their teachers compared with primary school pupils' (Ministry of Education, Singapore, 2010: 24).

Hence, structured informality, with clear structure in the presentation of ideational and textual meanings in the lesson but with informal interpersonal meanings, can arguably facilitate effective teaching and learning. This is because skills and content knowledge are transmitted in a collegiate setting where the adolescent students are put at ease as a result of specific choices in the enacting of the interpersonal relationships between the teacher and students.

The emergent meaning of structured informality, as observed in Mei's lesson, provides insights into how a specific learning experience can be designed by the teacher through multimodal classroom orchestration. This pedagogy may be particularly pertinent for classrooms where the adolescent students are generally more reticent and reluctant to verbalise their opinions and participate in the lesson.

Structured informality in the classroom is an example of effective multimodal classroom orchestration. It shows how teachers can design a collegial learning experience, within an ordered series of lesson stages with structured knowledge representations, and where students are encouraged to participate actively in their learning. With structured informality, teachers can design a learning environment where students are encouraged and are comfortable enough to engage with, participate, and challenge the teacher and the knowledge representations, as part of their learning.

In this chapter, we have explored how the combination of semiotic resources can work together to express the pedagogy of the teacher. Drawing examples from the case studies of Lee and Mei, we have considered how the contextualising relationship across the embodied semiotic modes and semiotic technologies can bring about both semantic convergence and semantic divergence. The semantic divergence can bring about ambivalence or work productively towards expressing the emergent meaning of structured informality where the formal ideational and

textual meanings and informal interpersonal meanings interplay to facilitate more engaging and participative learning experiences for the students. Developing this semiotic awareness can support the apt use of multimodal embodied modes and semiotic technologies to design unique learning experiences.

REFLECTION QUESTIONS

1. How can teachers use their bodily resources and different teaching tools to express their pedagogy?
2. How can teachers design for 'structured informality' in students' learning experience?

References

Baldry, A.P. & Thibault, P. (2006). *Multimodal Transcription and Text Analysis*. Sheffield: Equinox Publishing.

Bateman, J.A. (2014). *Text and Image: A Critical Introduction to the Visual/Verbal Divide*. New York: Routledge.

Bateman, J.A., Wildfeuer, J., & Hiippala, T. (2018). *Multimodality: Foundations, Research and Analysis: A Problem-oriented Introduction*. Berlin & Boston: De Gruyter.

Daly, A. & Unsworth, L. (2011). Analysis and comprehension of multimodal texts. *Australian Journal of Language and Literacy* 34(1), 61–80.

Greiffenhagen, C. (2008). Video analysis on mathematical practice? *Forum on Qualitative Social Research* 9(3). Retrievded from www.qualitative-research.net/index.php/fqs/article/view/1172/2585 (accessed: 28 Oct. 2019).

Halliday, M.A.K. (1978). *Language as Social Semiotic: The Social Interpretation of Language and Meaning*. London: Edward Arnold.

Halliday, M.A.K. (1994[1985]). *An Introduction to Functional Grammar*, 2nd edn. London: Arnold.

Iedema, R. (2003). Multimodality, resemiotisation: Extending the analysis of discourse as multi- semiotic practice. *Visual Communication* 2(1), 29–57.

Jewitt, C. (2011). The changing pedagogic landscape of subject English in UK classrooms. In K.L. O'Halloran & B.A. Smith (eds), *Multimodal Studies: Exploring Issues and Domains* (184–201). London & New York: Routledge.

Jewitt, C. (2013). Multimodality and digital technologies in the classroom. In I. Saint-Georges & J.J. Weber (eds), *Multilingualism and Multimodality. The Future of Education Research* (141–152). Sense Publishers: Rotterdam.

Jewitt, C., Bezemer, J., & O'Halloran, K. L. (2016). *Introducing Multimodality*. London: Routledge.

Jiang, J.X. & Lim, F.V. (submitted for publication). A Multimodal Discourse Analysis of TED Talks.

Kress, G. (2009). What is mode? In C. Jewitt (ed.), *The Routledge Handbook of Multimodal Analysis* (54–67). London & New York: Routledge.

Kress, G. & Bezemer, J. (2015). *Multimodality, Learning and Communication: A Social Semiotic Frame*. London: Routledge.

Kress, G., Jewitt, C., Ogborn, J., & Charalampos, T. (2001). *Multimodal Teaching and Learning: The Rhetorics of the Science Classroom.* London: Continuum.

Kress, G., Bourne, J., Franks, A., Hardcastle, J., Jewitt, C., Jones, K., & Reid, E. (2005). *English in Urban Classrooms: A Multimodal Perspective on Teaching and Learning.* London: RoutledgeFalmer.

Lemke, J.L. (1998). Multiplying meaning: Visual and verbal semiotics in scientific text. In J.R. Martin & R.Veel (eds), *Reading Science* (87–113). London: Routledge.

Lim, F.V. (2004). Developing an integrative multisemiotic model. In K.L. O'Halloran (ed.), *Multimodal Discourse Analysis: Systemic-Functional Perspectives* (220–246). London: Continuum.

Lim, F.V. (2007). The visual semantics stratum: Making meaning in sequential images. In T. Royce & W. Bowcher (eds), *New Directions in the Analysis of Multimodal Discourse* (195–214). New Jersey: Lawrence Erlbaum Associates.

Lim, F.V. (2011). A Systemic Functional Multimodal Discourse Analysis Approach to Pedagogic Discourse. Doctoral thesis. National University of Singapore.

Lim, F.V. (2019). Investigating intersemiosis: A systemic functional multimodal discourse analysis of the relationship between language and gesture in classroom discourse. *Visual Communication*, 1–25. https://doi.org/10.1177/1470357218820695

Lim, F.V. (submitted for publication). Towards Education 4.0: An Agenda for Multiliteracies in the English Language Classroom.

Lim, F.V. & O'Halloran, K.L. (2012). The ideal teacher: Analysis of a teacher recruitment advertisement. *Semiotica* 189, 229–253.

Lim, F.V., O'Halloran, K.L., & Podlasov, A. (2012). Spatial pedagogy: Mapping meanings in the use of classroom space. *Cambridge Journal of Education* 42(2), 235–251.

Lim & Toh, W (submitted for publication). Towards a Literacy for Digital Reading.

Liu, Y. & O'Halloran, K. L. (2009). Intersemiotic texture: Analyzing cohesive devices between language and images. *Social Semiotics* 19(4), 367–388.

Martin, J.R., Matthiessen, C.M.I.M., & Painter, C. (1997). *Working with Functional Grammar.* London: Arnold.

Martinec, R. (2000). Construction of identity in Michael Jackson's 'Jam'. *Social Semiotics* 10(3): 313–329.

Matthiessen, C.I.M.M. (2009). Multisemiosis and context-based register typology: Registeral variation in the complementarity of semiotic systems. In E. Ventola & A.J.M. Guijarro (eds), *The World Told and the World Shown: Multisemiotic Issues* (11–38). Chichester: Palgrave Macmillan.

Ministry of Education, Singapore. (2010). Secondary education review and implementation (SERI). Retrieved from https://planipolis.iiep.unesco.org/sites/planipolis/files/ressources/singapore_seri_2010.pdf (Accessed: 29 Oct 2019).

Moschkovich, J. (2002). A situated and sociocultural perspective on bilingual mathematics learners. *Mathematical Thinking and Learning* 4(2–3), 189–212.

O'Halloran, K.L. (1998). Classroom discourse in mathematics: A multisemiotic analysis. *Linguistics and Education* 10(3), 359–388.

O'Halloran, K.L. (2005). *Mathematical Discourse: Language, Symbolism and Visual Images.* London: Continuum.

O'Halloran, K.L. (2007). Systemic functional multimodal discourse analysis (SF-MDA) approach to mathematics, grammar and literacy. In A. McCabe et al. (eds), *Advances in Language and Education* (75–100). London: Continuum.

O'Halloran, K.L. (2008). Systemic functional–multimodal discourse analysis (SF-MDA): constructing ideational meaning using language and visual imagery. *Visual Communication* 7(4), 443–475.

O'Halloran, K.L. (2011). The semantic hyperspace: accumulating mathematical knowledge across semiotic resources and modes. In F. Christie & K. Maton (eds), *Disciplinarity: Functional Linguistic and Sociological Perspectives* (217–236). Sydney Australia: Bloomsbury Publishing.

O'Halloran, K.L. (2015). The language of learning mathematics: A multimodal perspective. *The Journal of Mathematical Behaviour* 40, 63–74.

O'Halloran, K.L. (forthcoming). *A Multimodal Approach to Classroom Discourse.* Sheffield: Equinox.

O'Halloran, K.L. & Lim, F.V. (2009). Sequential visual discourse frames. In E. Ventola & A.J.M. Guijarro (eds), *The World Told and the World Shown: Multisemiotic Issues* (139–156). Chichester: Palgrave Macmillan.

O'Halloran, K.L., Podlasov, A., Chua, A., Tisse, C.-L., Lim, F.V., & Smith, B.A. (2013). Challenges and solutions to multimodal analysis: Technology, theory and practice. In Y. Fang & J. Webster (eds), *Developing Systemic Functional Linguistics: Theory and Application* (271–297). London: Equinox.

O'Halloran, K.L. & Lim, F.V. (2014). Systemic functional multimodal discourse analysis. In S. Norris & C. Maier (eds), *Texts, Images and Interactions: A Reader in Multimodality* (135–154). Berlin: De Gruyter.

O'Halloran, K.L. et al. (2019). Interpreting text and image relations in violent extremist discourse: A mixed methods approach for big data analytics. *Terrorism and Political Violence* 31(3), 454–474.

Painter C., Martin, J.R., & Unsworth, L. (2011). Organizing visual meaning: Framing and balance in picture-book images. In E.A. Thompson et al. (eds), *Semiotic Margins: Meaning in Multimodalities* (125–143). London: Continuum.

Roth, W-M, & Jornet, A. (2014). Towards a theory of experience. *Science Education* 98(1), 106–126.

Royce, T. (1998). Synergy on the page: Exploring intersemiotic complementarity in page-based multimodal text. *JASFL Occasional Articles* 1, 25–49.

Royce, T. (2006). Intersemiotic complementarity: A framework for multimodal discourse analysis. In T. Royce & W.L. Bowcher (eds), *New Directions in the Analysis of Multimodal Discourse* (63–109). Mahwah, NJ: Lawrence Erlbaum.

Savery, J.R. & Duffy, T.M. (1995). Problem based learning: An instructional model and its constructivist framework. In B. Wilson (ed.), Constructivist Learning Environments: Case Studies in Instructional Design (135–150). New Jersey: Educational Technology Publications.

Takahashi, J. & Yu, D. (2017). Multimodality in the classroom: An introduction. *Teachers College, Columbia University Working Articles in TESOL & Applied Linguistics* 16(2): i–vi.

Taylor, R. (2014). Meaning between, in, and around words, gestures and postures: Multimodal meaning making in children's classroom communication. *Language and Education*, 28(5), 401–420.

Thibault, P. (2000). The multimodal transcription of a television advertisement: Theory and practice. In A. Baldry (ed.), *Multimodality and Multimediality in the Distance Learning Age* (331–385). Campobasso, Italy: Palladino Editore.

Thibault, P. (2004). *Brain, Mind and the Signifying Body: An Ecosocial Semiotic Theory.* London: Continuum.

Towndrow, P.A., Nelson, M.E., & Yusuf, W.F.B.M. (2013). Squaring literacies assessment with multimodal design: An analytic case for semiotic awareness. *Journal of Literacy Research* 45(4), 327–355.

Unsworth, L. & Cleirigh, C. (2009). Multimodality and reading: The construction of meaning through image-text interaction. In C. Jewitt (ed.), *The Routledge Handbook of Multimodal Analysis* (151–163). London & New York: Routledge.

7
DESIGNING LEARNING

Changing learners

This book is about how teachers can make use of their bodily resources and harness appropriate tools to design unique learning experiences for their students. We have explored the different types of discourses in the classroom, and how identifying the types of discourses used by the teacher can be useful in evaluating the focus of the lesson. We have also considered how the teacher's positioning and movement in the classroom, as well as her use of gestures, can work together with language, in a multimodal classroom orchestration to express the teacher's pedagogy. In addition, we have also examined the teacher's use of semiotic technologies, ranging from the traditional whiteboard and PowerPoint presentations to new technologies such as interactive learning systems with analytics, powered by artificial intelligence. The interest is in how the teacher's use of semiotic modes and semiotic technologies can afford various ways of knowledge representations, enact specific pedagogic relations, and contribute to the organisation and design of the student's learning experience. The discussion in this book is exemplified with the discussion of how teachers can orchestrate the range of multimodal semiotic resources to express an appropriate pedagogy for adolescent students in the design of their learning experience. One example of a pedagogy expressed through the teacher's multimodal classroom orchestration is described as structured informality.

This book has focused primarily on the teacher and on teaching. The premise has been that 'good' teaching is fundamental to productive learning. In this last chapter, we will turn our attention briefly to the learner and on learning. We will consider the changing profile and needs of the students in today's digital age, and explicate our assumptions on learning from a social semiotic lens. In this chapter, we will also reflect on what it means to be designing learning, both of experiences and environments. I will trace the development of the concept of design in learning

and discuss how these understandings inform the teacher's role as a designer of learning. This chapter concludes with the relevance and implications of the ideas discussed in this book to three groups of people – educational researchers, teacher-practitioners, and curriculum policy specialists. Finally, I discuss the contributions of this work, and possible future research directions, in light of preparing our students for the digital age.

The challenge for teachers today is to teach differently from the ways they were taught when they were students. I argue that teachers, as designers of learning, would need to develop a repertoire of strategies to engage today's learners and guide their learning. I posit that this involves the teacher developing both a semiotic awareness and a fluency in multimodal orchestration to design the students' learning experience. Some teachers may wonder why this is necessary when the traditional pedagogies have served teachers reasonably well over the years. A compelling reason for teachers to rethink and review their pedagogies is the recognition that the profile and needs of students in our classes have changed, and are changing, in today's digital age.

For a research project on multiliteracies in Singapore, we interviewed a group of nine-year-old children in a primary school in Singapore on what they would do after school when they go home. We were interested in understanding the 'literacy events' (Street, 1993) which they experience on a daily basis. Of the six students interviewed, all confessed to indulging in watching YouTube videos in the afternoon – some with their caregivers' permission. Three out of the six students also spoke excitedly about creating their own YouTube videos, uploading and sharing them in the public domain where anybody with the link can access. A girl, whose ambition was to be a professional dancer, records her dance routines and, together with her mother, curates her favourite performances, and uploads the videos on her personal channel. A boy, whose passion was in trains, shows off his growing train collection memorabilia in his videos. Another boy claims to make videos on 'random things' – which involved participating in the latest fads, and sub-cultures, trending on the Internet. This includes challenges such as making 1000 dabs and 'try not to laugh' videos, as well as toy 'unboxing' videos, 'how to' videos on making slime and videos of his game-play on Minecraft and Fortnite, imitating the likes of popular YouTube influencers. Such is the extent of the new literacy practices that children participate in the contemporary communication landscape. Children's self-directed multimodal authoring practices are an expression of their identity and culture and reflect the changing profiles and needs of learners in our classrooms and schools (Lim & Toh, in press).

These new literacy events and practices are made possible because of the easy access of students to a wide range of semiotic technologies in this digital age. Digital technology has presented our students today with an expansive and powerful array of semiotic resources to express their ideas, experiences, and identities. The 'literacy-events' of even the very young children are often mediated through a screen – as an interface into a digital world of infinite possibilities for semiosis. Young children are entertained, and often educated, as they watch videos, play games, and swipe across

photos, on their parents' and, often, personal tablets and mobile phones. These literacy events and practices as well as new semiotic technologies challenge the traditional view that a solely language-based curriculum is sufficient for the students and invite us to reflect on the literacy and learning needs of today's learners.

Considering the contemporary communication environment, with a myriad of technological tools offering a rich and new potential for meaning-making for our young, what then should the response of educators be? There are two dimensions in which we can offer our responses. The first being the pedagogical shifts that are required, that is rethinking how we teach our students, and the second being the curricular shifts that are required, that is rethinking what we teach our students. In this book, we have focused mainly on the first implication, which is the transformation of the teacher's role today from that of a sage on stage to that of a designer of learning. As Unsworth (2006a: 55) argues, '[a]n acknowledgement of the ways in which exponentially expanding and improving technology is changing the dynamics of pedagogic practices is essential to maintaining children's engagement with learning'.

The second implication involves the review and refresh of what we are teaching our students in the curriculum and whether the knowledge and skills are still relevant for our young today, as we prepare our students for the world of tomorrow. An example of a response towards curricular shifts is for the language curriculum to reflect an expanded notion of literacy, beyond language learning (Weninger, 2019; Lim, submitted for publication). Just after the turn of the millennium, Len Unsworth, Professor of English and Literacy Education, at the Australian Catholic University, had observed that

> [w]hile many of the fundamentals of established, language-based literacy pedagogies will endure in the foreseeable future, they are by no means sufficient for the development of the kinds of literacy practices that already characterise the continuously evolving information age of the new millennium.
>
> (Unsworth, 2002: 62)

He describes that what is needed is 'a plurality of literacies'. New skills for reading, finding information, authenticating information, and manipulating, linking and representing information are demanded in this increasingly interactive digital media enabled multimodal environment. Jewitt (2008: 244) notes that the recognition of the different types of literacies needed for the world of tomorrow 'marks a shift from the idea of literacy as an autonomous neutral set of skills or competencies that people acquire through schooling and can deploy universally to a view of literacies as local and situated'. Along a similar vein, John Potter and Julian McDougall in their book *Digital Media, Culture and Education: Theorising Third Space Literacies* (2017) propose the term 'dynamic literacies' to capture the range of literacies – from multiliteracies to digital literacy, from media literacy to multimodal literacy – students need to develop in preparation to navigate and be full participants in today's information landscape.

The subject of curricular shifts needed in response to the changing profile and needs of learners today is fodder for another, though related, trajectory of research within multimodality in education, specifically that of multiliteracies and multi-modal literacy, which I have explored in Lim (2018), Lim and Tan (2017; 2018), and Lim, O'Halloran, Tan, and E (2015). In this book, we will focus on the peda-gogic shifts needed in response to today's learners. I argue that the pedagogic shift involves an evolution of the role of the teacher from that of an authority of know-ledge to that of a designer of learning. We have looked at how a teacher can use embodied semiotic modes and semiotic technologies to express a pedagogy that encourages students' engagement and learning. In the next section, I shall explicate the assumptions and beliefs about learning from the social semiotic lens.

Defining learning

The social semiotic account of learning has been described in Jeff Bezemer and Gunther Kress's foundational text, *Multimodality, Learning, and Communication: A Social Semiotic Frame*. Bezemer and Kress (2016) argue that learning is essentially meaning-making and that learning happens whenever there is engagement. The term 'transformative engagement' is introduced 'in recognition of the fact that sign-makers do not "simply" – so to speak – copy, acquire, somehow straightfor-wardly internalize or absorb signs made by others… Learning… rests on inter-pretation as the outcome of principled, transformative engagement' (Bezemer & Kress, 2016: 38). Applying the semiotic lens of learning, we shall examine three other aspects of learning in relation to meaning-making through the students' transformative engagement with the knowledge. They are the understandings that learning is social, semiotic, and embodied.

Learning is a social practice where the students engage and negotiate with the knowledge representations through a pedagogical relationship with the teacher and, at times, collectively, with other students. Kress et al. (2005: 14) explain that 'the interpersonal and ideational transactions of education are shaped by social relationships… and that the classroom is, in important ways, a site of conflicts, to which the teacher's rhetorical activity is a response'. The process of collective nego-tiation of meaning is fundamental to learning as learning is about communication (Bezemer & Kress, 2016). Cope and Kalantzis (2015: 39) argue that 'learning is also very social, as we rely on the artefacts of collective memory, and work with others in the essentially collaborative task of knowledge making'. As such, learning is not just an individual achievement, but an engagement in communication with the teacher, and often in collaboration, with other learners.

Learning is semiotic in that it is about meaning-making. Kress (2007: 37) explains that the signs of learning 'can be seen as the individual's agentive selec-tion from engagement with and transformation of the world according to their principles'. The meaning-making in learning is also multimodal in nature. Lemke (2002: 23) explains that

semiotically, we never in fact make meaning with only the resources of one semiotic system: words conjure images, images are verbally mediated, writing is a visual form, algebra shares much of the syntax and semantics of natural language, geometric diagrams are interpreted verbally and pictorially, even radio voices speak to us of individuality, accent, emotional states and physical health through vocal signs not organized by the linguistic code.

In this light, learning is semiosis, both in the reception of meaning made, and in the production of meaning.

Learning is also embodied and involves material ways of knowledge representations. Students experience the teacher's multimodal classroom orchestration and construe the meanings made through the teachers' embodied semiotic modes, and use of semiotic technologies. This challenges the dominant paradigm as to what the teacher says is the main source of knowledge representation in the classroom. The social semiotic lens on learning posits that meaning is made, and knowledge is represented multimodally, through the teacher's use of embodied semiotic modes and semiotic technologies. Kress (2000) argues that multimodality is biological and intrinsic to all human beings. Kress (2000: 159) draws attention to the process of synaesthesia, which he describes as 'the transduction of meaning from one semiotic mode to another semiotic mode, an activity constantly performed by the brain'. In other words, the translation and interpretation of meanings through transformative engagement occurs as part of the cognitive functioning of the brain. Notwithstanding, Cope and Kalantzis (2015: 39) point out that 'knowledge is not (just) the stuff that ends up in our minds. It is what we do and make. Learning is a consequence of a series of knowledge actions, using multimodal media to externalize our thinking.' In this regard, the view of a teacher as a sage on a stage, dispensing words of wisdom, to students is increasingly irrelevant to the changing learners' profile and needs in today's digital age. Central to the pedagogic shift required today is the recognition that a teacher would need to orchestrate the use of embodied semiotic modes and semiotic technologies to design lesson experiences that both engage and educate the students. In this regard, learning is embodied and experienced through the verbal, visual, aural, and somatic sensory modes of the students. As such, learning is not just a cognitive achievement, but involves various embodied sensory resources, both through the teacher's multimodal classroom orchestration and the learner's transformative engagement.

Teachers as designers of learning

As part of the pedagogic shift, the role of teacher is evolving from that of merely transmitting knowledge to that of designing learning. Designing learning involves the teacher's skilful orchestration of the use of semiotic modes and semiotic technologies. The notion of design is not just about 'competence in use' which is traditional and 'oriented to the past'. Instead, the notion of design 'is prospective, future-oriented' and 'starts from the interest and the intent of the designer' (Kress,

2003: 169). Kress and Selander (2012: 267) elaborate that design 'offers the possibility to an agent to project her or his wishes, desires, proposals, forward into an imagined social future' – in this context, what the learning experience can possibly be. This requires the teacher to take on an active role in designing appropriate learning experiences in relation to the learning objectives as well as in response to the profile and needs of today's learners. As such, the teacher's agency and power to influence the learning experience and environment in the classroom have been the focus in this book. The changing profile of learners places a demand on the teacher to hone a repertoire of pedagogical strategies undergirded by a semiotic awareness and fluency in multimodal classroom orchestration.

The concept of 'designing learning' stems from the seminal work of the New London Group (1996). In what they described as a manifesto, *A Pedagogy of Multiliteracies: Designing Social Futures*, the members of the New London Group, comprising Courtney Cazden, Bill Cope, Norman Fairclough, Jim Gee, Mary Kalantzis, Gunther Kress, Allan Luke, Carmen Luke, Sarah Michaels, and Martin Nakata, introduced the concept of 'multiliteracies' and of 'pedagogy as design' to the world. The New London Group argued for curriculum reforms as a design for social futures so as to bring about greater social justice and equity. Teachers are to step into the role as designers of learning experiences and environments in the classroom. In their work, the New London Group argue that learning is meaning-making, and that teaching should be seen as design work. They develop the Learning by Design framework (New London Group, 1996, 2000) which describes the design processes as three elements: Available Designs, Designing, and The Redesigned. The Available Designs refer to the resources for Meaning or the available Designs of Meaning. It includes the 'grammars' of various semiotic systems and the 'orders of discourse' (particular configuration of Design elements). Designing refers to the work performed on or with Available Designs in the semiotic process. It involves re-presentation and recontextualisation. The Redesigned refers to the resources that are produced and transformed through Designing.

The idea of design in meaning-making has also been further developed by Gunther Kress, in his work on social semiotics and multimodality over the years. The term 'design(er)' or sign-maker has been used by Kress (2000, 2003: 4) to describe the individual who creates a message by judging the most apt mode that is suitable for his purposes, interests, and desires in a sociocultural context. Kress (2003: 28) argues that the shift in moving from a focus on the competent performance of children to the design [of the learning experience] as the foundational fact of contemporary social and economic life. In multimodal communication, the concept of design is deemed necessary for an informed, reflective, and productive practice (Kress, 2003: 28) due to the increased possibilities of choice made available with new ways of meaning-making. We extend this to recognising the role of teacher as a designer of learning in the classroom. As a designer of learning, the teacher judges the best way in which the learner can best achieve their learning outcomes, is mindful of how she uses the embodied semiotic modes and semiotic technologies

with an awareness of their affordances and demonstrates an aptness and fluency in use, expressing her pedagogy through multimodal classroom orchestration.

The notion of designing learning has also been extended by others, most notably by Staffan Selander, Senior Professor at Stockholm University in his work on designs for learning. Selander (2008: 14) challenges the traditional notion that 'the role of the teacher is to "bring" knowledge to the student, and the student's role is to remember by heart and to learn specific skills'. Instead, Selander (2008: 12) argues that the concept of designs for learning

> highlights the material and temporal conditions for learning as well as the learning activity itself… learning is an activity where signs in different media (information) are elaborated, and where the forming of new signs in new media (re-configuration and re-contextualization) takes place.

As such, as discussed in the earlier section, the social semiotic lens on teaching and learning is that learning is meaning-making, and that learning is socially situated and is achieved through embodied ways. The teacher, hence, takes on the role of the designer, and like all designers, reflects on her use of material resources and the structures of power in a specific environment to best express her meanings (Kress & Selander, 2012). As such, from the perspective of designing learning, the teacher is involved in the design work of multimodal classroom orchestration to best express a pedagogy for 'shaping social interaction' with students (Kress & Selander, 2012: 266).

The evolving role of teacher as designers of learning is also gradually gaining recognition and traction internationally as well. In 2018, the Organisation for Economic Co-operation and Development (OECD) published a report titled, 'Teachers as Designers of Learning Environment: The Importance of Innovative Pedagogies' by Alejandro Paniagua and David Istance. In the report, the authors argue for the importance of pedagogy in educational policy and that 'pedagogy must be deliberately designed' (Paniagua & Istance, 2018: 20). Pedagogy 'needs to be combined with expertise in the design of learning environments' and that 'the view of teachers is evolving from technicians who implement educational ideas and procedures of the curriculum to teachers as designers of learning environments and as experts in the art and science of teaching' (Paniagua & Istance, 2018: 20). The recognition of teacher as designers of learning has impacted not just on classroom practices, as the monograph from OECD represents, but has implications on educational policy, curriculum development, and, most directly, on teachers' professional practice and learning as well.

Educational systems from different parts of the world have also embraced the evolving role of teachers as designers of learning, even incorporating them as part of the goals in their educational framework. An example of this is Singapore, an internationally regarded high-performing educational system. With the expressed vision of preparing students to be future-ready, the Singapore Ministry of Education has championed for a paradigm shift in the teacher's role in the classroom as a learning

designer and in infusing the notion of 'design' into teaching and learning. In the Singapore ICT in Education Masterplan 4, launched in 2015, the role of teachers is described as 'designers of learning experiences and environments'. Teachers in Singapore are supported with 'sustained and differentiated professional learning' (ICT Connection, 2019) to grow into their roles as designers of learning. The vision and goals for teachers in Singapore ICT in Education Masterplan 4 represents a commitment from the system to respond adaptively to the changes brought about in today's digital age.

Designing learning with embodied teaching

In this book, I have offered ways to describe and discuss the teacher's use of embodied semiotic modes to make meaning and express her pedagogy through multimodal classroom orchestration. We have also explored how the use of semiotic technologies can influence the ways knowledge is represented, the nature of pedagogic relations between the teacher and students expressed, as well as contribute to the organisation of the students' learning experience.

The central thesis is that teachers are to become designers of learning experiences for their students and that this can be achieved through an apt and fluent use of meaning-making resources – both in terms of corporeal semiotic modes and semiotic technologies. This expectation is set against the pedagogical shifts which are needed in today's digital age to bring about various teaching and learning experiences for our students.

A key premise in this book is the recognition that teaching and learning are fundamentally about embodied ways of meaning-making. Jewitt (2008: 241) argues that 'how knowledge is represented, as well as the modality and media chosen, is a crucial aspect of knowledge construction, making the form of representation integral to meaning and learning more generally'. The recognition of the multimodal nature of pedagogic semiosis has consequences on the nature of curriculum content as well as on the teacher's pedagogical practices.

The ideas expressed here represent a contribution to the nascent field of educational semiotics, described in Chapter 1. Educational semiotics is about the application of multimodality in education. It focuses on meaning-making in learning and explores how the meaning ensembles are expressed through the range of semiotic resources, often taken for granted, in previous educational research. Research in multimodality and studies on multimodal discourses have flourished in the last two decades. In this book, we have situated our work within the approach of Systemic Functional Multimodal Discourse Analysis and have adopted the social semiotic lens on teaching and learning.

A goal of this book is to demonstrate the value of how recognising teaching and learning as multimodal meaning-making can be both productive in informing and influencing pedagogical practices. This book draws from the theories, principles, and ideas from the work of other scholars in the field of multimodality, and more fundamentally, from Systemic Functional Theory. Taken together, the application

of multimodality on the teacher's use of embodied semiotic modes and semiotic technologies to design students' learning experiences, represents a response towards Michael Halliday's clarion call for an 'appliable linguistics', where theories from linguistics inform and influence practice.

In this penultimate section, we will revisit the key ideas offered in this book and present the implications of these ideas by addressing the three potential groups of readers directly. First, I discuss the implications of the proposals and discussions in the book to other educational researchers, interested in studying teaching and learning from the multimodal social semiotic lens. Next, I also focus, in particular, on the teacher practitioners and address the implications of the ideas proposed on teaching and learning in the classroom. In addition, I also direct some of the recommendations towards educational administrators and curriculum specialists by highlighting the contributions of the relevant proposals made in this book on policymaking and educational reforms.

For the educational researchers, the recognition that pedagogic discourse is inherently multimodal is a powerful stimulus to inspire more work in researching educational semiotics. This book has proposed a way in which the multimodal discourses in the classroom can be coded and analysed through Curriculum Genre Theory and lesson microgenres. The value of this granular analysis of the types of discourses in the classroom is exemplified with an analysis of two English Language teachers in Singapore, drawn from an earlier corpus of study in Lim (2011).

In the proposal of mapping the pedagogic discourse of the teacher through coding the types of lesson microgenres, I extend Christie's (1993, 1997, 2002) Curriculum Genre Theory in classroom discourse analysis to multimodal pedagogic discourse. Curriculum Genre Theory was originally conceived to study the use of language in the classroom. Based on Lim (2011), instead of investigating language as the only semiotic mode, the Curriculum Genre Theory is extended to discuss the combination of embodied semiotic modes such as the teacher's use of language, gestures, positioning, and movement in the classroom to express a specific pedagogy. Multimodal research in the classroom reveals a certain inadequacy of classroom research which involves only language. Unsworth (2006b: 55) asserts that '[i]t is now widely accepted that literacy and literacy pedagogy can no longer be confined to the realm of language alone'. This recognition has 'significant implications in terms of epistemology and research methodology' (Jewitt, 2008: 245). A holistic understanding of the teaching and learning in the classroom requires consideration of the combination of multimodal semiotic selections, rather than a focus on language alone. Investigation into the nature of multimodal semiotic resources in the classroom offers a less impoverished understanding of the pedagogic work performed by the teacher in the classroom.

I have adopted O'Halloran's (1996, 2004) formulation of the lesson microgenres for the Mathematics classroom and have extended them to the English Language classroom. The lesson microgenres provide the immediate contextual reference for the meanings made by the multimodal semiotic resources in a given instance of the lesson. The sequence and time spent on each lesson microgenre also reflect

the pedagogic styles of the teachers. Furthermore, the lesson microgenres present a principled basis of comparisons across different lessons and by different teachers. The development of lesson microgenres as a methodological approach to study multimodal classroom discourse is also described more fully in Lim and Tan (submitted for publication).

Given the recognition that teaching is embodied and that meaning can be made across a range of corporeal semiotic modes, educational researchers would need a method to describe the ways meanings are made through these semiotic modes and the types of meanings made. This book introduces the notion of 'spatial pedagogy' and offers a categorisation of the different spaces in the classroom. As detailed in Lim (2011) and Lim, O'Halloran, and Podlasov (2012), Hall's (1966) work on proxemics is extended to multimodal pedagogic discourse analysis. Specifically, his formulation of Socio-consultative Space is applied to the classroom space where the teacher is positioned in relation with the students. The classroom space is sub-classified into Authoritative, Supervisory, Interactional and Personal spaces. These spaces are negotiated statically through the teacher's positioning and dynamically through the teacher's movement and pacing in the classroom. The teacher's semiotic selections in positioning, movement and pacing express what is described in Lim (2011) and Lim, O'Halloran, and Podlasov (2012) as a 'spatial pedagogy', which contributes to the design of the students' learning experience in the lesson. The typology of classroom spaces proposed provides a way for educational researchers to code and study the spatial pedagogy of the teachers, as well as to visualise and analyse their use of space in relation to the meanings made.

Likewise, the recognition that the teacher's use of gestures in the classroom is an embodied semiotic mode and can express specific types of meaning places a demand on educational researchers to have a way to code and describe the types of gestures used by the teacher as well as the meanings made. This book offers a typology of gestures, based on Lim (2011, 2019a) where both the form and functions of gestures can be coded for analysis. For example I describe the teacher's use of gestures in terms of Communicative Gesture and Performative Gesture. The notion of Performative Gesture enlarges the definition of gesture beyond that of 'wilful bodily movement' (Cienki, 2008: 6) and allows for the annotation of all actions, regardless of intent. The inclusion of Performative Gestures in the analysis also addresses the subjectivity in the researcher's bias on defining which movements are categorised as gesture. In terms of gestural-text relations, Communicative Gesture is sub-classified as Language Independent Gesture, Language Correspondent Gesture and Language Dependent Gesture. In order for the educational researchers to adequately describe the meanings made in the teacher's use of gestures, system networks, which detail the various types of meanings made through gestures are mapped out.

We have discussed the semiotic technologies available to the teacher in the classroom. Semiotic technologies are both tools and social practices – that is, in terms of what they are and how they are used. For educational researchers, adopting the view that the material and digital learning resources are semiotic technologies opens a space for discussing how these resources are not just channels of meaning-making

but in themselves are both artefacts of meaning-making and an expression of social practice. I have highlighted the importance of reflecting on the affordances in semiotic technologies and have illustrated with examples of popular digital semiotic technologies, such as PowerPoint presentation, new digital semiotic technologies, such as learning analytics in a web-based collaborative reading platform on students' personal computing devices, as well as traditional semiotic technologies, that is the whiteboard. Through the discussion, I hope to present to educational researchers a way to explore how semiotic technologies are used by the teacher to represent knowledge, define pedagogic relations, and contribute to the organisation of the learning experience for students.

This book also discussed how teaching and learning can be orchestrated with the use of the embodied semiotic modes and semiotic technologies. The notion of multimodal semiotic awareness and fluency in multimodal orchestration, based on Towndrow, Nelson, and Yusuf (2013); Lim & Toh (submitted for publication) and Lim (submitted for publication), are proposed in relation to the teacher's multimodal classroom orchestration. This is discussed in relation to the data of Lee and Mei from Lim (2011) and Lim (2019b). Through the teachers' use of embodied semiotic modes and semiotic technologies, we describe the pedagogy of 'structured informality'. Structured informality is where a specific combination of semiotic choices made in the classroom is coordinated to construct a participative learning environment for students where explicit displays of power dynamics between the teacher and students are managed. Through specific semiotic choices which function to maintain a didactic structure for learning, other semiotic choices are made to mitigate the hierarchical distance between the teacher and students. This achieves a degree of rapport between teacher and students uncharacteristic of traditional authoritative classrooms. The concept of structured informality in the classroom can be helpful for teachers to construct a non-threatening learning environment where students feel comfortable enough to respond and speak up within a structured progression of the lesson.

For educational researchers interested in extending this work, it can be productive to explore other different pedagogies that a teacher's multimodal classroom orchestration can express. For instance, how would the different combinations in the meanings made through the teacher's use of embodied semiotic modes and semiotic technologies in designing various types of learning experiences cater to the specific learning objectives and different profile and needs of students? How would the use of specific semiotic technologies, such as accessing a digital learning platform on students' personalised computing devices in the classroom, require a different multimodal classroom orchestration from the teacher in the design of students' learning experience? It can also be productive to complement the analysis of the teacher's embodied teaching with other empirical studies, such as reception studies, where the students' responses to the learning experiences as well as data on their subsequent learning and performance in assessment can be collected.

For the teacher in the classroom, such a recognition could bring about a greater sensitivity and reflexivity in their use of language, gestures, positioning, and

movement in the lesson. It also invites them to reflect on the affordances in their use of the whiteboard, PowerPoint presentation, or students' personal computing devices. Teachers are encouraged to think about what the gains and losses are (Kress, 2005), in terms of the ways knowledge can be represented, and the nature of their interaction and pedagogic relations expressed, when specific semiotic technologies are used. The hope is that with this awareness, it will bring about an aptness and fluency in their use of these resources in their lesson to achieve the learning objectives and cater to the profile and needs of their learners. While many teachers achieve an effective multimodal classroom orchestration through years of experience and intuition, I argue that these tacit understandings can be made explicit and with this, the process can be shortened as we develop teachers' awareness of the meaning-making potential in the repertoire of semiotic resources – that is the embodied semiotic modes and semiotic technologies they bring to the classroom.

For administrators and curriculum specialists, it is critical to reflect on the shifts needed in the educational system, in terms of the curriculum and pedagogy needed to prepare our students for the world of tomorrow. Given that it is now a cliché to say that the world is transforming due to the advances in digital technology, it is imperative to respond appropriately to the changes in our new communication, social and economic landscape as well as the changing profile and needs of learners today. The mandate for policymakers in education is to constantly review if what we are teaching and how we are teaching continues to be relevant and adequate in preparing our students well. We have argued that a fundamental pedagogical shift that is needed is to recognise the evolving expectations and roles of teachers to be designers of learning. Policymakers have both the power and responsibility to bring about this understanding, and more importantly, support teachers in growing into this new role as designers of learning through both pre-service and in-service professional learning.

A part of the professional learning to support teachers in their role as designers of learning experiences is to develop in them a semiotic awareness so as to use the embodied semiotic modes and semiotic technologies with aptness and fluency, just as how a designer would make selections and use material tools and semiotic resources in their work. This echoes the call made by Kress et al. (2005: 170) in their recommendation for an 'in-service programme' to bring about a greater multimodal semiotic awareness in teachers. Making explicit the ways meanings can be made through various semiotic resources used by the teacher enables an apt and fluent use of embodied modes and semiotic technologies to express unique pedagogies. This reduces irreconcilable semantic divergence which results in conflicting, and possibly confusing meanings. As such, I hope that the ideas offered in this book will invite teachers to reflect on their use of multimodal semiotic resources as they critique and design these aspects of their professional practice.

In light of the new literacy practices and the changing profile of learners in today's digital age, I have argued that the role of the teacher needs to evolve into that of a designer of learning, rather than just an authority of knowledge. With teachers being attributed as one of the success factors in students' achievements, it is of value

to develop deeper understandings of the pedagogic work performed by the teacher in the classroom. The multimodal perspective offered brings into focus the repertoire of semiotic resources in pedagogic discourse. Jewitt (2008: 262) explains that 'how teachers and students use gaze, body posture, and the distribution of space and resources produces silent discourses in the classroom that affect literacy'. We have explored how an apt combination of semiotic selections can be organised to express specific pedagogies. The aspiration for this book on multimodality in education is that it will pave the way towards the teachers' greater awareness and fluent use of semiotic resources to design meaningful learning experiences for their students.

Conclusion

The new paradigm of teaching and learning through multimodal lens presents a research space inviting deeper exploration and further investigation. Multimodal research offers promise and potential for classroom studies and applications. From the perspective of multimodal classroom discourse, the nonverbal is often as powerful as the verbal. Understanding the multimodal nature of teaching and learning can offer teachers the promise and potential of critical reflection on their use of embodied action, along with other semiotic resources, to critique and (re) design these aspects of their professional practice. Research in educational semiotics can also assist with the development of various pedagogical approaches, strategies, and models in the classroom. This book joins the growing field of scholarly work on educational semiotics, applying the perspective of multimodality on education. It aims to show how studies on the nature of multimodal semiosis in pedagogic discourse offer viable and valuable contribution to classroom research and practice. I hope to offer a way for educational researchers and teacher practitioners to think about and reflect on how they are designing the learning experiences for the students through the semiotic resources available to them

Teachers in the classroom are at the frontline of education. In light of the rapid changes brought about by today's digital age and the evolving roles and expectations of teachers, it is increasingly more crucial for administrators and curriculum specialists to work with educational researchers and teachers to strengthen the policy, theory, and practice nexus. Educational researchers serve the critical role of supporting teachers by providing insights and evidences on how teaching and learning can be better.

I have proposed that embodied teaching with multimodal classroom orchestration can help teachers reflect on how they can become designers of learning in the contemporary classroom. Just as a designer will select the most apt semiotic resources and material tools to express her ideas in her work, the teacher, as a designer of learning, makes apt and fluent selections in her embodied semiotic modes and semiotic technologies to express her pedagogy. The main argument is that in developing teachers' semiotic awareness and fluency in multimodal orchestration, they are supported in their roles as designers of learning experiences for their students.

The ideas proposed here are a reflection of my experiences as a former teacher in the classroom of a junior college, an administrator, and curriculum specialist at the Ministry of Education Headquarters in Singapore, and now an educational researcher at the National Institute of Education at Nanyang Technological University. In each of these roles, I have had the privilege to experience and reflect on what teaching and learning is about from different vantage points. As a teacher, my interest and responsibility were for the students in my classes to learn well. As such, the focus was on reflecting on how I could teach better, and design various learning experiences for students. As an administrator and curriculum specialist, my role was to ensure that all students in the educational system were equipped with the knowledge and skills to be future-ready. The curriculum we offer, and the pedagogies of our teachers, are to be reviewed regularly so that it remains responsive to the changing world and the changing profile of learners. I was keen to explore how academic research could be translated to inform curricular designs and pedagogical decisions, as well as influence educational policies. Now, as an educational researcher, my goal is to support teachers, as well as administrators and curriculum specialists, through research, evidences, and ideas, by translating research theories to inform and influence educational practices.

In writing this book, I have attempted to wear the different hats in various parts of the book, so that I may address the needs of the different groups of readers. The ideas on embodied teaching and designing learning offered here are not intended to be esoteric, and in fact, are arguably, fairly intuitive and commonsensical. In this regard, I hope that a multimodal semiotic awareness can be nurtured through the relatable ideas described in the book and, more usefully, can be easily applied by a motivated teacher keen to improve her craft. The ways and typologies introduced to code, analyse, and interpret the multimodal nature of pedagogic discourse, in terms of the embodied semiotic modes, and semiotic technologies used by the teacher, in the classroom, are rudimentary, and avail themselves to be critiqued, refined, and enhanced by other educational researchers for their own needs. The argument for the evolving role of the teachers as designers of learning can also be seen as a natural development in response to today's digital age, hence making it not such a hard-sell for policymakers. In other words, the ideas proffered in this book are intended to be accessible and actionable. By bringing together the ideas on embodied teaching, my ultimate aim is provoke thought and inspire action in you – dear reader – towards designing learning.

REFLECTION QUESTIONS

1. How should educators respond to the changing profile of our students and the new literacy demands in today's digital age?
2. What does it mean for a teacher to be a designer of learning?

References

Bezemer, J. & Kress, G. (2016). *Multimodality, Learning, and Communication: A Social Semiotic Frame*. London & New York: Routledge.

Christie, F. (1993). Curriculum genres: Planning for effective teaching. In B. Cope & M. Kalantzis (eds), *The Powers of Literacy: A Genre Approach to Teaching Writing* (154–178). Pittsburgh: University of Pittsburgh Press.

Christie, F. (1997). Curriculum macrogenres as forms of initiation into a culture. In F. Christie & J.R. Martin (eds), *Genre and Institutions: Social Processes in the Workplace and School* (134–160). London: Cassell.

Christie, F. (2002). *Classroom Discourse Analysis: A Functional Perspective*. London & New York: Continuum.

Cienki, A. (2008). Why study gesture? In A. Cienki & C. Müller (eds), *Metaphor and Gesture* (5–25). Amsterdam: John Benjamins.

Cope, B. & Kalantzis, M. (2015). The things you do to know: An introduction to the pedagogy of multiliteracies. In B. Cope & M. Kalantzis (eds), *A Pedagogy of Multiliteracies: Learning by Design* (1–36). London: Palgrave Macmillan.

Hall, E. (1966). *The Hidden Dimension*. New York, NY: Doubleday.

ICT Connection (2019). Vision and Goals. Ministry of Education, Singapore. Retrieved from https://ictconnection.moe.edu.sg/masterplan-4/vision-and-goals (accessed: 23 Nov. 2019).

Jewitt, C. (2008). What counts as knowledge in educational settings: Disciplinary knowledge, assessment, and curriculum. *Review of Research in Education* 32, 241–267.

Kress, G. (2000). Design and transformation: New theories of meaning. In B. Cope & M. Kalantzis (eds), *Multiliteracies: Literacy Learning and the Design of Social Futures* (149–157). London & New York: Routledge.

Kress, G. (2003). *Literacy in the New Media Age*. London & New York: Routledge.

Kress, G. (2005). Gains and losses: New forms of texts, knowledge and learning. *Computers and Composition* 22(1), 5–22.

Kress, G. (2007). Meaning, learning and representation in a social semiotic approach to multimodal communication. In A. McCabe, M. O'Donnell, & R. Whittaker (eds), *Advances in Language and Education* (15–39). London & New York: Continuum.

Kress, G. & Selander, S. (2012). Multimodal design, learning and cultures of recognition. *The Internet and Higher Education* 15(4), 265–268.

Kress, G., Franks, A., Jewitt, C., & Bourne, J. (2005). *English in Urban Classrooms: A Multimodal Perspective on Teaching and Learning*. London & New York: Routledge.

Lemke, J. (2002). Multimedia semiotics: Genres for science education and scientific literacy. In M.J. Schleppegrell & M.C. Colombi (eds), *Developing Advanced Literacy in First and Second Languages: Meaning with Power* (21–44). New York: Lawrence Erlbaum Associates, Inc.

Lim, F.V. (2011). A Systemic Functional Multimodal Discourse Analysis Approach to Pedagogic Discourse. Doctoral thesis. National University of Singapore.

Lim, F.V. (2018). Developing a systemic functional approach to teach multimodal literacy. *Functional Linguistics* 5, 13.

Lim, V.F. (2019a). Analysing the teachers' use of gestures in the classroom: A Systemic Functional Multimodal Discourse Analysis approach. *Social Semiotics* 29(1), 83–111.

Lim, F.V. (2019b). Investigating intersemiosis: A Systemic Functional Multimodal Discourse Analysis of the relationship between language and gesture in classroom discourse. *Visual Communication* 1–25. https://doi.org/10.1177/1470357218820695

Lim, F.V. (submitted for publication). Towards Education 4.0: An Agenda for Multiliteracies in the English Language Classroom.

Lim, F.V. & Tan, K.Y.S. (2017). Multimodal translational research: Teaching visual texts. In O. Seizov & J. Wildfeuer (eds), *New Studies in Multimodality: Conceptual and Methodological Elaborations* (175–200). London/New York: Bloomsbury.

Lim, F.V. & Tan, K.Y.S. (2018). Developing multimodal literacy through teaching the critical viewing of films in Singapore. *Journal of Adolescent & Adult Literacy.*

Lim, F.V. & Tan, J.M. (submitted for publication). Lesson Microgenres: An Approach to Multimodal Classroom Discourse.

Lim, F.V. & Toh, W. (in press). Children's Digital Multimodal Authoring in the Third Space – Implications for Learning and Teaching. *Learning, Media, and Technology.*

Lim, F.V. & Toh, W. (submitted for publication). Towards a Literacy for Digital Reading.

Lim, F.V., O'Halloran, K.L., & Podlasov. A. (2012). Spatial pedagogy: Mapping meanings in the use of classroom space. *Cambridge Journal of Education* 42(2), 235–251.

Lim, F.V., O'Halloran, K.L., Tan, S., & E, M.K.L. (2015). Teaching visual texts with multimodal analysis software. *Educational Technology Research and Development* 63, (6), 915–935.

New London Group (2000). A pedagogy of multiliteracies designing social futures. In B. Cope & M. Kalantzis (eds), *Multiliteracies – Literacy Learning and the Design of Social Futures* (9–36). London & New York: Routledge.

O'Halloran, K.L. (1996). The discourse of secondary school mathematics (unpublished doctoral dissertation). Murdoch University, Australia.

O'Halloran, K.L. (2004). Discourse in secondary school Mathematics classrooms according to social class and gender. In J.A. Foley (ed.), *Language, Education and Discourse: Functional Approaches* (191–225). London & New York: Continuum.

Paniagua, A., & Istance, D. (2018). *Teachers as Designers of Learning Environments: The Importance of Innovative Pedagogies, Educational Research and Innovation.* Paris: OECD Publishing. https://doi.org/10.1787/9789264085374-en.

Potter, J., & Julian, M. (2017). *Digital Media, Culture and Education: Theorising Third Space Literacies.* London: Palgrave Macmillan.

Selander, S. (2008). Designs for learning – a theoretical perspective. *Designs for Learning* 1(1), 4–22.

Street, B. (ed). (1993). *Cross-cultural Approaches to Literacy.* Cambridge: Cambridge University Press.

The New London Group. (1996). A pedagogy of multiliteracies: Designing social futures. *Harvard educational review, 66*(1), 60–93.

Towndrow, P.A., Nelson, M.E., & Yusuf, W.F.B.M. (2013). Squaring literacy assessment with multimodal design: An analytic case for semiotic awareness. *Journal of Literacy Research* 45(4), 327–355.

Unsworth, L. (2002). Changing dimensions of school literacies. *Australian Journal of Language and Literacy* 25(1), 62–77.

Unsworth, L. (2006a). *E-literature for Children: Enhancing Digital Literacy Learning.* London & New York: Routledge.

Unsworth, L. (2006b). Towards a metalanguage for multiliteracies education: Describing the meaning-making resources of language-image interaction. *English Teaching: Practice and Critique, 5*(1), 55–76.

Weninger, C. (2019). *From Language Skills to Literacy: Broadening the Scope of English Language Education through Media Literacy.* Abingdon: Routledge.

INDEX